Renoir at the Theatre

Looking at *La Loge*

THE
COURTAULD
Gallery

75 YEARS
OPENING
MINDS
TO ART

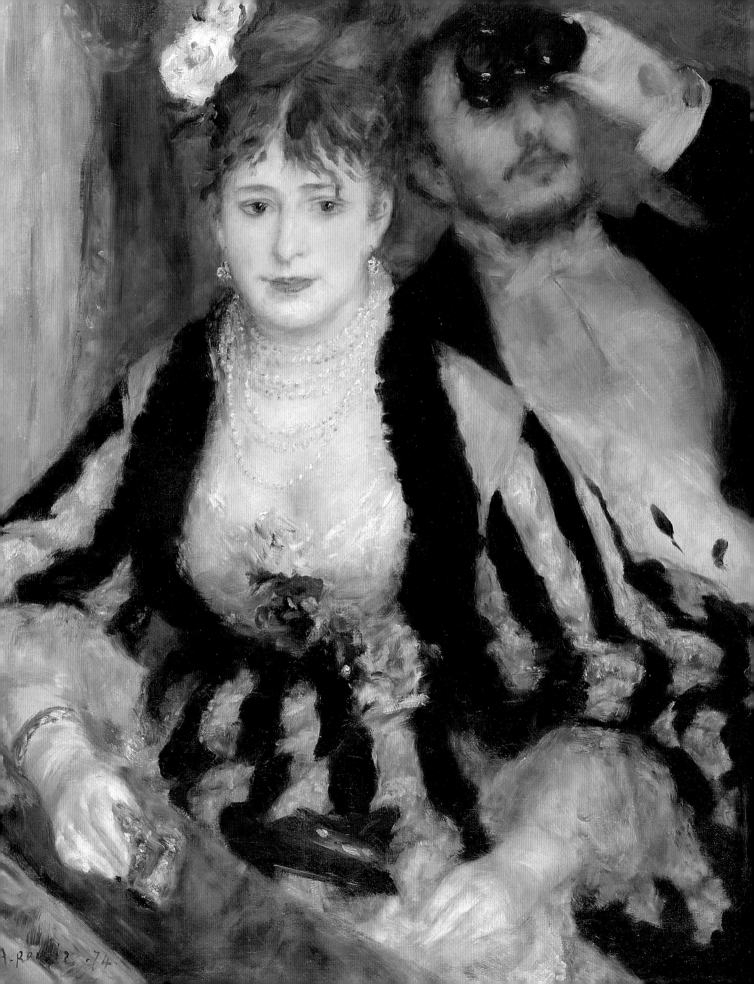

Renoir at the Theatre
Looking at *La Loge*

EDITED BY

Ernst Vegelin van Claerbergen
and Barnaby Wright

ESSAYS BY

John House, Nancy Ireson
and Aileen Ribeiro

CATALOGUE BY

John House, Ernst Vegelin van Claerbergen
and Barnaby Wright

The Courtauld Gallery

IN ASSOCIATION WITH
PAUL HOLBERTON PUBLISHING
LONDON

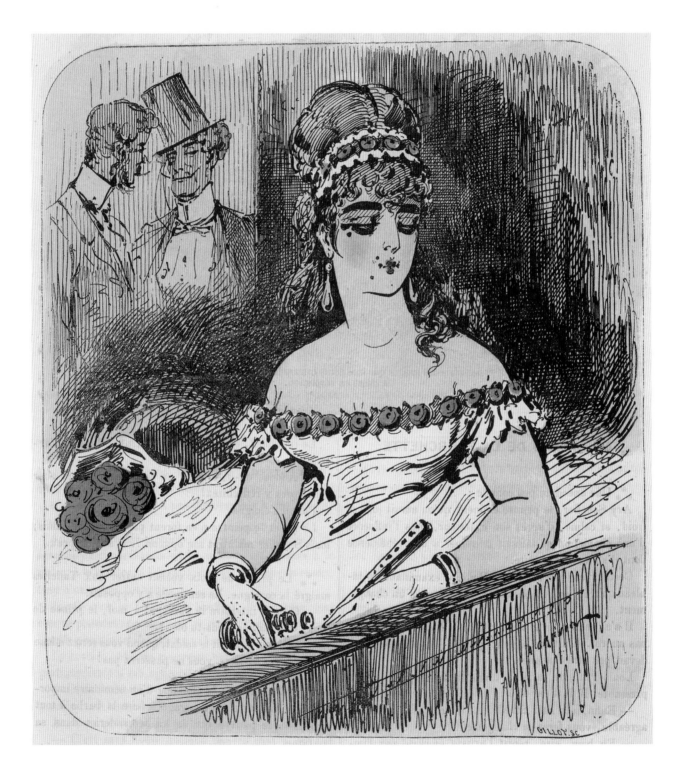

Contents

Director's Foreword

Renoir at the Theatre: Looking at La Loge is part of a programme of exhibitions and special events which celebrates the seventy-fifth anniversary of the year in which the Courtauld Institute of Art first opened its doors to students, single-handedly pioneering the study of art history as an academic university subject in Britain. Alongside the generosity of other supporters, it was the initiative of three key people that brought the Institute into being – the politician Viscount Lee of Fareham, the lawyer Sir Robert Witt and the industrialist Samuel Courtauld. I trust that our founders would have been delighted to see how the Courtauld now flourishes at Somerset House, and how it remains true to their founding vision as an international centre which brings together teaching and research in art history and conservation, rich book and image libraries and a world-class collection of art.

Pierre-Auguste Renoir's well-known painting *La Loge* (The Theatre Box) was one of the artist's principal exhibits in the first Impressionist exhibition in Paris in 1874. Yet, surprisingly, this exhibition will be the first to focus on its complex subject-matter and the role it played in establishing Renoir as a leader of this radical new artistic movement. The Courtauld is particularly well placed to shed fresh light on this great work. Our exhibitions focus on single or small groups of works from the permanent collection, examining these in the context of closely related loans. Placing new research in the public domain is an important aspect of the Gallery's role as a university art museum, and *Renoir at the Theatre* once again brings together our combined academic research and curatorial strengths. In this instance my colleagues have brought together expertise in the history of dress and fashion and in nineteenth-century popular graphic culture with deep knowledge of the relationship between the 'Impressionist' project of the late nineteenth century and the longer history of European traditional pictorial practice.

"Art is universal and eternal; it ties race to race, and epoch to epoch. It overlaps the divisions and unites men in one all-embracing and disinterred and living pursuit …. Moreover, the way to receive [art's] gifts can be thrown open to all; it is not reserved for the wealthy, the idle and the learned …." Samuel Courtauld, whose inspired collecting in the 1920s ensured that Impressionist and Post-Impressionist art became part of the heritage available to the British nation, held the passionate belief that art was essential to the good of society. Both the Courtauld Institute of Art and the Samuel Courtauld Trust, which holds in trust his collection and those donated so generously by other benefactors, sustain the same belief. We are immensely grateful therefore to Apax Partners; Mr and Mrs Gilbert Lloyd, Nassau, Bahamas; The Doris Pacey Charitable Foundation; and Toray Industries, Inc., who in the same spirit of philanthropy have made it possible for us to transform our scholarship into an exhibition which will give both pleasure and stimulation to the wider public.

Deborah Swallow
Märit Rausing Director
The Courtauld Institute of Art

Renoir at the Theatre: Looking at La Loge is the second exhibition organized during the seventy-fifth anniversary year of the founding of the Courtauld Institute of Art in 1932. It seems highly appropriate that it takes as its subject-matter one of the very greatest of the many outstanding works of art with which Samuel Courtauld endowed the institute that carries his name. Courtauld acquired *La Loge* in 1925 and gave it a prominent position in the beautiful music room of Home House in Portman Square, London, where he lived with his wife Elizabeth. Indeed, the picture may have had special resonance for Mrs Courtauld, who was a patron of the ballet and the opera. It had always been Samuel Courtauld's intention that the works assembled in his private collection should pass into the public domain for the widest possible benefit, and upon his death in 1948 *La Loge* was bequeathed to the Home House Society (now the Samuel Courtauld Trust). Displayed at the Courtauld Gallery, lent to exhibitions internationally, and reproduced countless times in numerous media, *La Loge* has grown rapidly in fame and today draws many thousands of admirers to the Courtauld every year. The ability of *La Loge* to give pleasure and delight so indiscriminately is fully in keeping with Samuel Courtauld's vision of the vital and open role which art should play in life. And yet, in some respects, fame has also veiled this picture, its familiarity and its reductive status as an archetype of Impressionism perhaps acting against close scrutiny. *Renoir at the Theatre* invites visitors to look again at *La Loge* for a richer understanding of this celebrated work. This too would surely have pleased Courtauld, for whom *La Loge*, with its "subtle charm of surfaces", was a source of constant renewal and inspiration.

Ernst Vegelin van Claerbergen
Head of The Courtauld Gallery

Foreword

La Loge displayed in the Music Room at Home House

Exhibition Supporters

This exhibition has been generously
supported by:

Apax Partners

Mr and Mrs Gilbert Lloyd, Nassau, Bahamas

The Doris Pacey Charitable Foundation

Toray Industries, Inc.

'TORAY'
Innovation by Chemistry

Exhibition Partner

Acknowledgments

The organisers would like to thank the staff and trustees of the following
institutions which have generously lent works to this exhibition:
Museum Langmatt, Baden; The Walters Art Museum, Baltimore;
The Museum of Fine Arts, Boston; The British Library, London; The
National Gallery, London; Bibliothèque – Musée de l'Opéra, Paris; Musée
Carnavalet, Paris; Philadelphia Museum of Art; Sterling and Francine Clark
Art Institute, Williamstown. We would also like to extend our warm thanks to
a number of private lenders who wish to remain anonymous.

The exhibition would not have been possible without the support
of the Government Indemnity Scheme and our thanks are due to
Gregory Eades and his colleagues.

This exhibition is the result of a close collaboration between the
Courtauld Gallery and the academic faculty of the Courtauld Institute
of Art, and we would like to thank John House and Aileen Ribeiro for
their invaluable contributions to the project. We would also like to thank
Nancy Ireson for her work on the catalogue, and Caroline Campbell
for her assistance in developing the project. We have relied upon the
generosity, goodwill and expertise of a number of other individuals in
realising this exhibition and we would like to thank especially Lady Jane
Abdy, Mathias Auclair, Sir Jack Baer, Clare Browne, Jean-Marie Bruson,
Jessie Fertig, Romain Feste, Ken Nishikawa, Susan North, Claire Durand-
Ruel Snollaerts and Françoise Vittu.

None of our exhibitions would be possible without the hard work and
dedication of colleagues at the Courtauld and we would like to thank
in particular Julia Blanks, Graeme Barraclough, Mary Ellen Cetra,
William Clarke, Ron Cobb, Katy Hadwick and Natalia Owdziej.

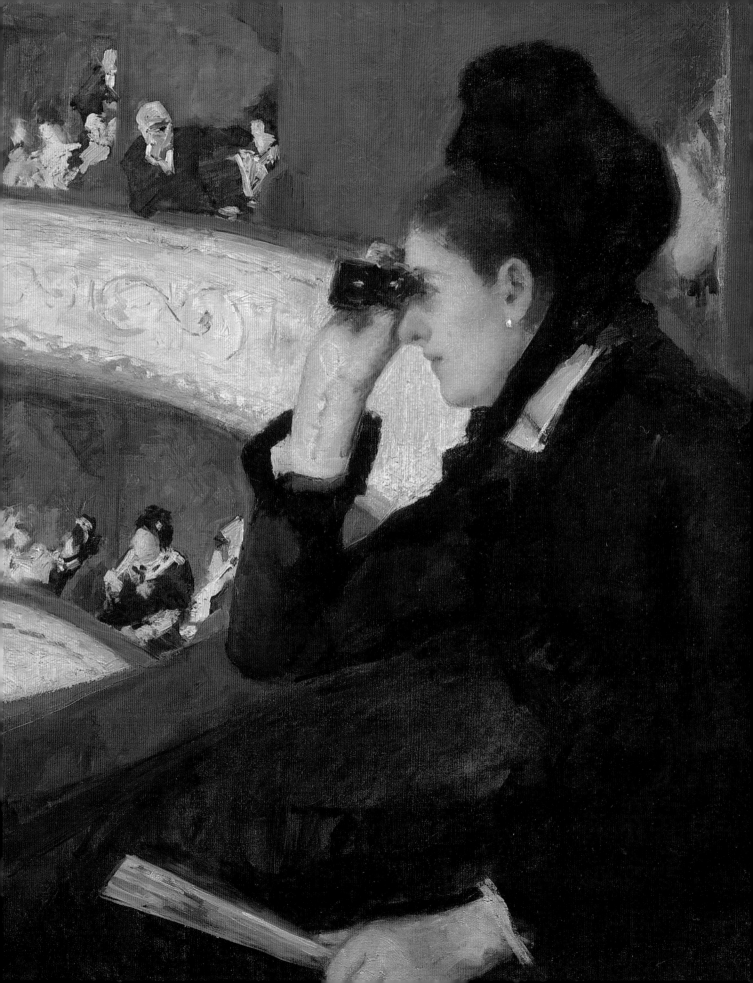

The Lure of the *Loge*

NANCY IRESON

Impressionist *loge* paintings seem to epitomise leisure and luxury, yet they were produced in a period of intense political and cultural renewal. The city that received them in the 1870s and 1880s had been marked by demolition, regime change, war and unrest. The building projects of Baron Haussmann had altered the face of the capital dramatically under the reign of Napoléon III.[1] Then, within weeks of the Republican rise to power in the autumn of 1870, the city had entered the most dramatic chapter of the Franco-Prussian War. The Siege of Paris – which caused widespread sickness and starvation – lasted until January 1871. In the spring, when a conservative faction of the government re-established some kind of order, the National Guard prompted a civil uprising. The Commune of 1871 cost Paris a further 20,000 lives. Countless more citizens were injured or imprisoned.[2]

It was against this background that the theatre box became a motif in a new art. Certainly, when Renoir exhibited *La Loge* (cat. 5) in a 'fine art' context in the first Impressionist exhibition in 1874, the subject was novel.[3] Honoré Daumier and Constantin Guys had depicted theatre boxes in small oils and watercolours before him (see cat. 1–4) but most often, since the eighteenth century, the subject had been the preserve of caricaturists and fashion-plate illustrators (see figs. 1 and 2). Nevertheless, in subsequent years, many progressive artists adopted the *loge* as an emblem fit for modern painting. Eva Gonzalès produced *Une loge aux Italiens* (fig. 18, p. 35) in the same year as *La Loge* and Renoir would himself return to the theatre box in several later canvases. Alongside Renoir it was Mary Cassatt who treated the *loge* most extensively, as she made a number of important canvases on the subject (in addition to pastels and prints) in the 1870s (see for example cat. 9 and 10 and fig. 3). Around 1880 Degas began a group of experimental pastels which presented dramatically cropped views of *loges* and their occupants (see for example cat. 12 and fig. 22, p. 41). By the end of that decade, the theatre box was a subject familiar enough for it to attract a less radical modern painter such as Jean Béraud, or one such as Henri Gervex, who continued to show his work at the *Salon des artistes français* (see figs. 4 and 21, p. 41).[4]

However, if the *loge* was new in the context of the art exhibition, it was an established feature of city life. The Parisian leisure industry had grown steadily throughout the nineteenth century; the theatre was extremely

Fig. 1 Grandville, 'C'est Vénus en personne', engraving from Grandville, *Un autre monde*, Paris, 1843

Fig. 2 Artist unknown, 'Coiffure de Théatre', engraving from *La Mode Illustrée*, 21 September 1873

popular in Third Republic France. If there had been only eleven such venues in Paris in 1828, by 1882 there were twenty-three.[5] These establishments catered for all kinds of clientele and budget, from the upmarket, state-supported, former Imperial theatres (the Opéra; the Opéra Italien, also known as the Théâtre Italien; the Opéra Comique; the Théâtre Lyrique, the Comédie-Française and the Odéon) to more modest venues such as the Gaieté and Variété, clustered around the Boulevard Saint-Martin. The *année terrible* had caused the theatres to close temporarily but when they re-opened it became clear that the public appetite for entertainment was strong. Now, more than ever, society craved distractions to boost post-war morale. Perhaps it was fitting, in this context, that the *loge* should make the transition to representation on canvas. Its associations of entertainment and escapism (and even its comic heritage in the popular press) might have recommended it to young painters at this time.

Yet it was not a simple love of the arts that fuelled enthusiasm for the theatre. These were also important public spaces where, in boxes and grand communal areas, people could advertise their presence and scrutinise the activity of others. This added to their allure: the best of such venues had long drawn the Parisian elite. On the subject of opening nights at the Comédie Française, in 1852, for instance, the *Tableau de Paris* declared that a typical audience would consist of "all the famous names in politics, science, art and fashion … all those who are well-known in Parisian society".[6] Fashions were set at these prestigious places; allegiances were dismissed or re-affirmed. Beneath the bright gas lights of the auditorium – and as interested in the activities of their neighbours as in the action on stage – nineteenth-century audiences observed and participated in a complex social ballet.[7] It is unsurprising that in *Le Rouge et le noir* by Stendhal, written during the Bourbon Restoration, the provincial Julien Sorel goes to the Opéra to learn city manners. Equally, when Flaubert describes an unexpected encounter between Madame Bovary and her lover in his Second-Empire novel of the same name, a *loge* provides the ideal setting.[8]

In addition to its function as a highly public space, the theatre (and more specifically the box) had associations of concealment. This had made it doubly attractive to authors. It provided an ideal locale for illicit affairs; in dark corridors and discreet *loges*, unbeknownst to their partners or families, couples might meet in secret. And in those arenas that required formal costume, make-up and dress could confuse the eye, appearances could deceive the onlooker.

Tensions of this kind were particularly pronounced in the 1870s as different types of spectator entered the theatre. Self-made businessmen flocked to display their wealth in a time-old arena; shopworkers and office staff found a new leisure pursuit with the arrival of matinée performances.[9] Rural migration swelled a working population that craved low-brow entertainment;[10] foreign tourists added to an increasingly eclectic social mix. Nonetheless, though these shifts were evident, the auditorium assimilated its new clientele. Its established status made the changes in the audience both more and less apparent. Surely, then, the

Fig. 3 Mary Stevenson Cassatt,
Women in a loge, c.1881–82
Oil on canvas, 80 × 64 cm
National Gallery of Art, Washington

lure of the *loge* – for public and painters alike – involved both the visible and the unseen, the obvious and an invitation to the imagination.

The most iconic building project completed in the 1870s – the new Paris opera house by Charles Garnier – also embodied dualities (see fig. 5). Started in 1861 under the Emperor and completed in 1875 under the Republicans, many of its developments were bold and unprecedented, but at times it went to great pains to conceal its advanced technological achievements. Electric light – which transformed air quality and visibility – shone out from conservative chandeliers; a conventional stage hid the unprecedented levels of flooring required to accommodate the latest mechanical engineering. And stylistically, though Garnier borrowed from a variety of architectural traditions, his particular mélange was peculiar to its epoch. "That's not a style!" complained the Empress Eugénie (who had wanted Viollet-le-Duc to have the commission). "It is neither Greek, nor Louis XVI, not even Louis XV!"[11] With its marble friezes and classical columns, with its grandiose foyer and ceremonial staircase, the form of the new house invited and evaded precise interpretation. Consequently, though it had started life as one of the most ambitious Second Empire

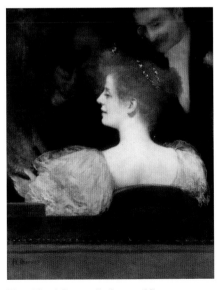

Fig. 4 Henri Gervex, *La Loge*, c.1885
Oil on canvas, dimensions and
whereabouts unknown

regenerative plans, for President Theirs and his administration it became a symbol of a new era in French history.[12] For the Paris of the 1870s it was an ostensible sign of recovery, at the very heart of the *grands boulevards*, but its specific message was unclear. As such, inadvertently, it was the perfect symbol of an uncertain age.

Though they could not be more different in terms of style, in other ways Impressionist *loge* paintings are analogous to the architect's confection.[13] They too combine multiple associations; their meaning is also open to interpretation. Naturally, as nineteenth-century Parisians would have noticed, both Garnier and Renoir employed progressive technical methods. As the critic Camille Mauclair observed in the 1920s, at almost the same moment that electric light enchanted audiences at the Opéra for the first time, "painterly vision was transformed, and finally they [painters] saw the theatre, above all, through colour".[14] But simultaneously, just as the theatre might ease Julien Sorel into high society, the associations of this venerable establishment could facilitate the reception of both these new aesthetics. The audaciously decorated boxes at the 'Palais Garnier' had caused offence (see fig. 6), but the weight of the Opéra as an institution meant that the outrage was short-lived. Perhaps artists believed that some of the venerable connotations of the theatre might ease acceptance of their audacious efforts in a similar way. The *loge* as subject was avant-garde but, as an apparent reluctance to indicate precise theatre interiors indicates, Impressionist use of it was tempered. The higher-end *café-concerts* had *loges*; the Ambassadeurs or the Eldorado were new arenas that blurred familiar social order.[15] Nevertheless, in most canvases of the

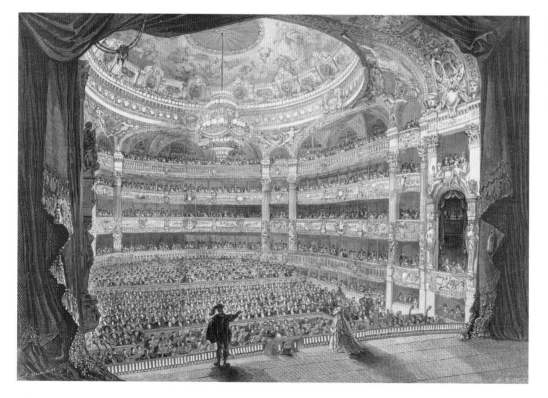

Fig. 5 MM. Scott and Lix, 'Inauguration du Nouvel Opéra – La Salle Vue de la Scène', engraving from *Le Monde Illustré*, 1875
Bibliothèque de l'Opéra, Paris

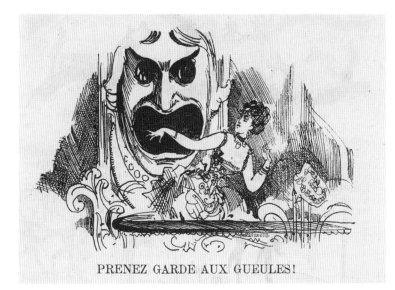

PRENEZ GARDE AUX GUEULES!

Fig. 6 Artist unknown, 'Prenez garde aux gueules – Les folies-Garnier', engraving from *La Vie Parisienne*, Paris, 6 February 1875

1870s and 1880s, the auditoria are non-specific and timeless – a strategy, perhaps, that might have made them more palatable to an adventurous (but not bohemian) market. The artists of the 'symbolist' theatre – Toulouse-Lautrec *et al.* – made the transition to recognisable locale soon afterwards, but, in the process, they blurred the boundaries between 'fine' art and popular imagery.[16]

While the other essays in this catalogue explore the visible messages of *La Loge*, this introductory text will examine some of the multiple associations of the box and the structures beneath the appearance of the paintings. Impressionist *loge* canvases – like the 'Palais Garnier' – have elaborate decorative façades, which conceal complex associations and meanings.

If the theatre box held a particular appeal for French artists, in part it was because they were popular with the French *per se*. *Loges* had been a regular feature in Parisian theatres since the seventeenth century, from the days when, in their temporary homes at the Palais Royal, the Comédie Française and the Opéra had become integral to the social scene.[17] Their peculiar hierarchy had survived even the French Revolution. In the late eighteenth century, for the sake of *fraternité*, the authorities had tried to do away with theatre boxes, but popular opposition won out.[18] Thus, to a far greater extent than in Italian or English theatres, French design accommodated the demand for such spaces. Modest or luxuriant, from the grand circle to the gods, boxes divided the different tiers of most auditoria into a series of distinct sections. They created units of around half a dozen spectators which (in theory at least) might offer some sense of personal space.

Certainly, as they were the only part of the auditorium that could be booked until well into the nineteenth century, there were practical reasons for the longevity of the box. For a fee of up to forty per cent of the ticket price, paid in advance, a reserved *loge* offered direct access to the performance, a chance to avoid the chaotic box-office queues that formed

outside theatres before performances. At the poorer Parisian venues, in particular, this was of no small consequence. In 1866, in his description of such a ticket queue, one foreign visitor had used the metaphor of a line of convicts "attached to the same chain" to describe those who waited to buy tickets. The company was motley; pickpockets and ticket touts were rife.[19]

Once inside the theatre, even for those who had not secured their places beforehand, comfort was an ample incentive to find a *loge* seat. Admittedly, as maybe the case in Daumier's *La Loge* (cat. 1), the inhabitants of boxes were often strangers. Owners tried to maximise the profits of popular performances, too, so they could become ridiculously crowded – a situation caricatured in *Le Petit Journal pour Rire* (see cat. 33). But they were usually preferable to the alternative seating options. Until the late eighteenth century, owing to the absence of orchestra stalls in even the best theatres, audiences in the pit were obliged to stand, elbow to elbow, desperate to see the stage. Not until 1850 did all theatres have seating in both the *parterre* and amphitheatre and, even then, the move was prompted by a desire for audience management rather than the demands of the clientele.[20]

The *parterre* and the amphitheatre had further disadvantages. The orchestra stalls were a suitable location for single men, but many theatres would not allow women access to the space until as late as the 1890s.[21]

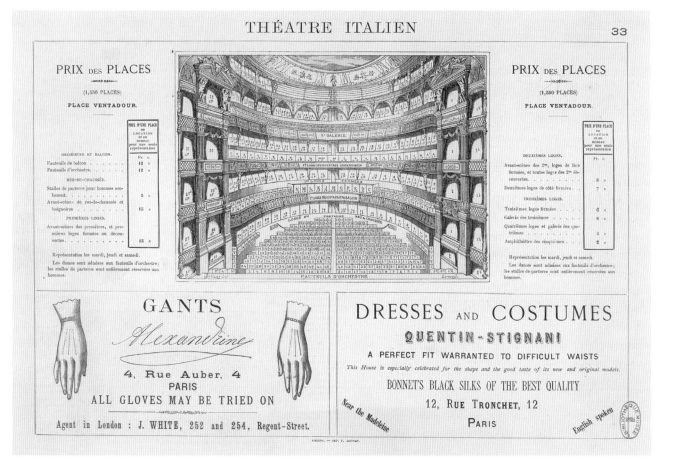

Furthermore, while neither area was particularly visible to the rest of the auditorium, nor did they offer seclusion. Relative to its location, in contrast, a *loge* could cater to either preference. As much as any mundane concerns these functions were crucial considerations.

In truth, the best seats in the theatre – the *premières loges d'avant scène*, extremely close to the stage – were relatively impractical. Most offered an unsatisfactory view of the performance. But this was of little consequence. It was here that French royalty and, later, the Emperor had sat, and in the Third Republic, with those regimes gone, new society figures flocked to take their place. Because these boxes were the most expensive, a well-situated *loge* was a symbol of status. Between 1871 and 1873, for example, a booked seat in a *première loge* at the Comédie Française cost twelve and a half francs, more than twelve times the price of the cheapest ticket.[22] A similar seat at the Italiens was as much as fifteen francs (see fig. 7). Even at the Théâtre de la Gaieté – a relatively 'popular' establishment – a reserved *avant-scène* box, at eight francs, was a world removed from the places at 50 centimes in '*paradis*'.[23]

Mindful of this distinction, as it awarded the *premières loges d'avant scène* at the best venues to dignitaries and other guests of honour, the young government perpetuated an old tradition. Equally, since these *loges* housed the most important spectators, they continued to attract the attention of the auditorium. They remained the perfect place to give visual announcement of an engagement, publicise a change of political alliance, or simply show standing. Boxes offered maximum exposure to the powerful and the wealthy, or, at least, so it might seem. Increasingly, the question remained as to who these people were; and, notably, many Impressionist *loge* paintings decline to give any clear indication.

The most logical occupant of the *loge* was the subscriber. Above even the pre-booked seat, for those who had the means an annual subscription to a box was the clearest way in which to articulate affluence. A look at the subscription records at the Opéra reveals regular entries for such well-known names as Rothschild, Laffitte and Beaumont who, in 1867 alone, each made numerous regular payments ranging from around 334 to 10,200 francs.[24] The absence of Renoir from these accounts is unsurprising. This was a privilege well beyond the reach of the average Parisian.

In certain families, from generation to generation, the rights to a particular *loge* had become something of a tradition. This sense of heritage was important: it indicated the pedigree of a person's social status. "One has been a subscriber for more or less time, that's where the all the difference lies", explained Nérée Desarbres, the private secretary to the director of the Opéra from 1856 to 1863, in his 1864 memoirs.[25] He went on to recount a heated visit from a marquis who had neglected to renew his subscription, furious to find that he had lost his place, for which he had paid an annual fee of 16,000 francs for thirty consecutive years. Because of his long-standing patronage, protested the aristocrat, he deserved "more consideration than the hoi-polloi of subscribers".[26] Even amongst the select few, it seems, there was a distinct pecking order.

But not all of those who sat in the finest seats in the house had the means of a marquis, and even less frequently in the Third Republic. In 1873, in a satirical dialogue entitled 'Les loges de Madame', *La Vie Parisienne* concocted a three-page comedy about a couple who struggled to afford their commitments at the various city theatres.[27] The wife argues that, after the example set by her mother and grandmother, it is imperative that they should hire a box at the Opéra-Italien (a venue satirised in a caricature from the same journal; see fig. 8). When her husband suggests that they give up their places at the Théâtre Français to counteract the increased expenditure, she becomes angry. The shame of the ticket queue would be too much to bear and, on a practical note, they would never get tickets for the popular plays. She concludes, icily, that she will have to hope for an invitation from a friend. "I'll go as a free-loader", she declares, "that will be something new."[28]

In her comment, albeit with hostility, the female character in 'Les loges de Madame' points to another peculiarity of the theatre in nineteenth-century Paris. It was particularly fashionable *not* to pay for a ticket, to take a place offered by an acquaintance or business contact, all the more so if it belonged to someone of higher social standing. This was nothing new. In the 1844 story of *The Count of Monte Cristo*, written by Alexandre Dumas under the reign of Louis Philippe, the author begins the fifty-third chapter with an evening at the Opéra. He explains how, unable to use the ministerial *loge* at his disposal, Lucian Debray extends the offer to the comte de Morcerf. But "Morcerf, like most young rich people, had his own orchestra stall, plus ten boxes belonging to people in his acquaintance in which he could request a seat".[29] With no need for the places, then, it was only logical that he should pass the offer on to the Danglars family. He was certain that they would accept. "No one is so fond of a box that costs nothing than is a millionaire."[30]

But it was not only the wealthiest who might secure access to a free ticket. Dramatists and composers had complimentary places at their disposal for their own productions, and it may be that artists – who often kept such company – secured access in this way. For critics and public officials, too, occupation was a *passe-partout*. Until the spring of 1872, when a new finance bill expunged public officials from the lists for complimentary seats, the best theatres lost almost half of their places to this particular perk. On opening nights – which became ever more popular as the century moved on – that figure was greater still. This put a considerable strain on theatres, and contributed to the bankruptcy of some of the less affluent institutions.[31] But it had a tangible impact on the character of audiences. In a review of the opening night of *Marion de Lorme* at the Théâtre-Français in 1873, for instance, a journalist noted how the 'classic' audience – the gentlemen of the academy and the like – had abandoned the terrain: "They still growl, they no longer bark". In their place were fashionable nouveau-riche women, and poets, painters, writers. "Young France, a noisy and teeming cohort, which takes its place all over the theatre, the *parterre*, the orchestra, in the galleries and *loges*. The upper middle classes … seem to be there only to fill the gaps."[32]

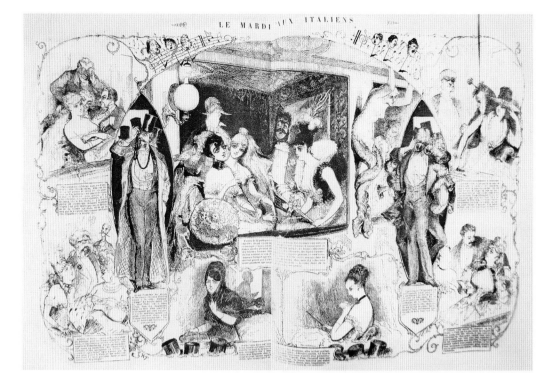

Fig. 8 Artist unknown,
'Le Mardi aux Italiens',
engraving from
La Vie Parisienne,
6 December 1873

Anomalies in the ticketing system are relevant to artistic depictions of the *loge*, and not only because they might have afforded painters access to the theatre. They introduce the possibility that the sitters in these images might have perplexed the contemporary viewer. *Loge* inhabitants had invited speculation since before the Second Empire and they continued to do so in the 1870s. Beauty and sophistication were undoubtedly helpful to those who wished to secure a place free of charge. "The composition of the auditorium does not always depend on the choice of the administration", concluded Desarbres in the 1860s, for "not all the elegant and graceful ladies ... whose bright eyes and diamonds illuminate the *salle de l'Opéra* have their names inscribed on the subscription list".[33] A guessing game was in play and, effectively, many *loge* paintings invite the audience to deduce the identity of the sitters.

For instance, if the marital status of the woman in Renoir's *La Loge* is unclear (as Ruth E. Iskin has underlined recently), her appearance is unquestionably iconic (see cat. 5).[34] The first critics to review the painting looked on it with admiration – the subject was undeniably appealing – though there was no consensus as to whether the woman was a lady or a flirt.[35] This duality renders her the more fascinating: her sensuality and ornament make her social position a secondary concern. And the same is true of the *Femme dans une loge* (cat. 10) by Mary Cassatt. This young woman might well be the kind of 'new-money' opera-goer that had met with the scorn of older subscribers, yet the viewer is invited to admire her fashionable dress and her self-assured pose without prejudice.[36] Surrounded by the reflections of the mirror, bathed in golden light, the red-head is caught in the embrace of the auditorium. Again, this

circumvention of hierarchies is one that Dumas had alluded to in his novel, when he described how Monte Cristo and Haydée entered the box that had once belonged to the Russian Ambassador. Haydée was 'exotic', she was both concubine and slave, but the audience was transfixed by her costume and looks. They wondered whether she was a princess. "The second act was played out against that dull murmur which indicates a great event amongst the assembled masses. No-one dared to shout 'silence'. This woman, so young, so beautiful, so dazzling, was the most interesting spectacle to be seen."[37] In the Third Republic, without a conventional genealogy and in defiance of social order, a dazzling new art might likewise win over the cream of society.

There were other potential reasons for the Impressionists to evoke the *loge*, ones that go beyond even the ambiguities of appearance. On occasion, contrary to usual behavioural codes, this space invented rules of its own. Even if respectability and a place in a *loge* did not necessarily go hand in hand, in order to maintain appearances spectators needed to follow strict codes of conduct within the theatre box. From the arrangement of seats to the manner in which to express praise for the performance, contemporary etiquette guides outlined the rules for the benefit of their readers. "Only a peasant would allow himself to whistle, to applaud by stamping his feet", explained one, in 1861. "As for women (who must be gloved conscientiously), they should only clap a little for form; making noise is left to the energetic hands of men."[38] It was up to men, too, to purchase tickets and to find refreshments in the interval.

Of course, given the relatively weak social position of women in the nineteenth century, many of these guidelines were in keeping with broader behavioural conventions. Even so, at times, the etiquette of the box overrode other social mores. Under normal circumstances, for example, men were meant to allow women the front seats in the box, even if they belonged to a different party. But particularly important figures might have to forgo this nicety. In the second volume of *Le Nouveau Savoir-vivre universel*, published in 1881, the reader learns of a minister who had no choice but to leave a lady-in-waiting standing behind him, with no view of the stage, because of his elevated status. The situation seems to have confounded the author.[39]

Perhaps *loges* in paint and print could also define their own terms – or at least use a satirical view of conduct in the box to acknowledge the ridiculous aspects of etiquette *per se*. Almost always, when artists and caricaturists depicted *loges*, they followed the logic set out in such guides. In a caricature by Grévin for *Le Petit Journal Pour Rire* (cat. 31), a conservative young daughter is appalled by the unseemly conduct of her father. "Really, papa, I'm ashamed. You laugh like you're in the four-penny seats." In a small watercolour by Guys (cat. 3), as two fashionable women at the front of a box seem to gaze down towards a stage, their male companions take the opportunity to survey the room.

Interestingly, in the Third Republic the blatant use of the opera glasses displayed in the latter image became increasingly unacceptable.

Lorgnettes make a regular appearance in much *loge* imagery but already, in 1861, *Le Petit Traité de la politesse française* had advised its readers to rein in their scrutiny of the other spectators. "Although habitually one uses this optical instrument to inspect the audience, we believe that it is always better to look as little as possible at the people in the auditorium and to point one's glasses only at the stage."[40] By 1881 – and *Le Nouveau Savoir-vivre universel* – young women were advised not only to avoid scanning the room but also to avert their glasses away from love scenes or from close scrutiny of male actors.[41] Notably, as painters who worked for the Salon or for more conservative private clients adopted the theatre box as subject, some 'fine art' *loges* began to avoid the *lorgnette* altogether, or at least ignore its more complicated discourses. Notably, as though she is aware of the onlooker, the woman in Forain's *La Loge* (cat. 13) declines to use her own pair; in other instances, in works by Gervex and Béraud, the stance towards the instrument borders on the comic.[42] These different types of engagement with vision reveal the audacity of the vanguard of Impressionist painters. Though she has no such instrument to hand, in Renoir's *Café-concert (Au Théâtre)* (cat. 8) the young model attracts the eye of a man in a lower *loge*. Meanwhile, with its interplay of gazes, *At the Français, a Sketch* (cat. 9) by Cassatt is the more remarkable for its engagement with the gendered associations of sight.[43]

However, in many artistic depictions of *loges*, proximity lessens the significance of such debate. *Lorgnettes* proliferate in popular and painterly material alike, but their presence is by no means universal. The act of looking is one of several facets to the genre and its importance varies from one work to another. For instance, since some of the best *loges* were akin to private drawing-rooms (with furniture and room to entertain guests),[44] it is almost as though the viewer and models in Renoir's *Une Loge au théâtre* (cat. 11) share the same box. If *La Loge* was an ambitious work, produced by an artist with social aspirations,[45] this later canvas – by an artist more secure in his future – places the model on an equal footing. In other *loge* paintings, more pointedly, intimacy is imbued with overtones that are amorous and distinctly private. Renoir uses the theatre box to suggest closeness in his two small *loge* paintings (cat. 6, 7); here it becomes a sanctuary within the auditorium. In the former composition, as the bearded man puts his arm around his companion, the figures in the adjoining *loge* become abstract touches of light and shade. A partition wall provides shelter from prying eyes.

This sense of secrecy was also in keeping with the actual conduct associated with the box. In contrast to the publicity of the *première loge*, other boxes were more discreet, none more so than those hidden away behind the first gallery. These *loges* – the so-called *baignoires* – could obscure all but the spectator's head and, because they were shielded from the audience, they provided cover for many an encounter. *La Vie Parisienne* alluded to this function in its comic round-up of *loges* and their occupants, 'Loges et types de grands théâtre', in 1875 (cat. 36). There, alongside the high-class *loge* and the ministerial *loge*, the spread includes 'The *baignoire* of the two lovers' (fig. 9). "They adore one another and have arranged,

skilfully, to spend this evening alone", reads the caption. "Her husband is at the hunt and, officially, she has invited a friend who has promised not to come. Here are two spectators who will find everything good."[46]

Such humour was not limited to the newspapers for, even at the theatre itself, an 1873 comedy entitled *Le Roi Candaule* had revolved around two couples and their liaisons in *loges*. It describes how the young Adèle, whose fiancé has forbidden that she should see the risqué play *Le Roi Candaule*, arranges to go to the performance in the company of the older, married, M. Duparquet. However, though her intentions seem innocent, her new companion has other ideas. He leaves Adèle for a moment to deliver an aside. "I've hired a *loge*, I've taken care to choose a *baignoire*, very dark, right at the back It's true that I promised to be reasonable, but ... you would bear too much of a grudge against us, you other women, if, having made such a promise, we should be stupid enough to keep it."[47] Meanwhile, on the understanding that their partners are otherwise engaged, Adèle's fiancé and Mme Duparquet have hired a *baignoire* of their own. Things get rather complicated when it emerges that they have double-booked the same space.

Of course, in addition to its obvious merits for an amorous couple, a *baignoire* offered privacy to those who preferred not to advertise their presence for more respectable reasons. But its potential hidden secrets, no doubt, made the box a more interesting subject for an artist. The proper ladies and gentlemen of their painted audiences might be part of any number of intrigues, and that uncertainty adds to the appeal of these images. The smooth paint that moulds the features of the sitter in Renoir's *La Loge*, the fluid lines of the coiffure, the translucent pastel hues that give brilliance to her skin – such sensual brushwork invites associations with the tactile. Even if there is nothing improper about the scene that meets the eye – here, as in an auditorium – beauty excites the imagination.

Beyond the sexual appeal of the model, too, artists may have enjoyed the compromised position of the bourgeois citizen that was sometimes imposed by the *loge*. The seating problems described in *Le Roi Candaule* were perfectly plausible: to find a place at the theatre was a complicated business. In most auditoria, visitors purchased a voucher (fig. 10) for

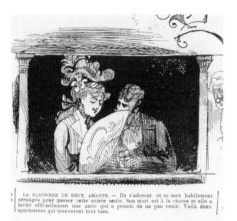

LA BAIGNOIRE DE DEUX AMANTS. — Ils s'adorent et se sont habilement arrangés pour passer cette soirée seuls. Son mari est à la chasse et elle a invité officiellement une amie qui a promis de ne pas venir. Voilà deux spectateurs qui trouveront tout bien.

Fig. 9 Artist unknown, 'La baignoire des deux amants', detail of 'Loges et types de Grands Théâtre', engraving from *La Vie Parisienne*, Paris, 6 February 1875 (cat. 36)

Fig. 10 Ticket for a place in a *loge sur le théâtre* at the Opéra, Paris, 1873, Bibliothèque de l'Opéra, Paris

Théâtre National de l'Opéra.
Loge sur le Théâtre. N.º 2
Représentation du 18 Juin 1873.

a place in a *loge*, which they would hand to a *contrôleur* (inspector) on arrival at the theatre. On receipt of this, under normal circumstances, the inspector would direct the spectator to the *ouvreuse* – or 'opener' – who would take them to a seat (fig. 11). But since the position of *ouvreuse* was often unpaid, if spectators neglected to provide an appropriate tip they would find themselves at a disadvantage. It is logical that the *ouvreuse* in *Le Roi Candaule* greets Adèle and Duparquet with the sarcastic observation, "There are only two of you, you aren't waiting for someone?"[48] These characters could be very difficult to negotiate. As Arthur Pugin would complain in his 1885 *Dictionnaire historique et pittoresque du théâtre*, here was a woman "created expressly for the despair of her fellow human beings of both the sexes".[49] All the more reason, then, for a lady or gentleman to treat them with respect – an ironic reversal of hierarchies that must have struck many a spectator.

The *loge* could be a leveller, and this might explain why, if Guys had painted society ladies in their *loges*, he could also paint wealthy courtesans in comparable opulence. Affluent Second-Empire prostitutes had hired boxes to solicit clients,[50] and so, because society both understood and turned a blind eye to such activities, Guys was able to produce pictures that were at once acceptable and subversive. "Monsieur G.", observed Baudelaire, "portrays women who are elaborately dressed and embellished by all the rites of artifice at will, from whichever strata of society they hail."[51] To recognise particular class positions required sophistication: and so the metropolitan viewer might congratulate him or herself on their ability to interpret the nuances. Therein lies a further rationale for the use of *loge* motif in the 1870s and beyond. With its peculiar rites and rituals, tied to both modernity and the past, the box was a radical space that operated within a conservative world. Free of the state system and its constraints, Renoir and his contemporaries worked in a similar way: they wished to champion a new style to the world around them, but they also wanted to sell their works to a Third Republic clientele, whose tastes were relatively unknown. Their pictures of theatre interiors are not conspicuously political, but they engage with the ambiguities of the epoch and so cast their authors as agents of their age.

Consequently, on many levels, the choice of the *loge* motif was particularly astute. As the pictures in this exhibition reveal, as they broached the box the Impressionists enjoyed a new kind of autonomy – one unavailable to Garnier, whose opportunity for creative expression was reliant on a patron to whom he would always be subordinate. On the opening night of his opera house in January 1875, though the Parisian public applauded his achievement, the authorities denied the architect a *première loge* for the performance; he lacked sufficient political weight.[52] After that date – with the most illustrious of official commissions behind him – his most notable achievement was the 1879 Salle Garnier of the Opéra de Monte Carlo, a replica, in miniature, of what had been his *magnum opus*.[53] Fortunately, since the Impressionists did not seek official endorsement, they would not suffer such frustrations. They built on their innovations. Paris could only look on in amazement.

Fig. 11 *Ouvreuse* (Usheress), engraving from Edmond Texier, *Tableau de Paris*, vol. 1, Paris, 1852

Notes

I would like to thank the staff of the Bibliothèque de l'Opéra and the Musée Carnavalet in Paris for their assistance in my archival research; thanks also to Vincent Gile for his verification of selected references.

1. For a brief history of Haussmannisation see Francis Démier, 'La révolution haussmannienne', *La France du XIXᵉ siècle, 1814–1914,* Paris, 2000, pp. 262–66. For a discussion of modern architectural developments in specific relation to Renoir, see Christopher Riopelle, 'Renoir in the City', *Renoir Landscapes 1865–1883,* exh. cat., National Gallery, London, 2007, pp. 33–47.

2. J.P.T Bury, *France 1814–1940,* London, 2003, p. 133.

3. See the essay by John House in the present catalogue.

4. Jean-Christophe Gourvennec, 'Réalisme social, réalisme mondain: les années 80', in *Henri Gervex 1852–1929,* ed. Anne Porot, Paris, 1992, pp. 145–49.

5. F.W.J. Hemmings, *The Theatre Industry in Nineteenth Century France,* New York, Cambridge University Press, 1993, p. 3.

6. *"Tous les noms connus dans la politique, les sciences, les arts, et la mode [....] Tout ce qui est célèbre dans la société parisienne":* anon., 'Les théâtres', *Tableau de Paris,* Paris, 1852, p. 103.

7. Martine Kahne, *The Magic of the Paris Opera: 300 Years of French Style,* exh. cat., Art Gallery of New South Wales, Sydney, 1991, p. 14.

8. Chapter VI, 'Manière de prononcer', Stendhal, *Le Rouge et le noir (livre second),* Paris, 1964, pp. 282–83 (1st edition 1830).

9. F.W.J. Hemmings, *The Theatre Industry in Nineteenth Century France,* New York, Cambridge University Press, 1993, pp. 51–54.

10. On rural migration in the Third Republic see Jean-Marie Mayeur and Madeleine Rebérioux, *The Third Republic from its Origins to the Great War, 1871–1914,* trans. J.R. Foster, Cambridge, Cambridge University Press, 1984, pp. 43–45.

11. *"Ce n'est pas un style! C'est ni du grec, ni du Louis XVI, même pas du Louis XV!":* cited in Louise Garnier, 'Charles Garnier', *L'Architecture,* XXXVIII, Paris, 1925, p. 382; from which cited in Christopher Curtis Mead, *Charles Garnier's Paris Opera: Architectural Empathy and the Renaissance of French Classicism,* Cambridge, Mass., and London, 1991, p. 3.

12. Curtis Mead 1991, pp. 4–5.

13. Renoir disliked the new house. He argued that "The groups stuck on the façade of the Opéra or perched above do not seem integral parts of the building and embarrass it more than they ornament it": letter to *L'Impressionniste,* 14 April 1877, reproduced (in translation) in R.L. Herbert, *Nature's Workshop: Renoir's Writings on the Decorative Arts,* New Haven and London, 2000, p. 94.

14. *"La vision des peintres s'est transformée, et ils ont enfin vu le théâtre, avant tout, par la couleur":* Camille Mauclair, *Le théâtre, le cirque, le music-hall et les peintres du XVIII siècle à nos jours,* Paris, 1926, p. 11. Mauclair confuses the chronology of events slightly, but the point is valid nonetheless.

15. T.J. Clark, *The Painting of Modern Life: Paris in the Art of Manet and his Followers,* London, 1993, pp. 210–14.

16. Richard Thomson, 'Representing Montmartre', in Daniele Devynck, Claire Freches, Anne Roquebert and Richard Thomson, *Toulouse-Lautrec,* New Haven and London, 1991, pp. 226–30.

17. The frequent movement of the Paris *Opéra* before 1875 is outlined in Curtis Mead 1991, pp. 45–46.

18. Hemmings 1993, p. 31.

19. Pier Angelo Fiorentino, *Comédies et comédiens, feuilletons,* Paris, 1866, vol. II, p. 351, cited in Hemmings 1993, pp. 12–13.

20. Claire L. Anderton, *The Audiences of the Theatre and Café-Concert as Metaphors for the Spectacle of Modern Life in Nineteenth Century Paris,* unpublished MA dissertation, Courtauld Institute of Art, London 1997, pp. 7–8.

21. Hemmings 1993, p. 35.

22. Poster detailing prices for the Comédie Française, 1871–73, Musée Carnavalet, Paris (Topo 34 B).

23. Poster detailing prices for the Théâtre de la Gaité, 1871, Musée Carnavalet, Paris (Topo 49E).

24. Unpublished subscription records for the Opéra de Paris, Bibliothèque de l'Opéra, Paris, n.p. (microfilms CO 179–81).

25. *"On est depuis plus ou moins de temps abonné, c'est là toute la différence":* Nérée Desarbres, *Sept ans à l'opéra: souvenirs anecdotiques d'un secrétaire particulier,* Paris, 1864, p. 9.

26. *"Je crois avoir droit à plus d'égards que le commun des abonnés": ibid.,* pp. 12–13.

27. Val, 'Les loges de Madame', *La Vie Parisienne,* Paris, 18 October 1873, p. 659.

28. *"Laissons la loge des français ; j'espère que Bérengère m'invitera quelquefois. J'irai en parasite, ce sera nouveau": ibid.,* pp. 659–60.

29. *"Morcerf, comme la plupart des jeunes gens riches, avait sa stalle d'orchestre, plus dix loges de personnes de sa connaissance auxquelles il pouvait aller demander une place":* Alexandre Dumas (père), *Le Comte de Monte Christo,* Paris, 1995, chapter LIII, 'Robert le Diable', p. 822 (1st edition 1844).

30. "*Nul n'est friand de loges qui ne coûtent rien comme un millionnaire*": ibid.

31. Hemmings 1993, p. 25.

32. "*Les classiques ont abandonné beaucoup le terrain; ils grognent encore, ils n'aboient plus [...]. La jeune France [...] qui s'étale à toutes les places du théâtre, au parterre, à l'orchestre, aux galeries et dans les loges. Les bourgeois [...] semblent être là pour boucher les trous*": Dom, 'La première représentation du Marion de Lorne', *La Vie Parisienne*, Paris, 8 February 1873, p. 83.

33. "*La composition de la salle ne dépend pas toujours du choix de l'administration [...] toutes les élégantes et gracieuses personnes qui, aux grandes soirées, éclairent des feux de leurs yeux et de leurs diamants la salle de l'opéra, n'ont pas leurs noms inscrit sur la feuille de location*": Desarbres 1864, p. 29.

34. Ruth I. Iskin, 'Was there a New Woman in Impressionist Painting?', in *Women in Impressionism: From Mythological Feminine to Modern Woman*, exh. cat., Ny Carlsberg Glyptotek, Copenhagen, 2006, pp. 191–93.

35. For a summary of the first critical responses to the painting see the essay by John House following.

36. Aileen Ribeiro in the present catalogue describes how the model has a "sense of innocence [that] triumphs over the sophistication of a *grande toilette*":

37. "*Le second acte se passa au milieu de cette rumeur sourde qui indique dans les masses assemblées un grand évènement. Personne ne songea à crier silence. Cette femme si jeune, si belle, si éblouissante, était le plus curieux spectacle qu'on pût voir*": Dumas 1995, p. 822.

38. "*Un homme ne doit jamais souffrir qu'une femme, fût-elle étrangère, soit placée derrière lui dans la même loge [....] Un rustre seul se permet de siffler, d'applaudir en frappant des pieds. Quant aux dames (qui doivent être soigneusement gantées), elles n'applaudissent [en] quelque sorte [que] pour la forme; le bruit à faire est laissé aux mains vigoureuses des hommes*": Eugène Muller, *Le Petit Traité de la politesse française: code des bienséances et du savoir-vivre*, Paris, 1861, pp. 105–06.

39. Louise d'ALQ (pseudonym of Mme. d'Alquiè de Rieupeyroux), *Le Nouveau Savoir-vivre universel*, vol. II, Paris, 1881, p. 59.

40. "*Quoique l'usage veuille qu'on se serve de cet instrument d'optique pour inspecter les spectateurs, nous croyons qu'il est toujours mieux de lorgner le moins possible les gens de la salle, et de ne braquer jamais sa lunette que sur la scène*": Muller 1861, p. 106.

41. d'ALQ 1881, p. 62.

42. Richard Thomson has questioned Beraud's intent in his portrayal of the Opéra clientele; his depictions of aristocrats behaving badly rest uneasily with the idea of the artist as an uncomplicated society painter. See Richard Thomson, 'Jean Béraud', *The Burlington Magazine*, London, vol. CXLI, no. 1160, November 1999, pp. 699–700.

43. Griselda Pollock, 'The Gaze and the Look: Woman with Binoculars – a Question of Difference', in *Dealing with Degas: Representations of Women and the Politics of Vision*, London, 1992, pp. 106–25. A recent, rich, response to this text is contained in Ruth E. Iskin, *Modern Women and Parisian Consumer Culture in Impressionist Painting*, Cambridge, 2007, pp. 23–53.

44. Anderton 1997, p. 9.

45. Robert L. Herbert, *Impressionism: Art and Leisure in Parisian Society*, New Haven and London, 1988, p. 96.

46. "*Ils s'adorent et se sont habilement arrangés pour passer cette soirée seuls. Son mari est à la chasse et elle a invité officiellement une amie qui a promis de ne pas venir. Voilà deux spectateurs qui trouveront tout bien*": anon., *La Vie Parisienne*, Paris, 6 February 1875, pp. 76–77.

47. "*J'ai loué la loge, j'ai eu le soin de choisir une baignoire bien sombre, bien au fond [...] il est vrai que j'ai promis d'être raisonnable, mais vous nous en voudriez trop, vous autres femmes, si, après avoir fait une telle promesse, nous étions assez bêtes pour la tenir*": H. Meilhac and L. Halévy, *Le Roi Candaule: comédie en un acte*, Paris, 1873, pp. 15–16.

48. *Ibid.*, p. 2.

49. "*Ouvreuse: Mammifère du sexe féminin, préposé à la garde des loges dans nos théâtres, et tout exprès créé pour le désespoir de ses semblables des deux sexes*": Arthur Pougin, *Dictionnaire historique et pittoresque du théâtre*, pp. 575–76. Though most usheresses were women – often ex-actresses – the position was taken by a man on occasion.

50. Anderton 1997, p. 19.

51. "*M.G. [...] représente volontiers des femmes très-parées et embellies par toutes les pompes artificielles, à quelque ordre de la société qu'elles appartiennent*": Charles Baudelaire, 'La peintre de la vie moderne', *Critique d'art*, ed. Claude Pichois, Paris, 1965, p. 478 (1st edition 1863).

52. Curtis Mead 1991, pp. 194–95.

53. Alain Desmarchelier, Bruno Foucart, Adrien Goetz, Alain-Charles Perrot and Philippe Thanh, *L'Opèra de Monte-Carlo: renaissance de la Salle Garnier*, Paris, 2005.

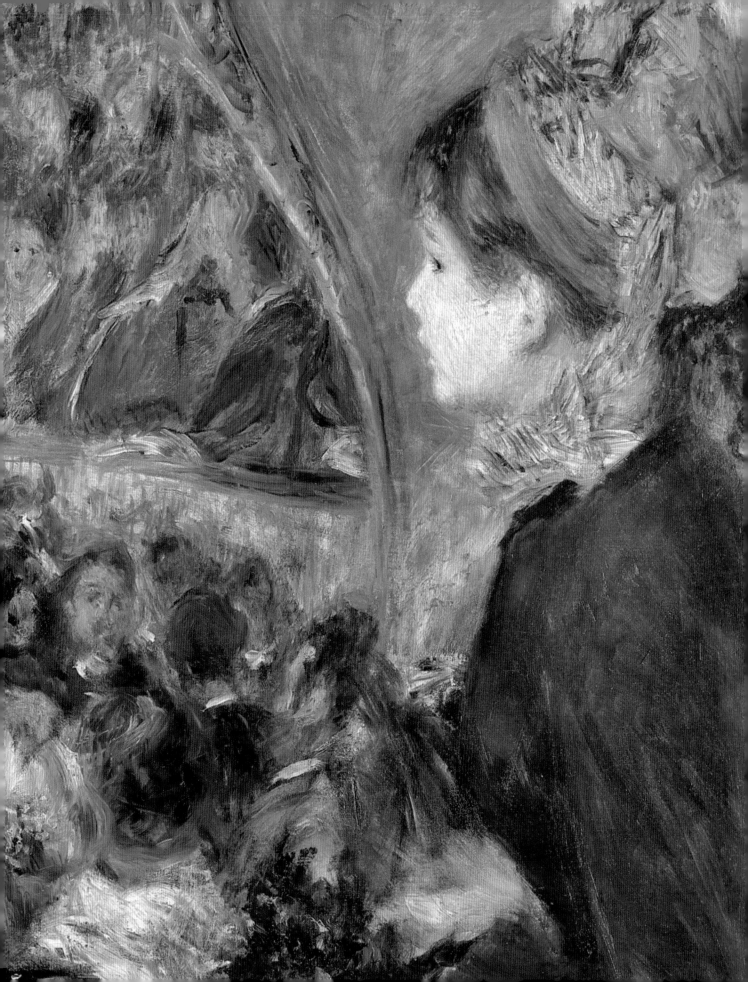

Modernity in Microcosm
Renoir's *Loges* in Context

JOHN HOUSE

The theme of the theatre box played a central role in Renoir's work through the crucial years of the Impressionist movement, between 1873 and 1880. It offered him the opportunity to explore the world of Parisian fashionable entertainments, and to focus on the glamorous women's costumes and on the interplay of gazes and glances that animated the audience. His paintings of the theatre box were part of his larger project in these years to depict the most characteristic scenes and sights of modern Paris.

However, the path of his career through the mid and late 1870s was not straightforward. Although he participated in the first three 'Impressionist' group exhibitions in 1874, 1876 and 1877, he had great reservations about the wisdom of mounting alternative exhibitions, and returned to the official Salon in 1878. His paintings, too, were markedly diverse in subject, scale and treatment, ranging from ambitious and highly worked canvases to the most informal sketches, and from large set pieces to exquisite near-miniatures.

Taken as a whole, these paintings can be seen as a sustained attempt to reconcile explicitly modern subjects with the hierarchy of genres that had underpinned traditional pictorial practice since the seventeenth century. His paintings of contemporary Parisian life could be viewed as a form of modern history painting – especially an ambitious canvas such as *Bal du Moulin de la Galette* (Ball at the Moulin de la Galette; Musée d'Orsay, Paris), exhibited in 1877, which represents the Sunday afternoon dance at one of Montmartre's most celebrated places of entertainment on a scale appropriate to a significant historical subject. As Renoir's brother Edmond wrote in 1879 about his modern-life canvases, "Beyond its artistic value, his work has all the charm of a faithful image of modern life. What he paints, we see every day; it is our everyday life that he has recorded in pages that will certainly remain among the most vivid and the most harmonious of our epoch".[1]

Many of Renoir's smaller canvases of the period, representing one or two figures going about their daily business or relaxing indoors or outdoors, clearly fall into the category of genre paintings. *L'Atelier de l'artiste, rue Saint-Georges* of 1876 (fig. 12), showing Renoir's most intimate friends conversing in his studio, belongs in this category, with its small scale and informal composition; yet this gathering can also be viewed

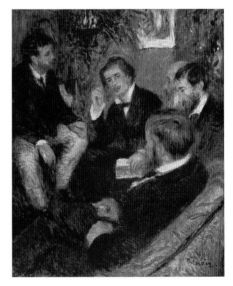

Fig. 12 Pierre-Auguste Renoir
L'Atelier de l'artiste, Rue Saint-Georges
(The Artist's Studio, Rue Saint-Georges), 1876
Oil on canvas, 45.1 × 36.8 cm
Norton Simon Museum, Pasadena

as the nineteenth-century equivalent of the Dutch group portraits of the seventeenth century, and thus as a form of history painting.

Renoir blurred the boundary between portraiture and genre painting in other ways, too. *Parisienne* (fig. 15), shown together with *La Loge* in the first group exhibition in 1874, is presented in the format and on the scale of a full-length court portrait, although the title shows that its subject was meant to be viewed as generic – as a representation of the typical young Parisian woman of the period – rather than as a portrait of the woman who acted as model for the painting. Throughout these years he was also painting portraits of named individuals, some depicting his friends and some commissioned; in the late 1870s, commissioned portraits formed a major part of his production, and his *Portrait de Madame Georges Charpentier et de ses enfants* (Portrait of Madame Georges Charpentier and her Children; Metropolitan Museum of Art, New York), a marked success at the 1879 Salon, established his public reputation in this field.

In other genres, too, he translated conventional imagery into explicitly modern contexts – in his representations of the female nude, indoors or outdoors, in his landscapes of the scenery around Paris, which so often include markers of the recent transformation of the region,[2] and in his still-life paintings, set in everyday surroundings.

Viewed in this context, Renoir's paintings of the theatre box clearly fall into the category of genre paintings – images of everyday life. However, as we shall see, *La Loge* (cat. 5) could also be viewed as a modern moral subject picture, *Café-Concert* (*Au théâtre*) (cat. 8) was initially conceived as a more complex figure subject, and the final canvas in the sequence, *Une Loge au théâtre* (cat. 11), seems to have begun life as a group portrait.

La Loge was included in the first Impressionist group show in April 1874; though this title has come to be associated with the canvas, an alternative version of the 1874 exhibition catalogue named the picture *L'Avant-scène* (that is, the *loge* immediately in front of the stage; see further below).[3] At this date, it seems, genre scenes of theatre audiences were unprecedented in the context of recent fine art exhibitions in France.[4] As the watercolours by Guys and the engravings by Gavarni, Grandville and others in the present exhibition show, the theme was common in more informal, popular visual media, used as a vehicle for social typecasting and satirical humour. However, critics and theorists alike considered that urban entertainments were not an appropriate subject for fine art painting. As a precedent, Renoir had only a canvas such as Hippolyte Lazerges's *Théâtre de l'Odéon* (fig. 13), shown at the 1869 Salon, which represented the leading figures of the Parisian literary and theatrical worlds promenading in the foyer of the Odéon. Lazerges's canvas was a group portrait, whereas the two figures in *La Loge* are anonymous, presented as types rather than individuals. Edgar Degas's first theatre interiors, too, were informal group portraits, for instance *L'Orchestre de l'Opéra* (The Orchestra of the Opéra; Musée d'Orsay, Paris) of *c*.1870. However, in the first version of *Le Ballet de 'Robert le Diable'* (The Ballet from *Robert le Diable*; Metropolitan Museum of Art, New

Fig. 13 Hippolyte Lazerges
Théâtre de l'Odéon, 1869
Oil on canvas, 70.5 × 120 cm
Private collection

York), painted in 1871–72, he began to explore the play of gazes in the theatre interior, and in 1874 exhibited the grisaille version of *Répétition de ballet sur la scène* (Ballet Rehearsal on Stage; Musée d'Orsay, Paris) at the group exhibition.[5]

The specific locales depicted in Renoir's theatre pictures cannot be identified, but the settings in *La Loge* (cat. 5), *Une Loge au théâtre* (cat. 11) and the two small canvases (cat. 6 and 7) are clearly fashionable theatres; although *Une Loge au théâtre* was given the title *Une Loge à l'Opéra* when it was first exhibited in the 1882 group exhibition, the pilaster in the background bears no resemblance to the décor of Charles Garnier's then new Opéra. The surroundings in *Café-Concert* (*Au théâtre*) (cat. 8) seem less elaborate.

For the nineteenth-century viewer, a genre painting was expected to present various signs and indicators that would enable it to be readily interpreted. These included the setting and other attributive details, the grouping and body language of the figures, and their facial expressions and physiognomies (facial features were regularly viewed as expressions of character and personality). Reviewing Edouard Manet's Salon exhibits in 1869, the critic Jules Castagnary spelt out the requirements for a successful genre painting: "A feeling for functions, for fitness are indispensable. Neither the painter nor the writer can abandon them. Like characters in a comedy, so in a painting each figure must be in its place, play its part, and so contribute to the expression of the general idea.

Nothing arbitrary and nothing superfluous, that is the law of every artistic composition."[6] Viewed by these criteria, Renoir's theatre box pictures present a number of puzzles and uncertainties.

The two small canvases both present a man and a woman, seemingly looking towards the stage; in cat. 6 the gesture of the man's left arm enfolds the woman, while his right hand holds a pair of opera glasses; in cat. 7 their profiles are closely aligned and there is no clear interaction between the figures. Both include the front edge of the box, implying perhaps that the viewer's position is in a nearby box, a short distance around a curved auditorium, but in neither canvas do the figures engage in any way with the viewer. Nor does either canvas include any clear cues to further narrative interpretation.

La Loge (cat. 5) is very different from this point of view. The figures look in our direction; the woman faces us directly, her opera glasses in her gloved hand, but her eyes are seemingly not quite focused on us, while her male companion, behind her, gazes through his binoculars upwards – and thus at something or someone on a higher level of the theatre, not at the stage. The lights are up, but this does not suggest that this is an intermission, since at this date lights were not dimmed for the performance.[7] The contrast between the two figures reiterates stereotyped notions of the gendered gaze – setting active male looking alongside a woman who is there to be looked at.[8] The viewer is placed on the same level as the box, implicitly viewing the figures from another box; this is set at an angle to theirs, as the velvet-covered box-front shows. Given this implied distance, the figures seem very large in relation to the format of the canvas, perhaps hinting that we, too, might be using binoculars to scrutinise the woman. The X-ray of *La Loge* (fig. 35, p. 74) suggests that the female figure may originally have been wearing a hat, but shows no other significant changes in the composition.

At around this date, Renoir painted a smaller version of this composition (fig. 34, p. 72). It is uncertain whether this is a study for the larger painting or a subsequent replica; however, the fact that it follows the details of the larger canvas so closely – including the final state of the model's head, bareheaded, with a rose in her hair – strongly suggests that it is a replica. However, Renoir showed that he considered it a complete and autonomous work by including it in the auction that he, Monet, Berthe Morisot and Sisley mounted of their work in March 1875.[9]

The figure grouping in *La Loge* is a reprise of a long-established joke that had been given visual form by Gavarni thirty years earlier in 'Une Lionne dans sa loge' (cat. 25): a woman looks out from her box in the expectation of being admired, while, behind her, her male companion gazes intently through his binoculars across the auditorium. This set of images belongs to a larger group that explore different aspects of the by-play of gazes in the theatre – a recurrent theme in magazine illustration in the 1870s (see cat. 23–38)

However, Gavarni's image has a satirical edge that Renoir's lacks, through the assumption that his evidently ageing 'lioness' is less of a focus of admiration than she would like to think. By contrast, the age and status

of Renoir's female figure is left uncertain. In recent years, she has generally been regarded as unproblematically pretty, but, taken together, the reviews of the canvas when it was first exhibited in 1874 make it clear that there was something ambiguous and potentially troubling about this figure.

Some critics took the image at face value. Ernest Chesneau, praising its "qualities of observation and remarkable qualities of colour", commented that "this new school is evidently preoccupied by the theatre, this aspect of modern life that has until now been ignored in painting".[10] For the one traced female critic who reviewed the show, Marie-Amélie Chartroule de Montifaud, writing under the male pseudonym Marc de Montifaud, the woman in *La Loge* was straightforwardly "a figure drawn from the world of elegance", though she noted that her dress gave her "a feline appearance".[11] In the opinion of Philippe Burty, an associate of the Impressionists, writing for the English magazine *The Academy*, Renoir had "rendered, with supreme fidelity to modern life and artificial light, a lady and gentleman seen …in a box at a play".[12]

Jules Castagnary's reading of the figure was more equivocal: "The *Loge* is drawn from contemporary life …. In the evening, by artificial light, this woman, in her low-cut dress, wearing gloves and make-up, with a rose in her hair and a rose between her breasts, creates an illusion."[13] Jean Prouvaire imagined a link with Renoir's other two figure-paintings at the exhibition, *Danseuse* (fig. 14), an image of a young girl in ballet costume, and *Parisienne* (fig. 15), seeing them as representing "the three stages through which the young girls of Paris generally pass", with *La Loge* showing what they would become: "With your cheeks whitened with pearl white (*blanc de perle*), your eyes lit up with a trivially passionate expression, this is what you will become, attractive but empty, delicious and stupid".[14] F. de Gantès was even more outspoken about what lay behind this "illusion": 'The octopus is there, fully developed, in the flowering of her triumph. The small young man seen in the shadows demonstrates her success and proves that the pearl white that we see plastered on her has produced a brilliant result. How this cynical and vulgar midge dominates him; how her vague and unfocused eyes make him contemptible, this *gentleman* who rented this box in order to reveal to the world the fortune that he is squandering and the emptiness inside him."[15]

Prouvaire doubted that Renoir himself had thought of the narrative of decline and fall that he read into the three canvases, and de Gantès made no claim to be charting the artist's intentions. However, their readings of the canvas, and the extreme divergence between theirs and the interpretations of Chesneau and de Montifaud, force us to ask what it was about it that created such uncertainty among its viewers in 1874. In part, the negative responses were presumably a generalised reaction to the public display of conspicuous luxury in the repressive moralistic climate of the 'moral order' regime of the mid-1870s, in the aftermath of the Franco-Prussian War and the Paris Commune. However, there seem to have been more specific concerns that gave rise to these doubts and this disquiet – about the appearance of the model in *La Loge* and the precise setting in which she is placed.

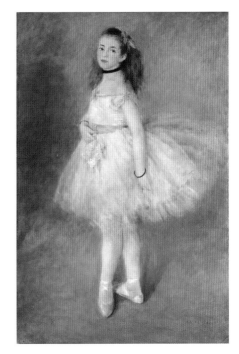

Fig. 14 Pierre-Auguste Renoir
Danseuse (Dancer), 1874
Oil on canvas, 142 × 94 cm
National Gallery of Art, Washington

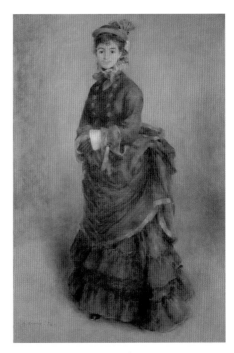

Fig. 15 Pierre-Auguste Renoir
Parisienne, 1874
Oil on canvas, 163 × 108 cm
National Museums and Galleries of Wales, Cardiff

Three of the reviews quoted above comment on the fact that the female figure is depicted wearing make-up. Clearly, from their comments, this could be seen as suggesting that she was not all she seemed and that her glamorous garb masked her true identity – as Castagnary put it, her image was "an illusion". Baudelaire had celebrated make-up as the means by which women transcended the imperfections of 'nature', but his ironic stance stood in stark opposition to the often-repeated misogynistic view that make-up was a form of deceit used to mask physical decay and putrefaction.[16] There may also have been something about the physiognomy of the figure that disquieted viewers. In the imagery of the period, following contemporary physiognomic theory, fashionable women from a 'good' background were standardly depicted with wide-spaced eyes and delicate cheekbones, mouth and chin; in contrast to this stereotype, Renoir's figure has a slightly puffy, bloated face and a wide, fleshy mouth.

According to Julius Meier-Graefe, the model for the female figure in *La Loge* was named Nini; Meier-Graefe commented that, looking at her appearance in this picture, "nobody would divine the profession of the little Nini whom Renoir painted often as God had made her, without the sumptuous envelope that surrounds her here".[17] Georges Rivière, a close friend of Renoir in these years, noted that Nini modelled for many of his paintings between 1874 and 1880; she had "an admirable head of golden-blonde hair" and was "the ideal model, punctual, serious, discreet", though finally she disappointed her watchful mother by marrying a minor actor.[18] When she modelled for Renoir, Rivière noted, the artist often depicted her after a formal posing session sewing or reading in the corner of his studio. Ambroise Vollard added the detail that, despite her "charming docility", Renoir was somewhat put off by her "Belgian deceitfulness".[19] In recent years, it has been suggested that Renoir worked from not one but two models named Nini in these years, a Nini whose nickname was '*gueule de raie*' or 'fish-face', who modelled for the two versions of *La Loge* and little else, and Nini Lopez, who sat for a considerable number of canvases between *c.*1875 and 1880.[20] However, Meier-Graefe, Rivière and Vollard, the only three early sources who mention her, speak of only one Nini, and Meier-Graefe specified that the Nini who modelled for *La Loge* also modelled for other very different paintings. The sources agree that the model for the male figure in *La Loge* was Renoir's brother Edmond.

Without further evidence, it seems very possible that there was indeed only one Nini, and that *La Loge* was the first, or one of the first, of the canvases for which she posed. Identifying Renoir's models on the basis of their appearance in his paintings is notoriously tricky, given his tendency to make all his female figures look alike; however, the proportions and features of the face in *La Loge* bear a clear resemblance to a portrait of *c.*1875 identified as representing Nini Lopez (fig. 16) and to the features of the model for *Jeune femme tricotant* of *c.*1875 (fig. 17), where she is presented as a domestic servant. Meier-Graefe's suggestion that she had posed nude for Renoir raises the possibility that she was also the model for *Etude* (Study; Musée d'Orsay, Paris), the notorious outdoor nude study shown in the 1876 group exhibition;[21] alone of Renoir's nudes in

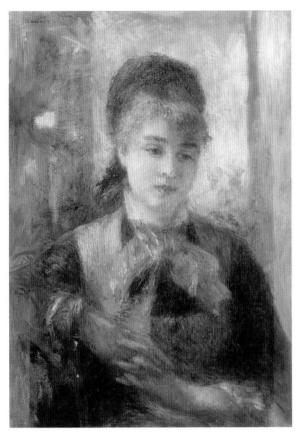

Fig. 16 Pierre-Auguste Renoir
Portrait de Nini Lopez (Portrait of Nini Lopez), *c.*1875
Oil on canvas, 54.5 × 38 cm
Musée Malraux, Le Havre

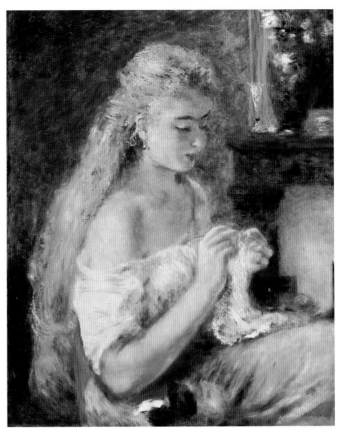

Fig. 17 Pierre-Auguste Renoir
Jeune femme tricotant (A Girl Crocheting), *c.*1875
Oil on canvas, 73.3 × 60.5 cm
Sterling and Francine Clark Art Institute, Williamstown

these years, this canvas depicts a model whose features and hair-colour resemble Nini's.

Nini's reported nickname '*gueule de raie*' suggests that her face did not conform to current canons of beauty. The wide range of subjects and types of picture for which she seems to have posed highlights the fact that modelling was a form of acting or role-playing that enabled the painter to construct a distinct identity for the figure within each painting. Thus we cannot see the role that she assumes in *La Loge* as being in any sense an attempt to express her personality, in the way that a portrait might. However, the fact that Renoir chose a model for *La Loge* whose physiognomy did not match current norms of fashionable elegance suggests that he was well aware that the social and moral status of the female figure in this painting would be open to multiple interpretations.

The interpretation of the painting is further complicated by the picture's alternative title *L'Avant-scène*; this title was used by several of the reviewers of the show. The *avant-scène* was technically the area of the stage in front of the drop curtain; by extension, the term came to be used to describe the boxes closest to, or directly above, this part of the stage. By designating his theatre box thus, Renoir was invoking a set of associations that are fundamental to understanding the uncertainties that the picture

raised. The entry on *Loge* in Larousse's *Grand dictionnaire* noted that the view from the *avant-scène* boxes was the worst in the theatre, but commented, "The *avant-scène* boxes, whose occupants are exceptionally visible, are sought by people who pose and want to put on a show".[22] Larousse's entry on *Avant-scène* was still more explicit: "At the Opéra and the Italiens, [the *avant-scène* boxes] are occupied by society's elite Nobility has its boxes here, face to face with the world of finance. In lower-class theatres, the *avant-scène* boxes are normally occupied by women of doubtful morality, by the queens of a single day, belonging to the *demi-monde*, who flaunt themselves there in the company of young men, and sometimes even of old gentlemen."[23]

It would be mistaken to see Larousse's text as proof that there was a cut-and-dried boundary between respectable and non-respectable establishments, since other texts suggest that this was not so.[24] However, the distinction that he makes shows that the class of the venue was a crucial element in determining the implications of the ways in which women presented themselves in theatrical spaces. Thus the viewer of Renoir's canvas was invited to judge whether the theatre was of a class with the Italiens, and the occupants of the box were presenting themselves to their social or financial peers, or whether the woman was setting herself up as part of the spectacle, parading herself for the benefit of the whole audience. The diversity of the reviewers' commentaries indicates that the signs offered by the picture gave no unequivocal answer to these questions.

The issue at stake is clarified by comparison with another canvas of a theatre box painted at the same time as Renoir's: Eva Gonzalès's *Une loge aux Italiens* (fig. 18), an ambitious picture rejected by the jury of the Salon in 1874, while Renoir's *La Loge* was on view at the group exhibition. The fact that Gonzalès specified that the theatre represented was the Italiens suggests that she was seeking to defuse or bypass the equivocal moral issues that Renoir's *La Loge* raised.

However, in many other ways Gonzalès's canvas demands to be viewed in tandem with *La Loge*. We must assume that the two artists were acquainted, through the intermediary of Edouard Manet, but there is no evidence to indicate which of them conceived the idea of a theatre box canvas first, or even whether they were aware of each other's project while they were at work on them. However, the similarities are so clear that some contact between them seems likely, though we cannot tell in which direction the influence, if any, may have passed.

Whether or not there was any such contact, comparison between the two pictures highlights the distinctive qualities of each. In both, the female figure looks in the direction of the viewer, but neither seems to catch our eye directly; Gonzalès's figure, leaning slightly forwards, appears intent on something or someone near or behind us, while Renoir's seems more passive and detached, as if receiving the gazes that are directed towards her, rather than herself focusing on anything.[25] Both hold binoculars, Renoir's a pair of small opera glasses, Gonzalès's a much larger, simpler instrument, more comparable to the binoculars of Renoir's male companion. The two male figures differ most strikingly. Renoir's is subordinated to the

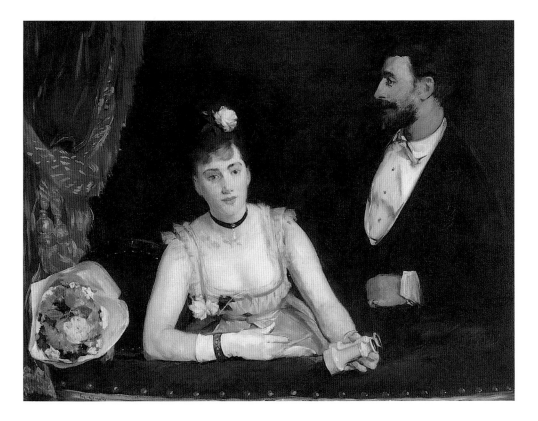

Fig. 18 Eva Gonzalès
Une loge aux Italiens
(A Box at the Italiens)
1874
Oil on canvas
98 × 130 cm
Musée d'Orsay, Paris

female figure and absorbed by what he can see on an upper register of the theatre, while Gonzalès's is seen in full profile; he seems to be looking beyond his companion towards something outside the picture, but the effect of his somewhat stilted pose is to suggest that he is presenting himself to the gazes of others. Unlike Renoir's male figure, he is just as much a part of the spectacle as his female companion.

For *Café-Concert* (*Au théâtre*) (cat. 8) we have no contemporary commentary, since it was not exhibited at the time it was painted. However, its history is complex in two ways – in the stages of its physical execution, and in terms of its title and the site represented. It first appeared in public, it seems, at the sale of the collection of Armand Doria in 1899, with the title *Café-Concert*; the accompanying text in the sale catalogue described the site: "A music-hall, with, on the left, the auditorium, where the talkative, curious crowd is crammed in".[26] However, in Ambroise Vollard's provisional catalogue of Renoir's work, published in Renoir's lifetime, in 1918, the picture was given the very different title *Au théâtre*.[27] The title *La Première Sortie* (The First Outing), with its invitation to the viewer to empathise with the apparent timidity of the foreground figure, was given to the picture when it was exhibited at the Knoedler Gallery in London in 1923; like the other such sentimental titles that have been given to works by Renoir, this would have been crisply repudiated by the artist, who is on record as expressing his disgust when one of his canvases was titled *La Pensée*.[28]

The depiction of the lower part of the auditorium, as we see it now, with figures facing in various directions, might support the identification of the space as a *café-concert*, with its more informal seating, rather than a formal theatre; however, this area of the picture is so freely sketched that it is hard to be certain of the way in which the seating is configured. Interpretation of the picture is made more complex by the evidence of infra-red and X-ray photographs (figs. 36 and 37), which show that originally there was no partition between the two young women and the space beyond, and there were two further figures, a man and, at the far left, a woman, seated immediately beyond them. Thus the entire present background of the canvas was added after these figures were erased.[29]

The present figure group, once detached from the spurious associations of a 'first outing', gives little clue to any anecdotal reading. The principal figure is young and holds a bouquet; there is little hint of expression on her face, seen in profile, and the eyes of her companion are hidden, thus deliberately denying the viewer any indication of her responses to the scene. All we can tell is that they are segregated from the remainder of the audience by the partition, which seems to be more substantial and different in shape from the division that can be seen in the balcony in the background; the viewer, close alongside the figures, seems to be positioned in the same box as them, rather than assuming the role of the outside viewer/voyeur.

The final depiction of a theatre box that Renoir executed during the years of 'high Impressionism' (cat. 11) also had a complex history. It was bought by the dealer Paul Durand-Ruel from his fellow dealer and close associate Dubourg in November 1880 with the title *Une loge au théâtre*, and was first exhibited in the seventh Impressionist group show in March 1882 with the title *Une loge à l'Opéra*. At subsequent exhibitions it has appeared as *Au théâtre*, or simply as *La Loge*, giving rise on occasion to confusion with the Courtauld canvas. The picture itself does not clarify this issue; the women are holding a musical score, but the setting is clearly not the Paris Opéra, since the pilaster in the background bears no relationship to the lavish neo-Baroque décor of the Opéra Garnier.

However, this account conceals the complexity of the picture's origins. According to Durand-Ruel, the canvas was initially a portrait of the daughters of Edmond Turquet, then Under-Secretary of State for Fine Arts, but Turquet disliked the canvas and rejected it.[30] This account is complicated by the infra-red and X-ray photographic evidence provided by the picture itself (figs. 40 and 41); in its original state, the canvas included a male figure in the upper right corner, seen in profile and leaning over the two women. This may well have been an image of Turquet himself.

It seems very likely that it was after Turquet's rejection of the canvas that Renoir reworked it and sold it as a genre painting. The changes were dramatic. He removed the male figure and completely repainted the background. The X-ray reveals softly and freely brushed forms across the top left corner of the picture, in the area that now depicts the pilaster and a hanging curtain; thus it is very possible that, in its original state,

the painting represented a domestic interior, not a theatre. Moreover, the X-ray shows extensive dried brushwork beneath the right figure that ignores her position and seems to relate to the deleted figure of the man; thus it seems possible that this female figure was wholly added, together with the bouquet she holds, and that the canvas originally included only a man and a woman, perhaps Turquet and his daughter, or Turquet and his wife.[31] Beyond this, Renoir presumably modified the left figure to ensure that she was no longer recognisable; she was originally wearing full evening dress, as now, but repainting around her head suggests that her hair was very different or she was wearing some sort of headdress.[32]

As the picture now stands, there is a clear differentiation between the two figures, in terms of dress and body language. The older figure on the left wears a full evening gown, and looks confidently out into the viewer's space, holding a music score in her gloved right hand, but ignoring it; the younger girl is seen in profile, wearing a simpler white dress, looking downwards as if in shyness or modesty, and evidently not engaging with the wider space of the theatre interior. The sense of her enclosure, in contrast to her companion's expansiveness, is emphasised by the large bouquet of flowers on her lap, and also by the somewhat uncomfortable proximity of her profile to her companion's elbow. There is no communication between the two figures, who seem to be occupying different worlds. However, in contrast to *La Loge* (cat. 5), we cannot see the front edge of the box; the viewer is thus placed within the box occupied by the women, which acts to defuse the questions of voyeurism that *La Loge* so clearly raised, though the image does not establish a credible sense of space in which we can imagine the two figures and ourselves to be seated.

Despite Turquet's rejection of the canvas, it bears the stamp of its origins, in its relatively conventional tonality and, in parts, careful finish. The primary effect of the picture is that it is composed of blacks, whites and mellow reds, in contrast to the strongly blue tone of *Café-concert* (cat. 8). Its tonality is reminiscent of *Portrait de Madame Georges Charpentier et de ses enfants*, Renoir's success at the Salon in 1879, and it is possible that initially he hoped that the present canvas, in its original form as a portrait of the Turquets, could prove an effective follow-up at the Salon.

Opinions were markedly divided when the canvas was exhibited in 1882. However, the disagreements did not concern the status of the figures, as they had with *La Loge*, but rather its style and treatment. Armand Sallanches reiterated familiar criticisms in describing as "crudely drawn" this scene "where two elegant women converse about everything except what is taking place on the stage".[33] By contrast, Emile Hennequin commented: "He is the only [Impressionist] who seems to me to paint accurately the colours he sees. His *Box at the Opera* contains a young girl in black whose eyes and smile are deliciously lively."[34] Paul Leroi made an explicit contrast between this canvas and the landscapes that Renoir exhibited: "The good people who, on seeing *A Box at the Opera*, think that he is beginning to see sense, will fall into complete despair [on seeing his views of Venice]."[35] The same contrast, between the incoherence of

the Venice views and the present canvas, was developed at some length by Louis Leroy: "Strangely, the same Renoir exhibits a *Box at the Opera* which would not too greatly displease the philistines. The sweet little faces of the two young girls, their attire and the colour of the ensemble have bourgeois qualities that Impressionism execrates. He should not continue along this path. He would soon quietly start showing signs of common sense, which would be devastating for the official critics of the sect."[36]

The contrast of treatment between *Une loge au théâtre* (cat. 11) and *Café-Concert (Au théâtre)* (cat. 8) is part of a pattern that ran through Renoir's work throughout the years covered by the present exhibition. His work varied constantly in terms of paint-handling and degree of finish. This cannot be seen simply as a contrast between pictures that he exhibited and those he did not, for in the first three Impressionist exhibitions, for which he undoubtedly selected his own submissions, the pictures he showed differed startlingly in treatment. At the first, in 1874, his three figure-paintings were treated with considerable finesse. In *Parisienne* (fig. 15) and *Danseuse* (fig. 14) though both are set against indeterminate backgrounds,[37] the figures are carefully and fluently brushed so that their three-dimensional forms and the textures of the costumes are effectively suggested. *La Loge* shows still greater elaboration in the treatment of both the woman's surroundings and especially her dress, the details of

Fig. 19 Pierre-Auguste Renoir
Moissonneurs (Harvesters), 1873
Oil on canvas, 60 × 74 cm
Bührle Collection, Zürich

which are vividly conveyed by the play of the brush, but wholly without illusionistic detail. At the same show, though, Renoir also exhibited *Moissonneurs* (fig. 19), a markedly anti-picturesque landscape in which all the elements are rendered in a rapid and seemingly casual shorthand that subordinates all the elements in the scene to an overall effect of bright daylight. At the 1876 exhibition, too, elaborately finished canvases hung beside highly informal works such as the half-length nude shown with the title *Etude* (Musée d'Orsay, Paris), and in 1877 other small informal paintings were displayed. However, in 1882, in the only other group show in which Renoir's works appeared, all the pictures included were relatively highly worked; this was not, though, Renoir's own decision, since they all came from the stock of Durand-Ruel, and were exhibited against the artist's wishes.

The sequence of theatre-box pictures demonstrates both the evolution and the diversity of Renoir's technique. The variegated handling of *La Loge* (cat. 5), with its bold tonal contrasts juxtaposed with coloured nuances, contrasts with the small, distinct touches of colour that animate the entire surface of the two small canvases (cat. 6 and 7); in *Café-concert* (*Au théâtre*) (cat. 8) the whole scene is more freely and fluently brushed, and the composition dominated by the contrast between rich blues and warm accents, while the more conventional tonality and finish of *Une loge au théâtre* (cat. 11) is punctuated by loosely brushed passages in which the forms are suggested by subtle shifts of colour.

Recent studies that discuss Renoir's Parisian subjects of the 1870s have tended to focus on comparisons with contemporary popular imagery – with the caricatures and prints of all sorts that appeared in books and magazines in such quantities from the 1840s onwards.[38] Such comparisons, reiterated in the prints and watercolours included in the present exhibition, are without doubt of central relevance to Renoir's art in these years; indeed, the Gavarni print discussed above (cat. 25) may have played a direct role in the conception of *La Loge* (cat. 5). Renoir's project was to transpose this imagery into the medium of oil paint and to present it in the context of the fine art exhibition.

However, this focus ignores the other side of the question – the chain of associations that these images invoked when presented as fine art. The fact that theatre imagery was so common in popular visual media whilst seemingly remaining taboo in the fine art context until the 1870s emphasises the gulf that separated 'fine' from 'popular' in terms of values and expectations. When presented as fine art, these paintings invited the viewer to classify them by genre, as we saw at the beginning of this essay. Beyond this, they also invoked comparisons with the art of the past. Renoir's close friend Georges Rivière in 1877 compared Renoir's outdoor paintings of Montmartre types, such as *La Balançoire* (The Swing; Musée d'Orsay, Paris) with Watteau's *fêtes galantes*,[39] and the first two art-historical accounts of *La Loge* (cat. 5) both placed the canvas securely within a long historical lineage. Meier-Graefe in 1912 compared it with Watteau, Velázquez, Rubens, Rembrandt and the Venetians, and also with Gainsborough and Reynolds, whilst admitting that at this date Renoir could

Fig. 20 Titian (Tiziano Vecellio)
Woman at her Toilet, c.1514–15
Oil on canvas, 93 × 76 cm
Musée du Louvre, Paris

not have known the Englishmen's work.[40] In 1923, Paul Jamot, writing in the *Gazette des Beaux-Arts*, looked back from *La Loge* via Delacroix to – again – Rubens and the Venetians.[41] More specifically, *La Loge* can be compared with Titian's *Woman at her Toilet* of c.1514–15 in the Louvre (fig. 20); here, the male figure, behind the woman, holds a mirror from which she has momentarily turned, enabling the viewer to see the reflection of her head. Renoir's canvas may be seen as a modernisation of the *vanitas* theme made explicit by Titian; we can imagine his model seeing her own reflection in the mirror of the viewer's gaze. Though we cannot be sure that Renoir had this canvas in mind, many of his paintings, even in the 1870s, testify to his continuing interest in the art of the past, even before the techniques of the Old Masters became his prime focus of attention in the 1880s.

The compositional format of *Café-concert (Au théâtre)* (cat. 8) is very different, with its multiple focuses and sharp contrasts of scale and space; comparisons with past European painting seem far less relevant. The devices that Renoir used here, in the picture's final state, bear comparison with Degas's contemporary interest in such formal disjunctions, and may also testify to a momentary interest in the compositional effects of Japanese prints; though Renoir reiterated his dislike of the art of Japan which had such an impact on his colleagues,[42] a few canvases of c.1876–79 suggest that he did for a short period explore the ways in which such fragmented compositions could be used to give a sense of modernity. Mary Cassatt, in her reprise of this compositional arrangement in *At the Français, a Sketch* (cat. 9), made her engagement with Japanese compositional devices far more explicit, in the picture's sharp contrasts of silhouette and tone.[43]

Une Loge au théâtre (cat. 11) may in broad terms be seen as a descendant of the Baroque court portrait; comparable generic references can be seen in a number of Renoir's portraits of these years, as, indeed, they can in the work of other fashionable portraitists in this period, such as Carolus-Duran; the rich bourgeoisie of the French Third Republic could legitimately be presented in the same terms as the aristocracy of the sixteenth and seventeenth centuries.

The nature of the relationships with past art suggested by both *La Loge* and *Une Loge au théâtre* is very different from the self-conscious remodelling of his entire practice and painterly technique that Renoir undertook during and especially after his trip to Italy in the autumn and winter of 1881–82. In the theatre interiors, the central element in his project was to validate this quintessentially modern, Parisian subject as the inheritor of a particular lineage in the history of European painting: the spectacle of Paris, and especially of the *parisienne*, fully merited the virtuoso brush of a latterday Titian or Rubens.

The display of *La Loge* in 1874 seems to have precipitated a flurry of canvases depicting theatre boxes. Cassatt's three ambitious oils, *At the Français, a Sketch* (cat. 9), *Femme dans une loge* (cat. 10), exhibited in the fourth Impressionist group show in 1879, and *Women in a Loge* (fig. 3), exhibited by Durand-Ruel in London in 1882, were accompanied by a number of smaller works in the form of pastels and prints. Gonzalès's *Une loge aux Italiens* (fig. 18), rejected by the Salon jury in 1874, was accepted and shown at the 1879 Salon. Artists such as Henri Gervex, Jean-Louis Forain (see fig. 4 and cat. 13) and Jean Béraud took up the theme (fig. 21), and in the late 1870s Degas embarked on a sequence of pastels in which a ballet on stage is viewed from a box, with a female figure in the foreground, implicitly sharing the box with the viewer (e.g. fig. 22); Degas's remarkable view of a box from below (cat. 12), with just one female head appearing above the box-front, leaves it to the viewer to imagine who might be keeping her company in the recesses of the box.[44]

Taken together, these canvases show how the theatre box could be viewed as a quintessentially modern subject. Paris's theatres in these years were the acknowledged centre of the city's entertainment industry (see Nancy Ireson's essay in this catalogue), and the boxes – with their tantalising give-and-take between display and concealment – enabled artists to distill the much-discussed issues of viewing and voyeurism in the city's public spaces into a sustained exploration of a specific site. The theatre box represented modernity in microcosm.

Fig. 21 Jean Béraud
La Loge, c.1880
Watercolour on paper, 23 × 12.5 cm
Private collection

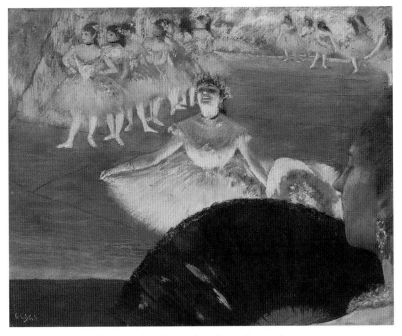

Fig. 22 Edgar Degas, *Dancer with a Bouquet, Seen from a Loge*, c.1877–79
Pastel and mixed media over monotype on paper, 40.3 × 50.5 cm
Museum of Art, Rhode Island School of Design

Notes

I am most grateful to Nancy Rose Marshall and to my colleagues Ernst Vegelin and Barnaby Wright for their helpful and constructive comments on drafts of this essay.

1. Edmond Renoir, 'Cinquième exposition de la Vie moderne', *La Vie moderne*, 19 June 1879, as reprinted in Lionello Venturi, *Les Archives de l'impressionnisme*, Paris, 1939, II, p. 337: "*Ce qu'il a peint nous le voyons tous les jours; c'est notre existence propre qu'il a enregistrée dans des pages qui resteront à coup sûr parmi les plus vivantes et les plus harmonieuses de l'époque.*"

2. On his landscapes, see *Renoir Landscapes 1865–1883*, exh. cat., National Gallery, London, 2007.

3. Reproduced in Anne Distel, *Renoir impressionniste*, Paris, 1993, p. 40; the surviving copy of this version of the catalogue, which includes handwritten notes of the prices that the artists were asking for their works, was in the collection of Claude Roger Marx and is conserved in the Bibliothèque centrale des Musées nationaux in the Musée du Louvre, Paris; I am indebted to Anne Distel for this information, and to Rachel Holm for drawing my attention to this issue. We do not know which version of the catalogue was the first.

4. By contrast, such themes were relatively common from the 1850s onwards in painting in Britain, where the boundaries between the subjects appropriate in fine art and popular illustration seem to have been far less clear-cut.

5. On the complexities of dating Degas's work in these years and identifying his exhibited pictures, see *Degas*, exh. cat., Grand Palais, Paris; National Gallery of Canada, Ottawa; and Metropolitan Museum of Art, New York, 1988–89, and Carol Armstrong, *Odd Man Out: Readings in the Work and Reputation of Edgar Degas*, Chicago, 1991, chapter 1.

6. "*Mais le sentiment des fonctions, mais le sentiment de la convenance sont choses indispensables. Ni l'écrivain, ni le peintre ne les peuvent supprimer. Comme les personnages dans une comédie, il faut que dans un tableau chaque figure soit à son plan, remplisse son rôle et concoure ainsi à l'expression de l'idée générale. Rien d'arbitraire et rien de superflu, telle est la loi de toute composition artistique*": Jules Castagnary, *Salons (1857–1879)*, Paris, 1892, I, p. 365.

7. The darkened auditorium was introduced by Wagner at Bayreuth in 1876; Renoir later remembered the upset he had caused by lighting a match in the dark auditorium on a visit to Bayreuth in 1896 (Ambroise Vollard, *En écoutant Cézanne, Degas, Renoir*, Paris, 1938, p. 205).

8. For an analysis of the complex power relations implied by the gendering of the gazes in *La Loge*, see Tamar Garb, 'Gender and representation', in Francis Frascina *et al.*, *Modernity and Modernism: French Painting in the Nineteenth Century*, New Haven and London, 1993, pp. 223–30. For discussion of the play of gazes in Renoir's *Les Parapluies* (National Gallery, London), with some discussion of *La Loge*, see Charles Harrison, *Painting the Difference: Sex and Spectator in Modern Art*, Chicago, 2005, pp. 27–36.

9. The canvas is described as a replica in Julius Meier-Graefe, *Auguste Renoir*, Paris, 1912, p. 44. On the auction, see Merete Bodelsen, 'Early Impressionist Sales 1874–94 in the Light of Some Unpublished "Procès-verbaux"', *The Burlington Magazine*, June 1968; for Jean Dollfus's purchase of the small version of *La Loge* at the 1875 sale, see Anne Distel, *Impressionism: The First Collectors*, New York, 1990, pp. 152–54.

10. Ernest Chesneau, *Paris-Journal*, 7 May 1874, reprinted in Ruth Berson, *The New Painting: Impressionism 1874–1886, Documentation*, San Francisco and Seattle, 1996, I, p. 19: "*Il y a là des qualités d'observation d'une part, et, d'autre part, des qualités de couleur des plus remarquables, dans une donnée absolument neuve. Le théâtre, cet aspect de la vie moderne qui a jusqu'à ce jour complètement.échappé à la peinture, préoccupe évidemment cette école nouvelle.*"

11. Marc de Montifaud, 'Exposition du boulevard des Capucines', *L'Artiste*, 1 May 1874, reprinted in Berson 1996, I, p. 29: "*Cette figure empruntée au monde élégant [...] La robe [...] achève d'envelopper la jeune femme d'une apparence féline*".

12. Philippe Burty, *The Academy*, 30 May 1874, reprinted in Berson 1996, I, p. 10.

13. Jules Castagnary, *Le Siècle*, 29 April 1874, reprinted in Berson 1996, I, p. 17: "*La Loge [...] est encore empruntée aux moeurs contemporaines [...]. Le soir, à la lumière, cette femme, décolletée, gantée, fardée, rose aux cheveux et rose entre les seins, fait illusion.*"

14. Jean Prouvaire, *Le Rappel*, 20 April 1874, reprinted in Berson 1996, I, p. 34: '*Les trois étapes par où passent communément les petites dames de Paris*' [...] "*Les joues blanchies de blanc de perle, les yeux allumés d'un regard banalement passionné, vous serez ainsi [...] attrayantes et nulles, délicieuses et stupides.*"

15. E. de Gantès, *La semaine parisienne*, 23 April 1874, reprinted in Berson 1996, I, p. 23: "*La pieuvre est là, bien développée,*

dans tout l'épanouissement de son triomphe. Le petit jeune homme que la pénombre laisse entrevoir nous montre ses succès et prouve que le blanc de perle dont on la voit plâtrée a produit son brillant effet. Comme elle le domine, ce moucheron cynique et vulgaire; comme ses yeux, vagues et inoccupés, rendent méprisable le monsieur qui a loué cette loge, pour faire part au monde de la fortune qu'il dissipe et du vide dont il est bourré."

16. See e.g. 'Bibliophile Jacob' [Paul Lacroix], *L'Art de conserver la beauté*, 1858, as quoted, and thus given wide circulation, in Pierre Larousse, *Grand dictionnaire universel du XIX^e siècle*, vol. V, 1869, p. 226. Baudelaire's celebration of make-up appeared in 'Eloge du maquillage', in his essay 'Le Peintre de la vie moderne', published in 1863.

17. "*Personne ne devinerait, à voir cette dame d'aspect si réservé, la profession de la petite Nini que Renoir peignit souvent telle que Dieu l'avait faite, sans l'enveloppe somptueuse qui l'entoure ici*": Meier-Graefe 1912, p. 44.

18. Georges Rivière, *Renoir et ses amis*, Paris, 1921, pp. 65–66: "*...une admirable chevelure d'un blond doré et brillant*"; "*C'était le modèle idéal: ponctuelle, sérieuse, discrète.*"

19. Vollard 1938, p. 181: "*...d'une docilité charmante*"; "*il y avait un peu de la contrefaçon belge*".

20. The suggestion that there were two Ninis seems to have been made first in François Daulte, *Auguste Renoir: Catalogue raisonné de l'oeuvre peint, I, Figures 1860–1890*, Lausanne, 1971.

21. This was exhibited in 1892 with the title *Torse; effet de soleil* (Torso, Effect of Sunlight).

22. Larousse, *Grand dictionnaire*, vol. X, 1873, p. 623: "*Les loges d'avant-scène, où les occupants se trouvent en vue d'une façon exceptionnelle, sont recherchées par les gens qui posent et qui veulent faire du genre*".

23. *Ibid.*, vol. I, 1866, p. 1034: "*A l'Opéra et aux Italiens, elles sont occupées par l'élite de la société [....] La noblesse y a ses loges en face à la finance. Dans les théâtres d'ordre inférieur, les loges d'avant-scène sont occupées, assez ordinairement, par des femmes de mœurs douteuses, des reines d'une jour, appartenant au demi-monde, qui s'y étalent en compagnie de jeunes gens, et quelquefois même de vieillards.*'

24. E.g. Jules Claretie's comment that "honest women" feared to be taken as *demi-mondaines* if they appeared in opera boxes, cited by Tamar Garb, 'Gender and representation', in Frascina 1993, p. 260.

25. Unlike certain recent authors, I do not see a reference back to Manet's *Olympia* (Musée d'Orsay, Paris) in Gonzalès's figure (see Tamar Garb, 'Gender and representation', in Frascina 1993, p. 260); the choker she wears and the bouquet beside her seem to be generic attributes, rather than specific quotations from Manet's canvas; moreover, they are most unlikely to have evoked memories of *Olympia* for viewers in the 1870s.

26. *Collection de M. le Comte Armand Doria*, sale catalogue, Paris, Galerie Georges Petit, 4–5 May 1899, lot 203: "*Un music-hall, à gauche, la salle, où tout le public est entassé bavard et curieux*".

27. Ambroise Vollard, *Tableaux, pastels & dessins de Pierre-Auguste Renoir*, Paris, 1918, vol. I, p. 83, no. 332.

28. Albert André, *Renoir*, Paris, 1928, p. 32.

29. The infra-red and X-ray photographs were first published in *Art in the Making: Impressionism*, exh. cat., national Gallery, London, 1990–91, pp. 152–57, where they, and the technique of the canvas, are discussed in more detail.

30. René Gimpel, *Journal d'un collectionneur, marchand de tableaux*, Paris, 1963, p. 181, recording a conversation with Paul Durand-Ruel in 1920.

31. François Daulte (Daulte 1971, no. 329) identifies the two figures as Turquet's wife and daughter, rather than, as Durand-Ruel stated, his two daughters. The X-ray suggests that neither account is correct.

32. The picture, together with the infra-red and X-ray photographs, will be discussed in more detail in the forthcoming catalogue of the nineteenth-century European paintings in the Clark Art Institute's collection. I am indebted to Sandra Webber and Sarah Lees for discussion of the X-ray and its implications.

33. Armand Sallanches, *Le Journal des arts*, 3 March 1882, reprinted in Berson I, p. 412: "*...crânement dessinées*"; "*...où deux élégantes [...] causent de tout autre chose que de ce qui se passe sur la scène*'.

34. Emile Hennequin, *La Revue littéraire et artistique*, 11 March 1882, reprinted in Berson I, p. 393: "*Il est le seul [impressionniste] qui me paraisse peindre sans inexactitude les couleurs qu'il voit. Sa Loge à l'Opéra contient une jeune fille en noir, dont les yeux et le sourire sont délicieusement vivants.*"

35. Paul Leroi, *L'Art*, vol. 29, 1882, p. 98, reprinted in Berson I, p. 401: "*Les bonnes gens qui, après avoir vu Une Loge à l'Opéra, croyaient à une commencement d'évolution sensée, désespèrent définitive-ment* [on seeing his views of Venice]".

36. Louis Leroy, *Le Charivari*, 17 March 1882, reprinted in Berson I, p. 402: "*Chose singulière, le même Renoir expose une Loge à l'Opéra qui ne déplaît trop aux philistins. Les frimousses des deux jeunes filles, leurs ajustements, la couleur de l'ensemble ont des qualités bourgeoises que l'impressionnisme exècre. Il ne faudrait pas s'attarder dans cette voie. On arriverait tout doucement à avoir le sens commun, ce qui serait désolant pour les critiques autorisés de la secte.*"

37. There are clear indications that the background of *Parisienne* originally included a more clearly defined setting.

38. See e.g., most recently, Ruth Iskin, *Modern Women and Parisian Consumer Culture in Impressionist Painting*, Cambridge and New York, 2007; and Joel Isaacson, 'Impressionism and Journalistic Illustration', *Arts Magazine*, June 1982, remains a fascinating presentation of such imagery in comparison with the Impressionists' paintings.

39. Georges Rivière, 'Les Intransigeants et les impressionnistes: souvenirs du Salon libre de 1877', *L'Artiste*, 1 November 1877, reprinted in Berson 1996, I, p. 186.

40. Meier-Graefe 1912, pp. 46–48. It is a pleasant and not coincidental fact that, shortly before acquiring *La Loge* in 1925, Samuel Courtauld bought Gainsborough's *Portrait of the Artist's Wife* of 1778, a canvas in some ways comparable to *La Loge*.

41. Paul Jamot, 'Renoir. I', *Gazette des Beaux-Arts*, November 1923, pp. 265–68.

42. See Rivière 1921, p. 58; Vollard 1938, p. 196.

43. This canvas, generally known as *Woman in Black at the Opera*, was first exhibited in Boston in 1878 with the title *At the Français, a Sketch* (see Judith Barter (ed.), *Mary Cassatt: Modern Woman*, exh. cat., The Art Institute of Chicago, 1998, pp. 318, 356); thus the identification of the site depicted as the Opéra is incorrect. Recent scholarship suggests that a copy of Renoir's *Café-concert (Au théâtre)* that has been attributed to Cassatt may not be by her hand; see Ruth Iskin, 'Was There a New Woman in Impressionist Painting?', in Sidsel Maria Sondergaard (ed.), *Women in Impressionism: From Mythical Feminine to Modern Woman*, exh. cat., Milan and Copenhagen, 2006, pp. 195–96 and p. 222, notes 29 and 30.

44. I do not share Robert L. Herbert's view that this can be seen straightforwardly as an image of solitude (see his *Impressionism: Art Leisure and Parisian Society*, New Haven and London, 1988, p. 57); our viewpoint is chosen so as to leave it uncertain whether she is alone.

The Art of Dress

Fashion in Renoir's *La Loge*

AILEEN RIBEIRO

"The art of dressing well is a complex and refined art, with undoubted importance, at least in the civilized world."

SAVIGNY *Résumé de l'histoire du costume en France* 1867 [1]

"In our era, where appearance is all-important, or at least plays a considerable role, dress must take the first place in the concerns of this book, just as it does with those of the public ... the costume of men and women is therefore of prime importance: it determines the character of our time and serves as a starting point."

BERTALL *La Comédie de Notre Temps* 1874 (see fig. 23) [2]

It was a truth universally acknowledged by the second half of the nineteenth century that Paris was the established capital of fashion. Fuelled by the growth of capitalism, the fashion industry, centred in Paris, was of huge importance to the French economy, and impacted on the lives and appearance of men and women in myriad, complex ways, not least in art.

Fashion had, particularly in France, been an inspiration to writers as well as artists. Balzac has been credited with pioneering the creation of fashion in literature by showing how it could explain much in human nature, and by defining in his *Traité de la vie élégante* what Carlyle called "the spirit of clothes".[3] And before Baudelaire's famous discussion of fashion as a key element in modern life in his essay 'The Painter of Modern Life' (1863), the poet Théophile Gautier – Henry James's "great apostle of beauty" – in *De la Mode* (1858) celebrated his delight in women's dress, notably their evening toilettes.[4] Gautier, the first (in 1852) to use the term 'modernity' à propos fashion, defended modern dress in art against such critics as Hipplolyte-Adolphe Taine (professor of aesthetics and art history at the Ecole des Beaux-Arts in Paris), who deplored Salon portraiture as "nothing but portraits of costumes".[5] Indeed, according to contemporary fashion journals, the Salon was itself a site for the display of the latest fashions; the *Journal des Modes* for 1874 noted that there "all the *élégantes* of Paris meet to look – not at the pictures but at each other. It is here that new fashions are now always first seen ...".[6] This link between art and fashion was made quite explicit by the celebrated couturier Charles Frederick Worth, whose creations featured prominently in the Salon, in declaring that a "toilette is as good as a painting".[7]

Fig. 23 Bertall (Albert d'Arnoux), 'Le Petit Chose', engraving from Bertall, *La Comédie de Notre Temps*, Paris, 1874

But, outside the confines of the establishment Salon, how was modernity to be effected in dress in what Edmond Duranty called the "new painting", that of the Impressionists? In a famous pamphlet of 1876 he urged the depiction of clothes "in social situations, at home or on the streets…the study of states reflected by physiognomy and clothing".[8] For there are both external and internal aspects to dress; it reveals wealth and status but it also expresses ideas of the ideal, of individual taste, of emotion, and our relationship to others; in art it is both transitory and eternal.

As a reflection of Parisian life, dress in art must certainly be fashionable; the artist Manet noted that the "latest fashion …is absolutely necessary for a painter. It's what matters most."[9] The art critic and editor of the *Gazette des Beaux-Arts*, the liberal and progressive Charles Blanc, Baudelairean in his admiration of fashion as essential adornment for women, discussed the links between art and fashion in his book *L'Art dans la parure et dans le vêtement* (1875). He declared that the artist invents "a superior truth, while the art of the ruling *modiste* is to create a happy illusion".[10] The "superior truth" lies in the representation of dress in art, the *spirit* of fashion as extolled by Baudelaire in his praise of Constantin Guys as 'The Painter of Modern Life', who freed fashion from the depiction of fussy detail; it was this spirit which artists like Renoir revealed in their art, evoking an imaginative response in the viewer.

The Painting

In *La Loge* (cat. 5) Renoir places fashion at the heart of the painting; it encompasses the conventional evening dress of the man and the modish outfit of the woman as they sit in a box at the theatre. The palette is mainly black and white, which might be seen as a reflection of the widespread availability and fashionability of photography in the 1870s, except that the painting incorporates the subtle colour nuances that the camera could not achieve.

We focus on the woman, for men – literally – take a back seat in a theatre box, and generally in terms of their costume they act as a sober foil to female finery. The *Guide sentimental de l'étranger dans Paris* (1878) firmly states: "The civilized man, from the point of view of dress, is merely a woman's escort; he lets her sing alone her symphony in white, in rose, in green…".[11] Formal evening dress for men – an English importation, like much menswear – consisted of a black coat and trousers, a white waistcoat (*gilet*) cut very low and wide so as to reveal a white shirt with a stiffened front; a starched white cravat completed the costume.

This is the *tenue de première* – evening dress as worn for the first night of a play, and for every performance at the elite theatres and the Opéra.[12] In *La Loge* Renoir draws our attention to the starched expanse of the bluish-white plain shirt-front and the gold cuff-links in the cuff as the man – the artist's brother Edmond – raises his gloved hand to view the audience with his opera glasses.

Men's evening dress appears as a kind of uniform, the male body distanced by clothing in shades of black (which absorbs light) and white

(which reflects light), with only minor differences in the nuances of tailoring – the cut of a lapel, the shape of a pocket etc. – and, as for the shirt, the exact degree of starch and the style of the cravat. Black was crucial for menswear generally, most famously (and ambivalently) described by Baudelaire in his notes on the Salon of 1846 as both funereal and "an expression of universal equality".[13] The sobriety of male clothing, first appearing at the end of the eighteenth century, was a reaction against court ostentation, and celebrated the growing political and social legitimacy of the middle class. Various types of cloth and dyes created different effects,[14] the blackest of black being worn for evening wear to create an intense and deep 'colour' under artificial light, which also caused the shirt front to gleam in a dramatic contrast.

Given the uniformity of men's formal dress, individuality lay in manner and facial appearance. Charles Blanc noted how much "expression there is in the cut of the beard, moustache, whiskers and hair".[15] The length of Edmond's hair suggests the mere hint of an artistic/bohemian temperament, but his slight moustache and short beard indicate a man of fashion, although not a dandy. "Ladies generally like to see a beard on a man's face", suggested the *Journal des Modes* (1874), but not long beards which looked too Turkish and "do not agree with modern costume".[16]

Nothing could be more *à la mode* than the dress worn by Edmond's companion, Renoir's model Nini Lopez, for striped outfits were all the rage in the early and mid 1870s, as fashion journalism indicated. In 1874, for example, we find *La Mode Illustrée* (April) describing the preponderance of striped toilettes, and the *Journal des Modes* (July) declaring that "black and white is always pretty, and will always be admired" (see fig. 24), although, as the fashion magazines relied on high-quality coloured plates, black and white striped dresses rarely appear.

Nini's dress– as often in Impressionist painting – is deliberately blurred and often difficult to 'read', but is probably of white silk gauze with appliquéd black ruched *tulle* (silk net); her sleeve ruffles are machine-made silk lace. Such insubstantial and hazy fabrics appear at their best in the evening, particularly in the *demi-toilette* which Nini wears here. The dress itself is the style known as a *polonaise* (or *polonaise-princesse*), deriving from the 1770s and consisting of an overgown looped up at the sides and back to create softly draped layers of fabric, and worn over a separate skirt, here of white. Nini's dress is an embryonic form of the princess gown (see below): "The *polonaise* is nothing else than a *princesse* dress worn over a skirt".[17] The vogue for eighteenth-century styles, frequently referred to in contemporary fashion magazines, can also be seen in the sleeve ruffles and in the striped pattern of the dress. Charles Blanc admired the "harmonious repetitions" created by stripes, especially "the effect of black and white" which reminded him of old engravings.[18] Under artificial light, Blanc notes, black becomes dense and heavy, but white sparkles, to become "*blanc-de-lumière*", a word also applicable to Nini's painted face. Baudelaire in his *Eloge du maquillage* (1863) uses the word 'face-painting' rather than '*maquillage*' (cosmetics), for this suggests the made-up woman as a finished work of art. The silvery, powdered face and neck create their

LA MODE ILLUSTRÉE

Bureaux du Journal 56 rue Jacob Paris

own slightly blurred texture to complement the gauzy fabrics of the dress.
The *Journal des Modes* for July 1874, praising black and white – "one of
the most charming Countesses in Paris scarcely wears anything else" –
records the latest appearance of this fashion icon in "the new *gauze perlée*,
which had the appearance of a sheet of silver", with "a real rose in the hair
and one in the front of the dress"; tiny glass tubes filled with water kept the
flowers fresh.[19] The roses on Nini's dress draw attention to the slight valley
between her breasts, giving her the appearance of leaning forwards, but
this effect is mainly created by new developments in corsetry, namely the
steam-moulded corset which helped to create an enticing décolletage.[20]
The corset (from the French *corps*, 'body') acted as the body's body, and
this new style thrust the bust forward and placed greater emphasis on the
torso. Blanc declared that the bodice of a dress was the most important
feature of the female ensemble "because a woman displays the beauty of
her figure above the waist";[21] more prosaically, "not only the bust but the
stomach must be well outlined" was the diktat of the *Journal des Modes*

(1874),[22] and this Renoir does with the lines of black *tulle* curving down the sides of the bodice and round the hips.

As Nini's face is 'finished' by face paint and powder, so her dress needs the finishing touches of luxury accessories, such as her diamond ear-rings, the rows of pearls at her neck and the gold bracelet on her wrist. Falling off her shoulder is an ermine *sortie de théâtre*; the *Journal des Modes* noted: "…ermine has been much used this winter [1874–75] for the lining of opera-cloaks".[23] As Nini places her arm on the faded red plush at the front of the box, one white gloved hand holds opera glasses, the other a painted black fan and a lace-edged handkerchief. Bare hands were not acceptable on such formal occasions, either for men or women; white silk or kid gloves for women, white or cream-coloured kid for men were prescribed by etiquette books. More thoughtful commentators noted how gloves both covered the imperfections of the hands and defined the status and character of the wearer.[24] Blanc thought gloves acted to 'moderate' the hand, which – if uncovered – might otherwise detract from the face.[25]

The Fashions

The defeat of France in the Franco-Prussian War of 1870-71 was sometimes attributed to an excessive pursuit of pleasure during the Second Empire,[26] and specifically the prominence of a *demi-mondaine* class[27] who promoted extravagant styles of dress – supplied by celebrity designers such as Charles Frederick Worth, whose business, opened in 1858 in the rue de la Paix, was, according to the English journalist George Augustus Sala, "the veritable Temple of Fashion … the sanctum sanctorum of feminine frivolity".[28] The notion (dating back to classical times) that luxury corrupted public morality was countered during the Second Empire with claims that the luxury industries (most obviously fashion and fashion accessories) were not only crucial to the French economy[29] but were democratically available to all with money, and an essential part of the national character.[30]

Haussmann's revolutionary changes to Paris in the Second Empire – the large *boulevards* steam-rollered through the capital and the concomitant destruction of ancient *quartiers* – were not universally appreciated, and T.J. Clark notes a sense of unease that the new city "was given over to vice, vulgarity and display".[31] But a new culture of fashion required sites for display and larger public spaces; for example, the vast skirts of the crinoline in vogue during the 1850s and 1860s were catered for by Haussmann's wide streets. The conspicuous consumption of fashion and leisure by the growing population of Paris (it doubled between 1850 and 1870 to approximately two million) took place in the streets, the cafés, entertainment venues, race courses, public parks and the shops – a complete theatre of public life. Shopping in particular became a popular leisure pursuit for women with the opening of *Bon Marché* in 1852, the first of the *grands magasins* or department stores which catered for all classes.[32] With free entry, large windows with attractively stocked goods, life-like mannequins (from the late 1860s) and luxurious interiors, these

shops provided a tempting theatre of display, as Zola records in his novel *Au Bonheur des Dames* (1883). By the 1870s fashion was widely available for more people (especially women and children) through the provision of a wide range of ready-to-wear clothes (*confection*) in the *grands magasins*. It is all the more curious that no Impressionist artist depicts these scenes of modern life, with the exception of Degas with his images of milliners – just one small facet of the vast fashion industry, with *grand couture* at its apex.

The Franco-Prussian War, followed by the Siege of Paris and the Commune, obviously had an impact on fashion; fashion magazines continued to appear, however, even while acknowledging what *La Mode Illustrée* (2 October 1870) called "*des tristesses, des douleurs générales* [sadness and general grief]" brought about by these events. A relative simplicity in dress was *de rigueur*, and black was widely worn, not just for individual mourning, but for France as well.

Fashion was, however, so important both to the French economy and to the morale of the French people that the industry quickly recovered (similar sentiments lay behind Dior's introduction of the New Look in 1947 – a boost to the nation's self-esteem in the aftermath of war).

An English journalist visiting Worth in the summer of 1871 (his salon re-opened in June that year) recorded the couturier's estimation of business ("orders are coming in very fast") as due to women coming to Paris for "the unnecessary and the frivolous".[33] Worth might have been talking up his prospects – although his was the most important and successful couture house in Paris, with a world-wide clientele – but soon fashion had made a complete return, aided by the election in spring 1873 of Marshal MacMahon as President of the Third Republic, whose monarchist sympathies encouraged the revival of elite life-styles.

From 1873, as Augustin Challamel remarked in his *Histoire de la mode en France* (1875), "women's dress became extremely complicated… simplicity gave way to a thousand accessories, and the decorations on dress were truly ruinous [in cost]".[34]

With the flounces, pleats, fringes and all kinds of ornamentation on their dresses, women were as fussily upholstered as furniture (see detail of cat. 21 on page 44). The numbers of couturiers doubled from the 1870s to the 1890s, and the sewing machine – in wide use from the late 1860s[35] – enabled the construction of intricate and elaborate dresses (over equally complex body-shaping understructures, such as corsets and *tournures* (bustles) – the English referred to them as 'dress-improvers' – made of horsehair, cork, sponge, or various fabrics). They can be seen both in contemporary fashion plates and in caricatures, such as those in Bertall's *La Comédie de Notre Temps* (figs. 25 and 26).

From the end of the 1860s the crinoline was abandoned, but the early 1870s still retained the soft, rounded look of the previous decade, what the English dress reformer Mary Eliza Haweis called "pregnant fullness"; the full-blown rose effect which we see in *La Loge* is underlined by the roses at her breast and waist. Nini's dress is relatively unstructured, as is Henriette Henriot's in Renoir's *Parisienne* of 1874 (fig. 15, p. 31), where the

blue silk overskirt is bundled up at the back (a similarly styled costume can be seen in fig. 30). Shortly after these two paintings by Renoir, Worth introduced the true princess line (named in honour of Princess Alexandra, wife to the Prince of Wales), a more flattering and streamlined shape, comprising a close-fitting gown over a skirt, the emphasis on the fluid line from bust to hip. A good example of this is in Renoir's *La Balançoire* of 1876 (The Swing; Museé d'Orsay, Paris), a long white *robe en princesse* trimmed with blue bows down the front and a matching blue for the skirt; when the artist was asked for the dress he liked best to paint women in, he replied "…the princess gown, which gives women a pretty and sinuous line";[36] this sinuous line remained in vogue throughout the 1870s and into the 1880s. With the expansion of fashion in this period, etiquette increasingly dictated an "elaborate system of appearance, which reveals the importance … attached to clothing's signifying role as opposed to its functional role".[37] A fashionable society woman might wear half-a-dozen different dresses in one day. A complicated hierarchy of clothing had to be learnt, and conduct manuals instructed their readers on dress appropriate to their age, physical appearance and social position.[38] They recited the correct outfits for different occasions, from the relatively simple dress

Fig. 25 Bertall (Albert d'Arnoux), 'Le Corset', engraving from Bertall, *La Comédie de Notre Temps*, Paris, 1874

Fig. 26 Bertall (Albert d'Arnoux), 'La Robe', engraving from Bertall, *La Comédie de Notre Temps*, Paris, 1874

LE CORSET. 127

Il est vrai que jamais une femme ne consentait à avouer le supplice qu'elle subissait.

Et quand on disait à une femme qui semblait à la torture dans son appareil de coutil, de fer et d'acier : « Prenez garde, vous êtes trop serrée ! » elle avait immédiatement à sa disposition une réponse qui consistait à soulever d'une certaine façon le bas du corset : « Vous voyez, disait-elle invariablement, je ne suis pas serrée du tout, on y passerait la main. »

Quitte à se trouver mal une demi-heure après ; de telle sorte qu'on était immédiatement contraint

LA ROBE.

Toute l'architecture de la toilette étant préparée et pour ainsi dire dessinée, c'est maintenant la robe qui doit apparaître comme la façade de l'édifice.

La robe, c'est-à-dire l'extérieur, l'apparence, le décor.

Soignez ce qui se voit, négligez ce qui ne se voit pas, tel est souvent, trop souvent le mot d'ordre usité de nos jours. Quelle influence suprême a le costume dans cette comédie aux cent actes divers qui se joue perpétuellement sous nos yeux !

Le choix des robes est donc chose grave et importante.

Le temps n'est plus où la duchesse de Duras disait : « La dernière personne que je consulterai pour ma toilette, c'est ma couturière. »

Maintenant, la couturière est maîtresse tyrannique, et sait imposer ses volontés.

required at home in the morning through the more formal costume worn for shopping to the even more elaborate outfits needed for afternoon visits (varying according to visits on foot or by carriage) and the formal toilettes for dinners, the theatre and balls. The more formal and splendid the occasion, the shorter the sleeve and the lower the neckline. Thus, looking at paintings by Renoir, *Parisienne* (fig. 15, p. 31) in her high-necked, long-sleeved ensemble, wears a costume for shopping on foot; Nini in *La Loge* wears a *demi-toilette*, with modest décolletage and elbow-length sleeves, half-way between day-dress and full dress; in *Une loge au théâtre* (cat. 11) we see a *grande toilette* of black silk with plunging neckline and barely-there sleeves of spotted net. These are undoubtedly *chic* outfits created by the magical alchemy of a great artist; Bertall defines '*chic*' as a word first used in artists' studios, and which when applied to fashion was "*une allure, une désinvolture, un aspect, une 'elégance impromptue* [bearing, ease of manner, appearance, an impromptu elegance]".[39]

The art of being *chic* was – as today – an elusive concept, reliant on character and deportment as much as on dress, but it requires the physical presence of the wearer, or her transmutation on canvas. It cannot be seen within the confines of fashion journalism with its banal descriptions of dress, the stiffness and lack of individuality of its illustrations, but these publications (a steady stream of which appeared from the Restauration, swelling in number as the century progressed) helped their readers to grasp the constantly changing styles which were quickly transmitted to the shops. "The commercialization of fashion brought with it an increasing visualization of the female body."[40] Shops and fashion designers paid to appear in the most prestigious publications, like *La Mode Illustrée,* with plates by Anaïs Toudouze depicting elegant models in sophisticated settings, such as at the theatre. It seems likely that Renoir, both in *La Loge* and in *Parisienne*, was inspired by fashion plates; the deliberate anonymity of the titles of the paintings might suggest that we are to see them as fashionable *types* rather than as portraits, although we know who posed for them.

What we see in such paintings by Renoir is a poetic interpretation of the prosaic details of fashion, visualising what earlier Gautier and Baudelaire had described in words and corresponding to what, later in 1874, the poet Stéphane Mallarmé tried to do. Mallarmé (who knew Renoir) became in the summer of 1874 the editor of the fashion journal *La Dernière Mode*; his aim was to study dress as art,[41] along with the theatre, books, the arts and fine dining. He visited couturiers, shops and theatres, noting the fashions, which he then – under various *noms de plume* – described in detail, at times in parody of the "gushing but despotic manner of women fashion-editors"[42] (and some critics have seen the work as a satirical attack on fashion journalism), but also as a lyrical prose-poem, inspired by Baudelaire's 'Painter of Modern Life' but with far more information on dress. Mallarmé dwells on the minutiae of fashion, its exquisite colours and decoration, its often poetic names for fabrics (*tulle illusion*, for example) and for styles of dress. As editor, the poet only lasted for eight issues; the materiality of fashion proved too exhausting – "fashion is peopled only

with objects", he remarked[43] – and ultimately Baudelaire's eternal and transitory could not be reconciled within the confines of a fashion magazine.

Dressing for the theatre

The theatre in Paris had a high reputation – "The theatres are the main attraction of Paris", stated a guidebook in 1878.[44] The theatre was an important place to see and to be seen, witness the way opera glasses are wielded in paintings to watch not just the performance but members of the audience as well, to register interest and appreciation, to examine what friends, acquaintances and strangers were wearing. Indeed, there was frequent comment, both literary and visual, that women only saw the theatre as a place for sartorial display, ignoring the performance. Taine at the Opéra complained: "I hear a hum of words; *moiré antique*, spangled velvet, tarlatan, poplin, *guipure*, flounces and the like … for women are obsessed with dress".[45]

This was the new Opéra, inaugurated in 1875, with a vast, impressive staircase for the parade of fashion; as Catherine Christophe-Naugrette remarks, this staircase, the *escalier d'honneur*, was a theatre within a theatre, "a privileged place in which the urban spectacle was acted out within the space of the theatre".[46] It provided *the* most stylish background to a display of fashions (see fig. 27). For the theatre, especially the state theatres, often launched and displayed the latest fashions, both on stage

Fig. 27 Unknown artist, hand-coloured engraving of women in the foyer of the new Opéra from *Le Journal des Modes*, October 1875

LE JOURNAL DES MODES

Fig. 28 (*right*) Unknown artist, 'Coiffures de théâtre et soirées', engraving from *La Mode Illustrée*, 11 January 1874

Fig. 29 (*opposite*) Cover of *La Mode Illustrée*, 7 January 1877

and off. Famous actresses were dressed by equally famous couturiers – Sarah Bernhardt liked Worth, Réjane patronized Jacques Doucet – and often had toilettes named after them.

On first nights in particular, and in a box at the Opéra, dress was very formal – a low-cut dress, either sleeveless or with minimal sleeves, and elaborately dressed hair, piled high and decorated with jewels, flowers, ribbons and lace (see figs. 28 and 29). For entering and leaving the theatre, women wore mantles known as *sorties de théâtre*, and these often feature in fashion plates (see fig. 29), although they would have been removed when actually in a box. On less formal occasions at the theatre, women in boxes wore *toilettes de soirées*, with modest décolletage and sleeves usually to the elbow. In less grand seats (and in lesser theatres) *toilettes de ville* or formal day-dresses were *de rigueur*, along with hats rather than evening headdresses.

N° 1 (avec patrons). DIX-HUITIÈME ANNÉE. 1877.

LA MODE ILLUSTRÉE

JOURNAL DE LA FAMILLE.

Monthly Part complete, with Plates and Patterns,
2 s. 6 pence.

Monthly Part of the Plates only, with English Description,
1 s. 6 pence.

Publishers for England : ASHER and C°, 13, Bedford Street, Covent Garden, London, W. C.
Subscriptions can be taken from the beginning of the first of any month, and are payable in advance.
Post-Office orders to be made payable to ASHER and Co. at King Street, Covent Garden, London, W. C.

Corsage en faye.

Robe en faye rose. Corsage ouvert en carré, garni de dentelle blanche, d'une bordure de plumes noires et d'une ruche en crêpe lisse blanc. Manches garnies comme le corsage. Sur le côté gauche, une touffe de narcisse. Dans la chevelure, mêmes fleurs, coques de ruban bleu et un rang de perles.

Sortie de théâtre
EN SICILIENNE BLANCHE.

Doublure de lustrine blanche ouatée. Garniture composée de dents brodées. Boutons en passementerie, nœuds de ruban blanc.

Corbeille
POUR USTENSILES DE MÉNAGE.

Les figures 65 et 66 (verso) appartiennent à cet objet.

Corbeille en osier recouverte à l'extérieur avec du cachemire brun, à l'intérieur, de toile cirée, employée aussi pour les poches et pour le lambrequin. Couverche en baleine brune. Recouvert à l'extérieur avec du cachemire brun orné de broderie. La corbeille a 49 centimètres de longueur, 36 centimètres de largeur, 24 centimètres de hauteur.

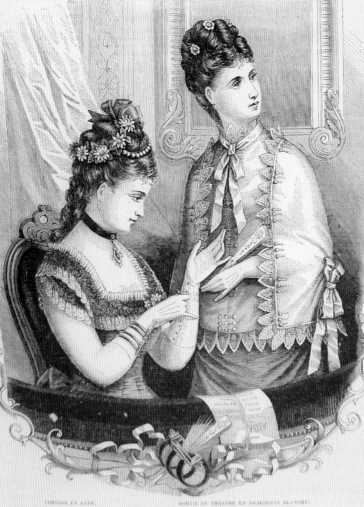

CORSAGE EN FAYE. SORTIE DE THÉÂTRE EN SICILIENNE BLANCHE.
Modèles de chez Mme Fladry, rue Richer, 43.

On recouvre l'extérieur de la corbeille avec du cachemire. On coupe le lambrequin, dont la hauteur est de 9 centimètres, et l'on découpe ce lambrequin en *dents* ayant chacune 5 centimètres de hauteur, 7 centimètres de largeur. On borde ces dents avec de la tresse de laine brune, on garnit leurs pointes et leurs intervalles d'une boule en laine brune. Une ruche en tresse de laine brune cache la couture du lambrequin : on double l'intérieur de la corbeille avec de la toile cirée dont on cache le bord supérieur sous une même ruche. On pose 4 poches ayant chacune un revers orné au préalable de broderie. Chaque poche a 24 centimètres de largeur, 12 centimètres de hauteur. La figure 65 représente le patron du revers. On borde le contour de celui-ci avec de la tresse de laine, on l'orne de deux rangées de soutache brun clair, entre lesquelles on exécute une couture en croix avec de la soie brune. Les étoiles sont entourées de point russe fait avec de la soie brun clair et garnies de soie brun foncé tendue. La jonction de ces points est fixée au milieu par un point double croix fait avec de la soie brun clair. Le reste de la broderie est fait avec de la soie brun foncé. Sur les contours on coud une soutache de laine brune. On fixe les revers sur les poches, on garnit le bord supérieur de celles-ci avec une ruche de même tresse de laine, en forme sur le bord inférieur un pli extérieur ayant 3 centimètres de largeur, on les pose comme l'indique le dessin. Sur le fond de la corbeille on pose un morceau de carton recouvert de chaque côté avec de la toile cirée. Le côté de dessus de ce carton est

LA MODE ILLUSTRÉE

Bureaux du Journal 56 rue Jacob Paris

Toilettes de M᷄ᵉ BREANT CASTEL 19 r du 4 Septembre

The theatre was "a social ritual, and there were fairly strict rules concerning who could sit where and what was the appropriate mode of dress to be worn".[47] The box was the best site for feminine display, as contemporary paintings and fashion plates suggest, and visits from box to box were as much to see what was being worn as to see the wearers themselves. Bertall claimed in *La Comédie de Notre Temps* that women's fashions were theatrical in their own right, elaborate enough to appear in a revue or an *opéra-comique*,[48] by implication pointing to a female propensity for heightened extravagance and fanciful, 'historical' elements in dress, such as the vogue for revivalist eighteenth-century styles.

In the slightly unreal world of fashion plates, where the aim was to reveal the details of feminine dress, scenes set in the theatre occasionally show the same dress, front and back; sometimes different 'ranks' of dress appeared (formal and less formal) in the same box. Among elite theatre-goers, wearing the identical dress as another woman of fashion (and worse still, meeting her) would have been a sartorial solecism, as would getting the etiquette of dress wrong within the context of a group. Another contradiction of reality is that no men appear in the fashion plate *loge*, for their relatively unchanging dress was of little or no interest to the editors and readers of such publications.

But it was usual for women to go to the theatre accompanied by men, even if fashion plates and paintings concentrate almost exclusively on feminine dress and appearance. There was a slight frisson of the improper about attending the theatre, and many middle-class women did not go until they were married. Unmarried women and girls who went were supposed to wear modest dress with no décolletage and little jewellery.

Of course not everyone obeyed the rules, either deliberately or through ignorance, American women being often cited in this respect. An illustration from the *Journal Amusant* of 6 May 1876 (fig. 31) depicts a young American woman in a low-cut sleeveless dress, with her hair *échevelée* (dishevelled); long, undressed hair was inappropriate with this formal evening dress. The accompanying text suggests that she has something of the spirit of an Amazon ("*du sang d'Amazone dans les veines*"). In the same vein, Mary Cassatt's *Femme dans une loge* of 1879 (cat. 10) might be one of those healthy American beauties of the kind described in Edith Wharton's novels, whose innocence triumphs over the sophistication of a *grande toilette*. Here the couture evening-dress of sleeveless pink silk is cut to slip down over her upper arms, but the effect is countermanded by the slightly muscular shoulders and chest and the simplicity of her hairstyle.

At the other end of the sartorial spectrum for the theatre-goer is Cassatt's *At the Français, A Sketch*, c.1877–78 (cat. 9), showing a sober black ensemble. In a somewhat long-winded discussion of this painting à propos the idea of the female 'active gaze', Linda Nochlin proposes that "her tense silhouette suggests the concentrated energy of her assertive visual thrust into space",[49] but without noting the part played by the dress here, probably mourning costume,[50] which in its starkness – dull black with touches of white at neck and cuffs – has a hint of masculinity.

Fig. 30 (*opposite*) Anaïs Toudouze, untitled, hand-coloured engraving from *La Mode Illustrée*, 4 September 1873

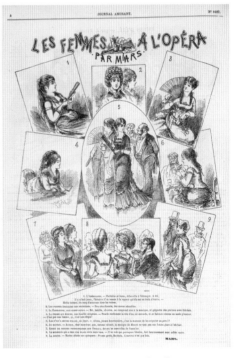

Fig. 31 Mars (Maurice Bonvoisin), 'Les Femmes à l'Opéra' (Women at the Opera), *Journal Amusant*, 6 May 1876

Both Cassatt's models carry fans, the indispensable accessory for women at the theatre, being both practical and decorative, and what Charles Blanc calls an "instrument of coquetry". Appropriately, the woman in sombre black, intent on the stage and unaware of being herself observed, holds a closed fan, while in the other painting, there is frank pleasure at being admired, and the fan is half-open in invitation. Against the stillness of the seated woman at the theatre the fan represents movement, a "flexible curtain" which "discloses all that is apparently hidden, conceals all that is apparently exposed".[51] For Degas, the open fan *is* the female theatre-goer, notably in his pastel *Ballet from an Opera Box, c.*1884 (Philadelphia Museum of Art), where – apart from the dancers on stage – we just see a feathered fan; and in his *Dancer with Bouquet, Seen from a Loge, c.*1877–79 (fig. 22, p. 41), a woman in profile with the very large fan of that decade, made of black lace.

The Painting (again)

In his work *L'Art moderne* (1883), J.-K. Huysmans attacked the idea that artists should depict dress as though they were couturiers, for mere externalism, he claimed, had no real meaning. Only the Impressionists (and here he includes Renoir) "understood the correspondence between dress and social class".[52] But, as Marie Simon points out, the Impressionist artists were, on the whole, quite selective in the dress they chose to paint, ignoring both the complexities of *grand couture* (mainly the preserve of society painters) and the truly modern tailored costumes[53] made of matte fabrics like wool which women were beginning to wear (and which we see, for example, in the work of Whistler), in favour of styles in which their sitters could be relaxed and move easily, made from materials which reflected the light. Mallarmé said that the Impressionist artists painted not so much the dress itself, but the effect of dress, the sometimes incoherent and blurred lines created by soft, full dresses of *tulle*, muslin, floating silks etc. But a process of selection is part of the imaginative process of being an artist, as is the freedom to generalise, to simplify the dress in a painting, which is also an aspect of the creation of a work of art.

Dress is crucial to portraiture, even though art historians (like critics) might deplore the specificity of fashion seen in the work of Renoir and his contemporaries.

Renoir (whose father was a tailor and his mother a dress-maker) was clearly at ease with fashion, although – according to his son – he supposedly hated signs of women's "slavish devotion" to their appearance, such as tight corsets, high heels and over-elaborate hairstyles.[54] Such sentiments were not inimical to the way in which he portrayed fashion as essential to the generic type of the *chic Parisienne*, a "French metropolitan femininity …indispensable to the representation of modern life".[55] Thus, in the *livret* of the first Impressionist exhibition of 1874, Renoir's *Parisienne* (modelled by Henriette Henriot, an actress at the Odéon) is listed directly after *La Loge*; both signify the *chic* Parisienne out walking and at the theatre.

Fig. 32 Jean-Auguste-Dominique Ingres
Vicomtesse de Senonnes, c.1814–16
Oil on canvas, 106 × 64 cm
Musée des Beaux-Arts, Nantes

A sophisticated sexuality and the ability to charm were essential aspects of the *chic Parisienne*; Octave Uzanne somewhat over-heatedly remarked that such women were "the sultanas of the West. They pass before the admirer's gaze, radiant, nimble, light, flighty and radiant, like houris in Mahomet's heaven".[56] As for charm, "*ce que j'aime dans la femme, c'est le charme féminin* [what I like in a woman is feminine charm]"[57] was Renoir's comment, and this is surely how he depicts Nini in *La Loge*, a figure possibly inspired by his favourite Ingres portrait, that of *Marie Marcoz, Vicomtesse de Senonnes* of c.1814–16 (fig. 32). Both women are *déclassées*, outside society to some extent; Nini was a model, and Marie a bourgeoise entering an aristocratic family who thought the marriage a *mésalliance*.[58] In both paintings the pose is similar (though reversed), the hand on a handkerchief, and the figure emphasised by expert corsetry and luxury fabrics; Marie's gauzy silk ruff becomes Nini's pearls, her cashmere shawl an ermine mantle.

The notion that dress has meaning, hinting at class, status, personality, taste and morality, is just as important as the interpretation of art in

general, and perhaps more so as a signifier of political and cultural trends. This is what the English journalist Adolphus had in mind when in August 1871 he had the "utterly new idea" of "the study of the psychology of women's gowns" as affected by the war that had recently ended. To do this, he interviewed Worth, as to whether dress had "abstract essence and hidden meanings", but to his chagrin he found out that the great couturier dismissed the suggestion, declaring that "the women who come to me want to ask for my ideas, not to follow their own...".[59] It was, apparently, an uncomfortable encounter, only ameliorated by the presence of Mme Worth, stylish in "white satin ... striped with bands of black velvet [and] a profusion of lace",[60] who he thought looked Spanish rather than French. That may suggest that Nini in *La Loge* declares her Spanish origins in her dress – although in fact Worth was famous for his black and white toilettes.

Adolphus, undismayed by Worth's views that women did not dress with any particular idea in mind, held to his view that their clothes had meaning. He underlined the importance of clothes to deportment, how a woman's gestures and behaviour alter according to the different dress she wears, and that each has a "story to relate": "...the perfect Paris woman has a bearing for every gown. Just as the nature of the dress itself dictates its purpose, its meaning, and the hour at which it is to be worn, so does she herself associate her ways with that meaning."[61]

So, ignoring what Susan Sontag denounces in a famous essay as the "itch to interpret"[62] (and, indeed, Renoir's impatience with attempts to theorise his work), what can be made of Nini's appearance in *La Loge*?

According to an author of popular conduct manuals, "...the mind or essence of a woman can be seen in what she wears".[63] Some critics, like Jean Prouvaire in *Le Rappel* (20 April 1874), declared that Renoir had depicted a "*cocotte* in black and white [who] will attract people with her wicked charms and [the] sensuous luxury of her clothes".[64] Certainly the artist focuses more on the sensual tactility of the fabrics of the dress than on the dress itself; this is the reverse of the hard realism of a fashion plate or a painting by, say, Tissot. The hazy, shifting white with bluish tints of the dress almost merge into the colour of the flesh; as John Harvey points out, this "colour that is close to skin colour" plays "with the pretence of uncovering while covering",[65] and almost becomes a second skin.

The cream colour of the ermine wrap (a very expensive accessory more suited to a *grande toilette* than the less formal dress that Nini wears) serves to divide her from her companion, and to echo the pearls arranged somewhat haphazardly round her neck, falling over her breast. The luxury of the pearls is an unexpected touch, as simpler jewellery was more usual with a *demi-toilette*, or even just a black ribbon with a locket round the neck. The expensive jewellery she wears contrasts with the careless simplicity of her hairstyle, with its rather ragged fringe and roses pinned at one side. An X-ray of *La Loge* (fig. 35, p. 74) suggests that Nini might originally have worn a black *toque* (small, brimless hat), but this was discarded by Renoir, perhaps because he preferred his model to show off more of her golden-brown hair unadorned with the hair ornaments and

fake locks which were often seen in fashionable *coiffures de théâtre* (see fig. 28), especially when on view in a box.

One of the prime signifiers of the *cocotte* referred to above was the obviously painted face; in an echo of Baudelaire's comments on the fashionable woman, Prouvaire addresses Nini's "artificially whitened cheeks, those eyes lit with banal passion ... attractive and empty, delectably stupid".[66] Make-up was not really regarded as respectable, being the preserve of actresses and the *demi-monde*, but for evening, in particular, some was permissible. As Gautier noted in *De la Mode*, "Just as clever painters establish a harmony between flesh and drapery in their portraits by applying light glazes to the canvas, so fashionable women whiten their skin, which would otherwise look too brownish when set beside the silks and laces of their costume".[67] But cosmetics had to be applied with discretion, and Nini's face is too whitened with 'rice' (i.e. mineral) powder[68] – even for a woman on display in a *loge* – to be acceptable according to the conventions of the time.

But because we know the identity of the sitters in *La Loge*, is it possible to take their images at face value? If Renoir uses those he knows well to act as characters in modern social narratives, if this is a 'pretend' situation, how far do the accepted rules of dress and behaviour apply? There is no suggestion that Renoir intends to subvert conventional notions about the relationships between men and women, that ultimately the former have power over the latter. Yet the notion of the male gaze of proprietary power is too simplistic, for women can accept this sometimes with pleasure, and return it; Harvey has argued that in fact men fear the female gaze, so they hide most of their bodies by the way they dress.[69]

Thorstein Veblen was one of the first to wonder why men and women looked so unlike in their clothes, arriving at the conclusion that this was due to the fact that women were used as *objets de luxe* by men to showcase their status and wealth. His influential *Theory of the Leisure Class* (1899), which defines the principles of pecuniary culture whereby people acquire social status through display, defines the "neat and spotless garments" of men as the "insignia of leisure", and as for women, the impractical and complicated artifice of their dress "goes even further in the way of demonstrating the wearer's abstinence from productive employment".[70]

Veblen's somewhat puritanical indictment of clothing, especially that of women, would not have concerned Renoir, for the "French have never shared the Anglo-American conviction that makes the fashionable the opposite of the serious".[71] For Renoir, dress was primarily "created expressly for the delight of painters, for the delight of the eye";[72] it was an essential part of the representation of beauty, what Stendhal called "the promise of happiness".

Notes

1. "*L'art de s'habiller est un art complexe et délicat dont l'importance ne peut-être mise en doute, au moins chez un people civilisé*": R. Savigny, *Résumé de l'histoire du costume en France*, Paris, 1967, p. 5.

2. "*A notre époque, où l'apparence est tout, ou pour le moins joue un rôle considérable, le costume doit prendre la première place dans les préoccupations de notre livre, comme dans celles du public [....] Le costume de l'homme et la toilette de la femme sont donc choses primordiales: ils fixent le caractère de notre temps et servent de point de départ*": Bertall (Albert d'Arnoux), *La Comédie de notre temps*, Paris, 1874, p. 25. The author distinguishes between the "*costume*" of men (as a relatively fixed dress with a limited number of styles) and the "*toilette*" of women (as many complex and changing styles).

3. Fortassier, *Les écrivains français et la mode*, Paris, 1988, p. 43. See also G. Froidevaux, *Baudelaire: représentation et modernité*, Paris, 1989, p. 66: "*Pour Balzac, la mode est le miroir des temps modernes...*".

4. For a discussion of Gautier's *De la Mode*, see A. Ribeiro, 'Concerning Fashion: Théophile Gautier's *De la Mode*', *Costume*, 1980, pp. 55–68.

5. H.-A. Taine, *The Ideal in Art*, London, 1870, p. 81.

6. *Journal des Modes*, June 1874, p. 5. In a journal for English-speaking visitors to Paris, an essay on the new importance attached to fashion declared that "dress is a work of art" (*The Boulevard*, April 1879, p. 17).

7. D. de Marly, *Worth: Father of Haute Couture*, New York, 1990, p. 117. Taine clearly disliked Worth and mocks his pretensions, putting the words in his mouth: "I am a great artist. I have Delacroix's sense of colour and I *compose* Art is God, and the bourgeoisie was made to take our orders" (De Marly 1990, pp. 116–17).

8. Quoted in C.S. Moffett (ed.), *The New Painting. Impressionism 1874–1886*, Oxford, 1986, pp. 43–44.

9. M. Simon, *Fashion in Art. The Second Empire and Impressionism*, London, 1995, p. 192.

10. C. Blanc, *Art in Ornament and Dress*, London, 1877, p. 149. Blanc's book was greeted with much acclaim in France, especially in the world of fashion. One writer hailed him as a "second Winckelmann" and claimed that his book had "elevated the science of feminine adornment to the rank of a real art"

(O. Uzanne, *Fashion in Paris*, London, 1898, p. 157). An English translation (1877) was not so well received; Mary Eliza Haweis disparaged the theme of Blanc's book as an obsession with fashion, claiming he demonstrated "the servility of a man-milliner" – referring to Worth (M.E. Haweis, *The Art of Beauty*, London, 1878, p. 19).

11. "*L'homme civilisé, au point de vue de l'habillement, n'est plus que l'accom-pagnateur de la femme; il la laisse chanter seule la symphonie du blanc, du rose, du vert*": *Guide sentimental de l'étranger dans Paris*, 1878, p. 83. Similar sentiments are expressed in other contemporary conduct manuals and etiquette books.

12. A. Mortier, *Les Soirées Parisiennes de 1875*, Paris, 1875, p. 416.

13. J. Mayne (ed.), *Art in Paris 1845–1862*, London, 1965, p. 118.

14. Given the importance of black, particularly for menswear, but for women's dress as well, such as mourning, the textile industry was keen to improve the quality of black dyes, which were prone to fade and often dyed clothes unevenly. In 1859 an aniline (chemical) black dye was invented (patented 1863) which helped to create longer-lasting and deeper black dyes.

15. Blanc 1877, p. 83.

16. *Journal des Modes*, February 1874, p. 11.

17. *La Mode illustrée*, 25 February 1877, p. 62: "*...la polonaise n'est autre chose qu'une robe princesse courte, portée sur une jupe*".

18. Blanc 1877, p. 34. A dress with the effect of the close lines of an engraving, a very fine black and white striped silk with black velvet trimming, c.1873–74, is in the Victoria and Albert Museum, T.8–1990.

19. *Journal des Modes*, July 1874, p. 6.

20. This corset was invented by Edwin Izod in 1868. The corset lining (impregnated with wet starch) was moulded on to a hollow metal form (different sizes were available), into which steam was fed; it was then allowed to dry and a permanent shape was achieved, "adapted with marvellous accuracy to every curve and undulation of the ... figure", according to an advertisement in the *Journal des Modes*, April 1874, p. 2.

21. Blanc 1877, p. 156.

22. *Journal des Modes*, December 1874, p. 5.

23. *Journal des Modes*, April 1875, p. 6.

24. Bertall 1874, pp. 54, 58.

25. Blanc 1877, p. 130.

26. For example, "*...le luxe effréné avait contribué à perdre la France* [unbridled

luxury was the downfall of France]":
A. Challamel, *Histoire de la mode en France*, Paris, 1875, p. 214.

27. A vigorous debate on the subject of luxury in France was prompted by a speech made in the Senate by the Procureur-général André Dupin (published as *Le Luxe des femmes*, 1865), in which he blamed the vogue for extravagance in dress on the influence of fashionable prostitutes who set styles which respectable women then followed. The actress heroine of Zola's novel *Nana* (set in the later 1860s) was the kind of sexually incontinent woman Dupin had in mind; the "beneficiary of male stupidity and lust She set the fashion, and great ladies imitated her": Emile Zola, *Nana*, trans. G. Holden, London, 1985, p. 311.

28. G.A. Sala, *Paris Herself Again in 1878–9*, 2 vols., London, 1880, II, p. 328.

29. See, for example, Henri Baudrillart, *Luxe et Travail*, Paris, 1866, a defence of the luxury trades.

30. On the equation of luxury with the French character, see Savigny 1867. See also Ernest Feydeau's *Du luxe des femmes* (1866), where the author argues that courtesans often have more grace and elegance in their clothing than respectable women, who can sometimes dress in a vulgar way.

31. T.J. Clark, *The Painting of Modern Life: Paris in the Art of Manet and His Followers*, New York, 1985, p. 46.

32. Broadly, *Bon Marché* and *Printemps* (1865) catered for the middle class, *Louvre* (1854) for the upper middle class, and *Samaritaine* (1869) for the working class.

33. F. Adolphus, *Some Memories of Paris*, London, 1895, pp. 189, 195.

34. "...les toilettes féminines devinrent extrêmement compliquées [...] et les garnitures de robes furent vraiment ruineuses": Challamel 1875, p. 218.

35. The sewing machine was first patented in France in 1829 by Barthélemy Thimmonier, and developed by other inventors, notably the American Isaac Singer, in the mid-nineteenth century.

36. "...la robe princesse, qui donne aux femmes cette ligne sinueuse si jolie": A. Vollard, *En écoutant Cézanne, Degas, Renoir*, Paris, 1938, p. 181.

37. P. Perrot, *Fashioning the Bourgeoisie. A History of Clothing in the Nineteenth Century*, New Jersey, 1994, p. 8.

38. See, for example, the *Almanach de savoir-vivre. Petit code de la bonne compagnie* by the comtesse de Bassanville, Paris, 1877.

39. Quoted in M. Thesander, *The Feminine Ideal*, London, 1997, p. 364. The word 'chic', referred to by Baudelaire in a disparaging way in his discussion of the Salon of 1846, had by the 1860s become a term of approval à propos fashion.

40. Thesander 1997, p. 76.

41. A. Kleinert, '"La Dernière Mode"; une tentative de Mallarmé dans la presse Féminine', *Lendemains*, nos. 17/18, June 1980, p. 175.

42. P.N. Furbank and A. Cain, *Mallarmé on Fashion*, Oxford, 2004, p. 25.

43. "...la Mode n'est peuplé que d'objets": J.-P. Lecercle, *Mallarmé et la Mode*, Paris, 1989, p. 128. Also the subscribers probably thought there was insufficient factual information about dress and too much in the way of poetic description.

44. "Les théâtres sont la grande, la première attraction parisienne": *Guide sentimental de l'étranger dans Paris*, 1878, p. 144. Similar sentiments are expressed in English guidebooks, such as *A Handbook for Visitors to Paris*, London 1874.

45. H.-A. Taine, *Notes on Paris*, New York, 1875, p. 9.

46. "Un lieu privilégié dans lequel le spectacle urbain se replie dans l'espace du théâtre (C. Naugrette-Christophe, *Paris sous le Second Empire, le théatre et la ville*, Paris, 1998, p. 165). The author (p. 207) makes a link between theatres and department stores, in terms of their design (especially their grand staircases), their luxury and decoration; both were key sites of feminine display.

47. V. Steele, *Paris Fashion. A Cultural History*, Oxford, 1988, p. 154.

48. Bertall 1874, p. 2; the words he uses for dress – "l'extérieur, l'apparence, le décor" (p. 139) – are equally applicable to the theatre. The point can also be made that dress is theatrical in itself: "vêtement et parure sont toujours ...un costume de théâtre, un déguisement, un rôle" (Fortassier 1988, p. 19).

49. See L. Nochlin, 'Impressionist Portraits and the Construction of Modern Identity', in C. Bailey (ed.) *Renoir's Portraits. Impressions of an Age*, 1997, p. 64.

50. Black was also worn by women in fashionable life, but the plainness of the sitter's dress and hat suggests second mourning.

51. Blanc 1877, p. 195.

52. Simon 1995, p. 201.

53. *Ibid.*, p. 227.

54. Jean Renoir, *My Father*, London, 1962, p. 83.

55. R.E. Iskin, *Modern Women and Parisian Consumer Culture in Impressionist Painting*, Cambridge, 2007, p. 198.

56. Simon 1995, p. 189.

57. Vollard 1938, p. 199. With regard to Nini, Renoir liked her beauty and her charming docility (Vollard 1938, p. 181).

58. For a discussion of the Ingres portrait, see A. Ribeiro, *Ingres in Fashion. Representations of Dress and Appearance in Ingres's Images of Women*, New Haven and London, 1999, pp. 129–37.

59. F. Adolphus, *Some Memories of Paris*, London, 1895, p. 190.

60. *Ibid.*, p. 185.

61. *Ibid.*, p. 299.

62. Sontag's essay *Against Interpretation* (1964) is discussed in my article, 'Re-fashioning Art: Some Visual Approaches to the Study of the History of Dress', *Fashion Theory*, no. 4, December 1998.

63. "L'esprit d'une femme se devine par sa toilette": Comtesse Dash, *Comment on fait son chemin dans le monde. Code du savoir-vivre*, 1869, p. 75.

64. As quoted in Steven Kern *et al.*, *A Passion for Renoir*, Williamstown 1996, p. 32.

65. J. Harvey, 'Showing and Hiding: Equivocation in the Relations of Body and Dress', *Fashion Theory*, vol. 11, no. 1, March 2007, p. 71.

66. As quoted in Kern 1996, p. 102.

67. A. Ribeiro, 'Théophile Gautier's *De la Mode*', in *Costume*, 1990, pp. 55–68, at p. 63.

68. 'Rice' powder was made from mineral substances such as bismuth, zinc oxide, carbonate of magnesium, talc, alabaster etc.: it was "vraiment reine dans l'arsenal de la coquetterie féminine", according to E. Monin, *L'Hygiène de la Beauté*, 1886, p. 80.

69. Harvey 2007, p. 79.

70. M. Carter, *Fashion Classics from Carlyle to Barthes*, Oxford, 2003, pp. 46–48.

71. S. Sontag (intr.) *A Barthes Reader*, London, 1982, p. XXVI.

72. Moffett 1986, p. 45.

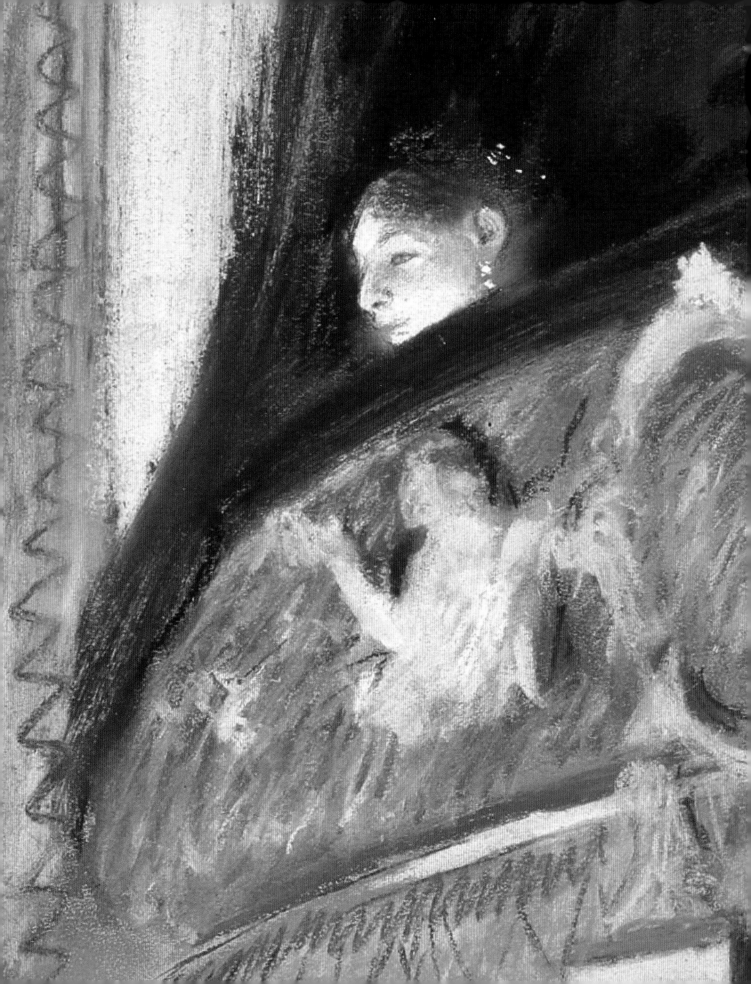

Catalogue

John House (JH)

Ernst Vegelin van Claerbergen (EVvC)

Barnaby Wright (BW)

I

Honoré Daumier
(1808–1879)

La Loge
(The Theatre Box)

c.1854–56
Oil on panel
24.1 × 30.7 cm
The Walters Art Museum, Baltimore

Fig. 33 Honoré Daumier, *'Croquis Parisiens'* (Parisian Sketches), lithograph from *Le Charivari*, 31 July 1856

Honoré Daumier's fame as the pre-eminent French caricaturist of the mid-nineteenth century was established in the pages of satirical illustrated journals such as *Le Charivari*. Alongside his prolific output of satirical prints, Daumier also produced oils and watercolours, usually for a private clientele rather than for exhibition. This little panel painting is typical of Daumier's interest, during the later 1850s and 1860s, in small, intimate scenes of modern urban life, often depicting subjects similar to those of his satirical illustrations. The social spectacle of the Parisian theatre was a favourite theme for Daumier's caricatures and in this painting he focuses specifically upon the occupants of a *loge*, as he did in a number of prints (see for example cat. 23). As one of the few French paintings of a theatre box before Pierre-Auguste Renoir and Eva Gonzalés took up the subject in 1874, Daumier's *La Loge* anticipates Impressionist treatments of the theme, most especially Renoir's two small canvases of c.1875 (cat. 6, 7).

In *La Loge*, Daumier uses the small scale of the panel to emphasise the compressed atmosphere of the crowded box. It was common practice for *loges* to be filled up if the principal occupant had not paid for its exclusive use. The suggestion here may be that the box of this proud-looking gentleman and his family, seated in the front, has been invaded by a number of strangers, who are all straining to get a good view of the stage from the back row. The appearance of the smart but plainly dressed occupants might suggest this to be a box at one of the cheaper and less fashionable establishments and the sitters to be respectable members of the petit-bourgeoisie. However, the location of the theatre is uncertain and the social status of the sitters left for the viewer to identify. Daumier's depiction of the figures deeply absorbed in the theatrical production conveys a sense of dignity, with the distracted young boy on the right-hand side acting as a gently humorous foil. The painting stands in stark contrast to the numerous caricatures which dealt more mockingly with the subject of the over-crowded loge (see for example cat. 30, 33), including by Daumier himself. In a lithograph for *Le Charivari* he used a similar composition as for this panel but filled the *loge* to bursting with grotesquely rendered leering figures (fig. 33). In the text Daumier highlights the difficulty of identifying the type of theatre audience he depicts, his joke being that it could be the high-end Opéra or the less prestigious Théâtre l'Ambigu; in either case his figures are said to be scrutinising the auditorium rather than the stage. The notion of the theatre box as space where social hierarchies could be confused or misunderstood would become a familiar trope of caricature over the following decades, as well as being a trait of the *loge* paintings of Renoir and his contemporaries. BW

2, 3, 4

Constantin Guys
(1805–1892)

A l'Opéra
(At the Opera)

c.1860
Pen and brown ink,
brown wash and watercolour on paper
20 × 15 cm
Private collection

Deux couples dans une loge
(Two Couples in a Theatre Box)

c.1860
Pen and ink and watercolour on paper
17 × 25 cm
Musée Carnavalet, Paris

La Loge
(The Theatre Box)

c.1860
13 × 22 cm
Pen and ink and watercolour on paper
Musée Carnavalet, Paris

These three watercolours are archetypal examples of Constantin Guys's numerous sketches of Second Empire Parisian society, for which he was immortalised as 'the painter of modern life' by the influential poet and critic Charles Baudelaire in his celebrated essay of 1863. Here, Guys offers different characterisations of fashionable occupants of *loges*. Guys's pen-and-wash technique conveys a sense of immediacy, as if sketched rapidly from life to capture fleeting moments observed in the theatre (even though Guys is not generally believed to have worked from life). However, they also monumentalise the social pretensions of their subjects in a mode that carries a satirical charge. In all three works the act of looking and being observed is the central concern. In *Deux couples dans une loge* the women self-consciously display themselves on armchairs at the front of the *loge*, whilst their male companions look elsewhere, one training his comically oversized opera glasses on the stage or perhaps towards another box. By contrast, *La Loge* has a woman looking assertively through her large *lorgnette*. Her female companion toys with her fan and looks for the attentions of an admirer, her ample bosom and low-cut dress seemingly her most alluring feature. The woman in *A l'Opéra* is more demure but here again Guys plays with her deliberately staged bid to attract admirers. Peering out of the edge of the *loge* she takes on the form of a sculpted torso on a pedestal and is artfully paired with the bouquet of flowers on the balustrade above a group of smartly dressed men, who are apparently unaware of her presence. Guys shared the satirical conceit of conflating a woman in a *loge* with a sculpture on a pedestal with the illustrator Grandville, whose plate for his book *Un Autre Monde* (fig. 1, p. 11) makes a comparable play on the theme.

Guys's three *loge* scenes mock the vanity and vulgarity of these fashionable theatre-goers to the extent that contemporary viewers may well have questioned whether these women were in fact courtesans rather than members of elegant society. For Baudelaire, Guys's depictions of women in theatre boxes are portraits of a world obsessed by surface appearance:

"At one moment, bathed in the diffused brightness of an auditorium, it is young women of the most fashionable society, receiving and reflecting the light with their eyes, their jewellery and their snowy white shoulders, as glorious as portraits framed in their boxes. Some are grave and serious, others blonde and brainless. Some flaunt precocious bosoms with an aristocratic unconcern…their gaze is vacant or set; they are as solemn and stagey as the play or opera that they are pretending to follow."[1] BW

1 Charles Baudelaire, 'The Painter of Modern Life' (1863), translated and republished in Jonathan Mayne (ed.), *The Painter of Modern Life and other Essays*, London, 1964

Cat. 2

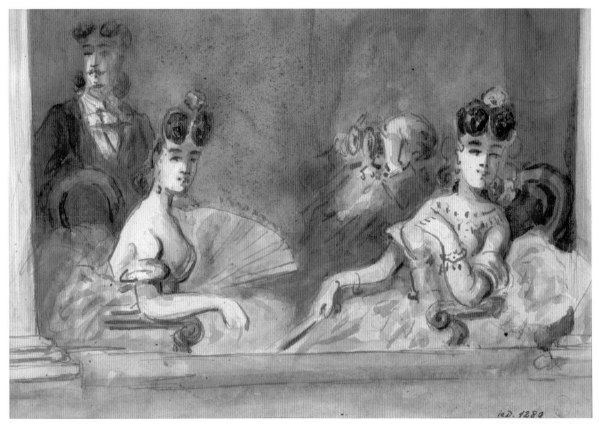

Cat. 3

Cat. 4

5

Pierre-Auguste Renoir

(1841–1919)

La Loge
(The Theatre Box)

1874
Oil on canvas
80 × 63.5 cm
The Courtauld Gallery, London

Probably Renoir's first depiction of a theatre box (see cat. 6, 7), *La Loge* attracted extensive commentary when it was included in the first Impressionist group exhibition in 1874. Its image of a young woman in an extravagant gown seated in a theatre box, while her male companion scrutinises the upper balcony of the theatre through his binoculars, was novel in the context of fine art, although *loge* settings had been used extensively in fashion plates and as the subject of caricature prints in popular journals. Critics could not agree upon the identity of the sitters: some saw the canvas as a representation of a woman of high fashion, some as an iconic image of a figure from the *demi-monde*. An alternative title, *L'Avant-scène*, invited the setting to be read as one of the most fashionable *loges* in the theatre (see essay by John House). In reality Renoir produced the painting in his studio using his brother Edmond and Nini, a model from Montmartre nicknamed '*gueule de raie*' or 'fish-face', as the sitters.

La Loge gained wide admiration for the virtuosity of its execution. The painting is a remarkable synthesis of tonal and colouristic painting. The model's gown, with its bold stripes, gives the composition a strong black and white underpinning and focuses the eye on the figure; actual black paint is used here, though often mixed with blue to suggest the play of light and shade across it. Around its strong tonal pattern, varied nuances of blue, green and yellow recur in the white materials, set against the soft warm hues of her flesh and the pinks and reds in the flowers on

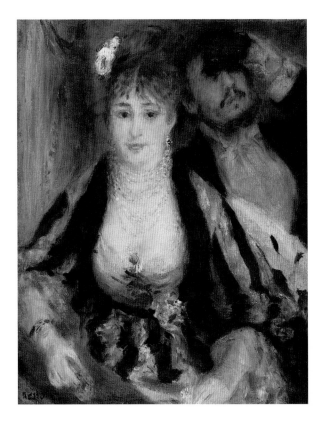

Fig. 34
Pierre-Auguste Renoir
La Loge (The Theatre Box)
c.1874, oil on canvas,
27.3 × 21.9 cm
Private collection

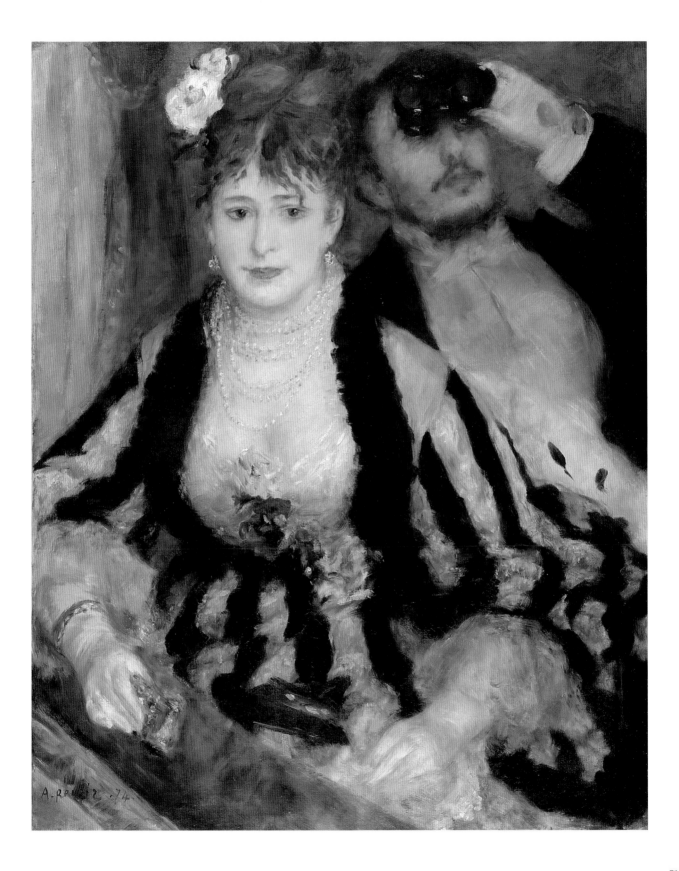

Fig. 35 X-radiograph of cat. 5
The Courtauld Gallery,
London

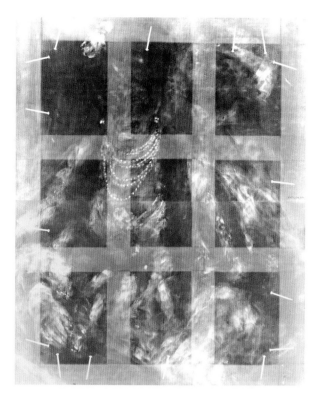

her bodice and hair. The paint handling is very varied and fluent; forms are delicately and softly brushed without crisp contours, and the execution of the model's bodice and the flowers on it is a particularly virtuoso display. The ermine stole, draped over the back of the woman's chair, is treated very summarily, but it acts as a crucial punctuation point between her figure and that of her male companion. Her face, though, is executed more minutely, its modelling more fully suggested; the viewer's eye fluctuates between bodice and face in search for the principal focus of the composition. Renoir seems to have made only minimal alterations to the canvas during its execution. The X-ray suggests that he may originally have given the female model a hat, and there are some minor changes to the position of the man's arm (fig. 35). In 1875 Renoir sold at auction a small canvas of the same composition, which seems to be a second version rather than a preliminary study (fig. 34).

Renoir deposited the canvas in 1874 with the dealer Paul Durand-Ruel, who included it in an exhibition of the Society of French Artists in London that winter; no British reviews that specifically discuss the canvas have so far been traced. Durand-Ruel did not buy the painting, and Renoir sold it, in 1875 or 1876, to the back-street dealer *père* Martin for 425 francs, although he had set its price at 2500 francs at the 1874 exhibition. Durand-Ruel bought it from the collector Louis Flornoy in 1899, and sold it, through the intermediary of Percy Moore Turner, to Samuel Courtauld in 1925, for £22,600, the price that Courtauld also paid for Manet's *A Bar at the Folies-Bergère*, and the highest prices that he ever paid for works in his collection. JH

6, 7

Pierre-Auguste Renoir
(1841–1919)

Dans la loge
(In the Theatre Box)

c.1875
Oil on canvas
27 × 22 cm
Private collection

La Loge
or *La Petite Loge*
(The Theatre Box;
The Little Theatre Box)

c.1875
27 × 20.7 cm
Oil on canvas
Museum Langmatt
(Stiftung Sidney und Jenny Brown), Baden

Throughout his career, Renoir on occasion worked on very small canvases. In some cases, these were rough, informal notations, but in others, such as the present two canvases, they are treated with quite as much care and finesse as his most ambitious paintings. The contrasts of scale between his largest and smallest works are one of the many signs of the remarkable diversity of his work; even in the mid-1870s, in the years of his participation in the Impressionist group exhibitions, there are extreme variations in his work – in handling, treatment, colour and subject-matter, as well as scale.

The two small theatre-box canvases are elaborately finished, but treated very differently from the Courtauld Gallery's *La Loge* (cat. 5). Their surfaces are animated throughout by small, fine strokes that give the entire surface a lively, almost flickering quality. Delicate, distinct touches can also be seen on the figures' faces – again, quite unlike *La Loge*. Though dating Renoir's work of the 1870s on stylistic grounds is notoriously difficult, he did not, as far as can be seen, adopt this fragmented touch before the summer of 1874; thus these two canvases seem very likely to postdate *La Loge*, rather than being, as has been suggested, his first attempts at the subject. Moreover, the two canvases are more variegated in colour than *La Loge*; their surfaces are articulated throughout in terms of colour relationships, in contrast to *La Loge*'s play on interrelationships between tonal contrast and colour nuances.

Rather than being placed in front of a grand theatre box, as in *La Loge*, here we are given oblique views on to more modest partitioned boxes, which typically lined the balcony levels of Paris's theatres. Equally the couples are not wearing flamboyant evening toilette but are unassumingly attired in what appears to be day dress. Whereas many representations of the *loge* play with themes of conspicuous display and observation, these couples appear engrossed in the performance and their relationship is treated as intimate and harmonious. This effect is heightened in *Dans la loge* by the depiction of the man leaning forward with his arm around the woman's shoulders.

Small, carefully realised canvases such as these must have been intended for sale to private collectors. The first traced owner of cat. 6 was Edouard Lainé, a friend of Degas and the director of a brass foundry; though it has been suggested that Lainé was the model for the male figure here, he bears no resemblance to Lainé as represented in a portrait by Degas (Musée d'Orsay, Paris). The first traced owner of cat. 7, for which the same two figures seem to have acted as models, was Dr Georges Viau, a dentist; it appeared in the auction sale of his collection in 1907. JH

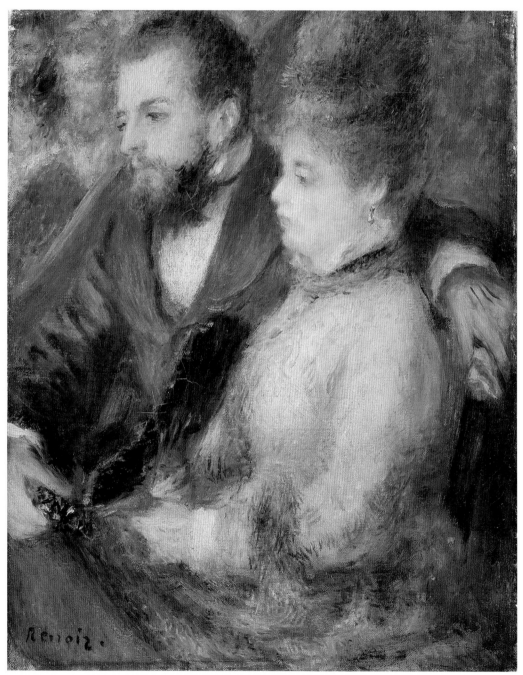

Cat. 6

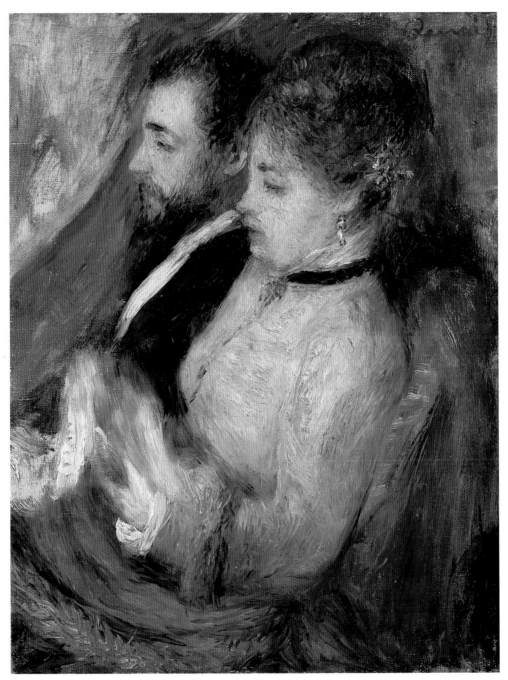

Cat. 7

8

Pierre-Auguste Renoir
(1841–1919)

Café-concert
or *Au théâtre*
(At the Theatre)

1876–77
Oil on canvas
65 × 49.5 cm
The National Gallery, London

Fig. 36 X-radiograph of cat. 8
The National Gallery, London

Fig. 37 Infra-red photograph of cat. 8
The National Gallery, London

At its first public appearance, in an auction sale in 1899, this canvas was titled *Café-concert*, but it remains uncertain whether what is depicted is the more informal environment of a *café-concert* or a conventional theatre, as in the alternative title, *Au théâtre* (see essay by John House). In its original form, the canvas did not include the present background, but showed two further large figures to the left, beyond the two young women, as is revealed in the X-ray and infra-red photographs (figs. 36, 37). The title *La Première Sortie* (The First Outing), by which it was known for many years, was not Renoir's; it was given to the canvas when it was exhibited in London in 1923.

The viewer is seemingly placed in the same box as the two women in the foreground, but no contact is set up between them and us. The young woman leans forward expectantly towards the edge of her *loge* and Renoir sets her profile off against the press of the audience beyond. Amidst the blurred mass of the figures only the face of a man comes into some sense of focus, apparently looking up towards her. Although the overall associations of the scene are of innocence and naivety (as registered in its later title), Renoir's arrangement of the figures prevents us from reading the woman's expression and frustrates a definitive interpretation of the painting in these terms.

In comparison with the two small *loge* canvases (cat. 6, 7), *Café-concert* (*Au théâtre*) is still more thoroughly conceived in terms of colour rather than conventional modelling or tonal contrasts. The whole canvas is suffused with a blue tonality, focused on the dress and hat of the foreground figure, but repeated throughout the canvas. This is set against sequences of warm tones – touches of yellow, pink and red – to create a composition that can be viewed in terms of contrasts of colour. Throughout, the brushwork is lively and fluid; the background figures are very informally sketched, with one form blurring into the next, and even the faces of the two women in the foreground are not presented in sharp focus. Despite the scale of these two figures, the viewer's eye moves across the entire canvas from one accent to the next without finding any one unequivocal point of focus.

The canvas was bought for the National Gallery, London, in 1924, with funds given to the Gallery by Samuel Courtauld for the purchase of modern French paintings for the British nation; a year later, he bought *La Loge* (cat. 5) for his private collection. JH

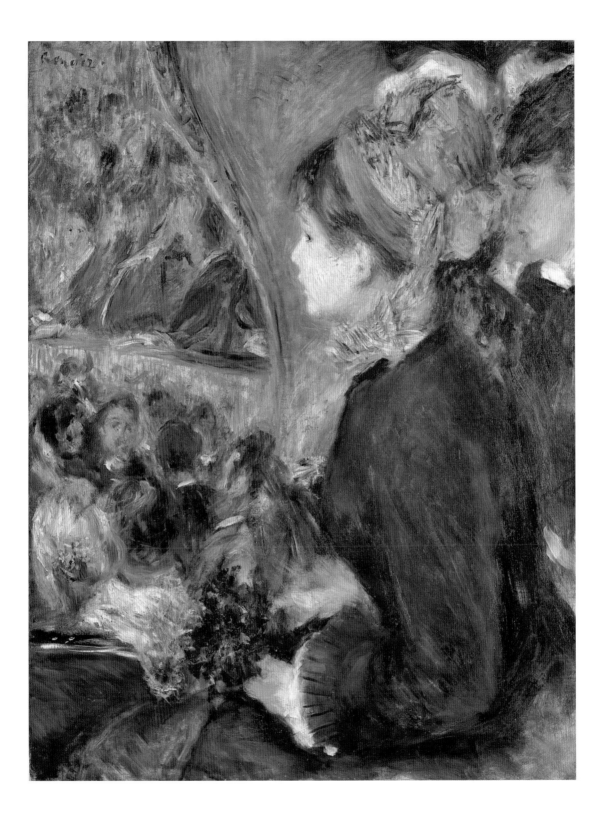

9

Mary Stevenson Cassatt
(1844–1926)

At the Français, a Sketch
or *In the Loge*

c.1877–78
Oil on canvas
81 × 66 cm
Museum of Fine Arts, Boston

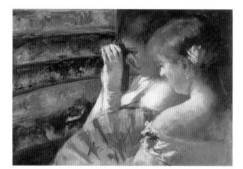

Fig. 38 Mary Stevenson Cassatt
A Corner of a Loge, 1879
Oil on canvas, 43 × 61 cm
Private collection

1. Ruth Iskin, 'Was There a New Woman in Impressionist Painting?', in Sidsel Maria Søndergaard (ed.), *Women in Impressionism, from Mythical Feminine to Modern Woman*, exh. cat., Ny Carlsberg Glyptothek, Copenhagen, 2006–07.

This was Mary Cassatt's first major painting of a *loge* and it marked the beginning of her sustained interest in the subject. Over the next few years she produced three more important *loge* canvases (see for example cat. 10 and fig. 3, p. 13), and explored the possibilities of the motif further in a significant group of pastels and an experimental series of lithographs. Cassatt's commitment to the *loge* as a subject for modern art perhaps even exceeded that of Renoir, whose earlier theatre-box paintings are likely to have been an initial inspiration for her own approach to the theme. However, whereas Renoir's *La Loge* and *Café-concert* (cat. 5, 8) enshrine conventional gender stereotypes, with the women figured as passive objects of desire for male consumption, Cassatt's image of a woman apparently alone in her *loge*, assertively looking through her opera glasses, disrupts these gender roles. In fact, Cassatt's elegantly dressed woman in black is able to play both roles: as she trains her *lorgnette* towards either the stage or another area of the theatre, she is in turn scrutinised by a man in an adjacent *loge* who leans forward and across his female companion to get a better view. Cassatt was the only artist of the Impressionist circle to depict women at the theatre actually looking through their opera glasses, rather than having them by their side as a fashionable accessory (see fig. 38). Contemporary etiquette guides warned women that such a bold use of their *lorgnettes* was unbecoming and unfeminine. Yet in Cassatt's image the respectability of the woman is beyond reproach and the directness of her gaze is made less confrontational to the viewer by the profile pose she adopts. As Ruth Iskin has argued, Cassatt was able to present "a refined bourgeois woman actively looking in a public space of entertainment without transgressing etiquette".[1] It was not uncommon for women to take *loges* unaccompanied, especially for matinée performances, for which this woman appears to be attired in high-necked day clothes (possibly mourning costume) rather than lower-cut evening dress. However, the final twist in Cassatt's game of gazes is that the viewer of the picture is positioned in the *loge*, implicitly figured as the woman's male or female theatre companion.

Cassatt painted *At the Français* during an important period in her career when, through her friendship with Degas, she was becoming closely involved with the Impressionists and was invited to exhibit with them (an offer she was able to take up in 1879). Both in terms of subject-matter and in technique, this painting demonstrates Cassatt's embrace of an Impressionist mode of representation. She skilfully captures in sketchy brushstrokes the flickering play of light across the balcony's gilt façade, rendering the occupants of other *loges* in a few swift dabs of the brush. Cassatt reserves more solidly modelled features for her principal subject, who emerges from the shadows of her *loge* and is silhouetted against the bright lights of the auditorium. Although it has been known by a variety of different titles, when Cassatt first exhibited the canvas in Boston in 1878 she called it *At the Français, a Sketch*, perhaps wishing to underscore to her American audience the work's sense of spontaneity and direct expression as well as its exotically foreign locality at one of Paris's premier theatres. BW

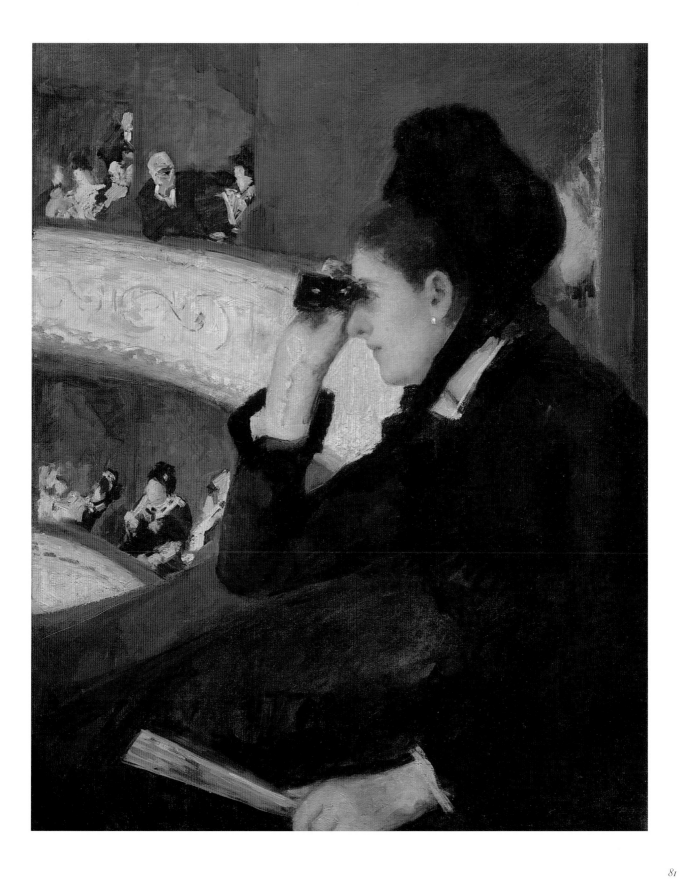

IO

Mary Stevenson Cassatt
(1844–1926)

Femme dans une loge
(Woman in a Theatre Box)
or *Woman with
a Pearl Necklace in a Loge*

1879
Oil on canvas
81.3 × 59.7 cm
Philadelphia Museum of Art

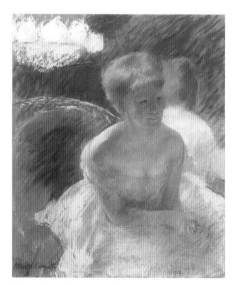

Fig. 39 Mary Stevenson Cassatt
Au théâtre (At the Theatre) or
Lydia seated in a Loge, c.1879
Pastel on paper, 55 × 45.1 cm
The Nelson Atkins Museum of Art, Kansas City

1. Translated and cited in Charles S. Moffett
(ed.), *The New Painting: Impressionism
1874–1886*, exh. cat., The Fine Arts
Museums of San Francisco, 1986, p. 276.

Femme dans une loge was one of the principal paintings Mary Cassatt submitted to the 1879 Impressionist exhibition, at the invitation of Edgar Degas, which marked her public debut with the group. The painting of a fashionably attired woman in a low-cut evening dress at the theatre attracted considerable attention in the press and garnered largely positive reviews. Ernest d'Hervilly, writing in *Le Rappel*, noted that "the work by this bold painter that has most impressed visitors is of a young red-headed woman in a theatre box, the back wall of which is a mirror reflecting the brilliantly lit theatre. This work suggests the flesh has been modelled by reflection, clearly revealing a very individual talent." One of the few critics to dissent from this view was Renoir's brother Edmond (who modelled for *La Loge*; cat. 5), who thought the painting too hesitant and suggested that "the complication of the mirror effect has no point".[1] He also disliked the painted green frame in which Cassatt exhibited the canvas. However, most critics recognised that the illuminated brilliance and opulence of the theatre's lavish interior was a perfect subject for Cassatt to express with full confidence her Impressionist technique. Pointless or not, the mirrored backdrop offered a further demonstration of her virtuosity as a modern painter. Critics could also be in no doubt of her commitment to the *loge* as a subject, for she exhibited a number of other depictions of women in theatre boxes at the 1879 show. Perhaps noting the success of this painting, she contributed a related pastel of the same model in a *loge* to the 1880 exhibition (fig. 39).

In this painting Cassatt uses the *loge* setting to depict a seemingly very different type of modern woman from that of her earlier, *At the Français, a Sketch* (cat. 9). Rather than actively looking, the woman here is clearly an object of desire; her fan lowered to reveal a fashionable and elegant vision of modern female beauty. Although unusual in painting at this time, images of 'glamorous' women showcasing themselves in *loges* were a favourite theme of contemporary caricature. However, whereas satirists mocked their often over-dressed or grossly made-up subjects as vulgar and vain (see especially cat. 34), Cassatt's woman is neither. Instead, Cassatt uses the space of the *loge* to present an ideal image of a modern woman who is confident in her appearance and whose attire and make-up complement her effortlessly. Indeed, she commands the space of the theatre as completely and self-assuredly as the woman in *At the Français* (cat. 9), and her relaxed, informal pose is far from brazen.

It is tempting to draw parallels between Cassatt's images of modern women at the theatre and her own life as a relatively wealthy American in Paris and a regular visitor to the city's fashionable entertainments. Some contemporary critics thought the sitter of this painting was certainly a foreigner and later she was identified as Cassatt's sister, Lydia – a claim now usually rejected. Whether or not they are drawn in part from her personal experiences of Parisian life, the importance of Cassatt's *loges* lies in their use of the theatre box as space in which modern bourgeois femininity could be celebrated through a new language of painting. BW

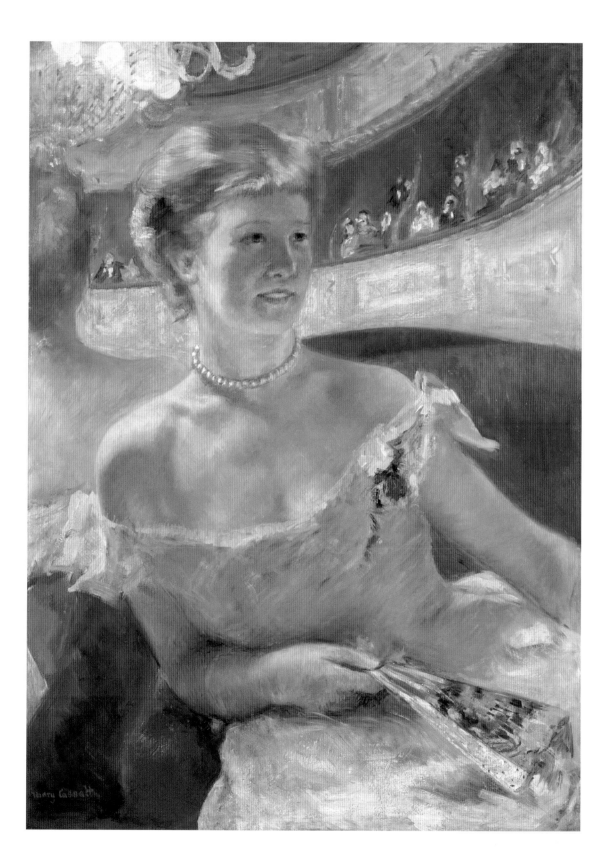

11

Pierre-Auguste Renoir
(1841–1919)

Une loge au théâtre
(A Box at the Theatre)
or *A Box at the Opera*

1880
Oil on canvas
99 × 80 cm
Sterling and Francine Clark Art Institute,
Williamstown

Fig. 40 X-radiograph of cat. 11,
Sterling and Francine Clark
Art Institute, Williamstown

Fig. 41 Infra-red photograph of
cat. 11 (detail)
Sterling and Francine Clark
Art Institute, Williamstown

Une loge au théâtre seems to have originated as a portrait of Edmond Turquet, the Under-Secretary of State for Fine Arts, and his wife. Clear traces of a man's head, seen in profile, can be made out beneath the red paint layers in the upper right corner of the picture, and his highly resolved figure is more fully revealed in the X-ray and infra-red photographs (figs. 40, 41). It is likely that it was transformed into the present genre painting of two young women in a theatre box after it was rejected by Turquet. The dealer Durand-Ruel bought it in November 1880 and registered it with the title *Une loge au théâtre*; although it was exhibited in 1882 with the title *Une loge à l'Opéra*, the background details in no way resemble the recently completed décor of the Paris Opéra.

The canvas is far more muted and conventional in tonality than *Café-concert (Au théâtre)* (cat. 8). Clear, light blues are largely confined to the areas of white across the foreground, and the remainder of the canvas is dominated by blacks, reds and browns. Strong tonal contrasts also give it a clear articulation that *Café-concert (Au théâtre)* lacks. The oppositions between the dark hues of the woman's dress and the girl's hair and the light zones are very emphatic, although soft coloured nuances appear in the dress and especially in the long swathe of hair that frames the right side of the composition, which is enlivened by muted blues and purples. Soft colour-modulations are introduced into the flesh painting, but far less assertively than in Renoir's recent work of the time, in terms of either hue or touch. The comparative finesse of the treatment of the faces and the woman's dress can be contrasted with the broadly brushed area across the foreground. Here, the boundaries between the music score, the girl's dress and the wrapping of the bouquet are quite unclear.

In contrast to *La Loge* (cat. 5) and the two small *loge* canvases (cat. 6, 7), the viewer is here placed in the same space as the two figures, rather than looking into their box from outside; however, there is no clear relationship between the women, and the position of the viewer within the space of the box remains uncertain. One might interpret the pair as a mother and her daughter, posed in a luxurious *loge*, although no definite relationship is established. The circumstances of the painting's production have resulted in an image that is neither fully a genre painting nor a portrait. The canvas bears some comparison to depictions of the *loge* in fashion plates of the period (see for example cat. 20, 21), in which men were largely superfluous. This relationship is most apparent in the carefully posed arrangement of the two women, which draws particular attention to their clothes and coiffures, but it is evident also in the lack of interaction between the figures as well as in such details as the printed score. Like the aspirational images presented in fashion journals, Renoir's painting can be read as an expression of elegant bourgeois society. JH

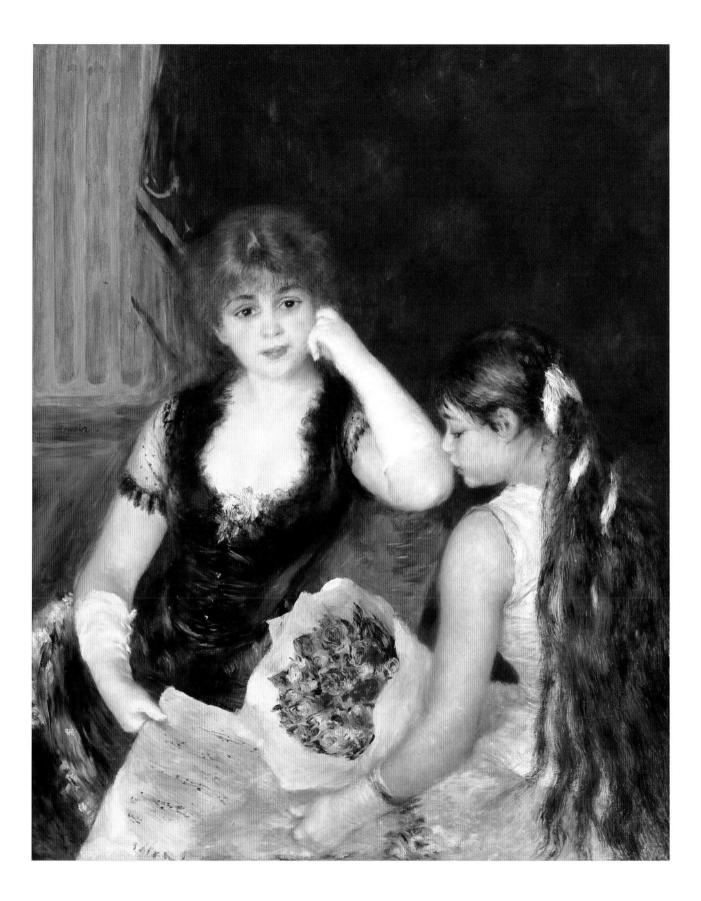

12

Edgar Degas
(1834–1917)

Étude de loge au théâtre
(Study of a Box at the Theatre)
or *La Loge*
(The Theatre Box)

1880
Pastel on paper laid on board
66 × 53 cm
Private collection

Fig. 42 Henri de Toulouse-Lautrec
La loge au mascaron doré
(The Theatre Box with the Gilded Mask), 1893
Lithograph, 37.2 × 32.7 cm

This startlingly original pastel was shown as *Étude de loge au théâtre* in the fifth Impressionist exhibition, held in April 1880 at 10 rue des Pyramides.[1] Although the exhibition was not a critical success Degas drew positive commentary, and *Étude de loge au théâtre* was singled out for praise in several reviews. Charles Ephrussi's comments on the work's "unexpected and curious effects" seem particularly apposite.[2]

Despite such early paintings as *The Ballet from 'Robert le Diable'* (Metropolitan Museum of Art, New York) of 1871–72, in which the play of gazes is presented as integral to the experience of the theatre, and a broader œuvre in which the *loge* is often implicit as the vantage point for different views on to the stage, the present pastel is unique in Degas's work in taking the *loge* itself as the primary subject. Even compared to the treatment of the *loge* by other progressive artists in the 1870s and early 1880s, its radical composition and unsettling character stand alone.

With his dramatically steep perspective, bold cropping and blurred effects Degas here aims to replicate for the viewer a momentary experience in the theatre. The critic Armand Silvestre assumed that the view was of a first-floor *avant-scène loge*, the most prestigious and expensive space in the theatre.[3] The sole visible occupant of this opulent *loge* is caught in the powerful light that also plays across the richly gilded decoration. The viewer is left to speculate who may be concealed in the recesses of the box. Adorned with a sparkling head-dress and ear-rings, the woman's head is radically truncated by the front rail of the *loge*, further heightening the artificial effect created by the light reflecting off her whitened face and the smudges of colour at her lips and ear. Rather than chair-backs, the two slabs of pink in the space below may be the screens of the *baignoire loge* directly beneath the *avant-scène*. The emptiness of this box further emphasises the isolation of the lone woman, whose impassive presence seems central to the work. In his review for *L'Art Moderne* J.-K. Huysmans imagined her looking imperiously over the "yapping mutts below", the heat from the auditorium rising to her cheeks.[4] The critic Jules Claretie evoked something of the same quality in his article 'La Femme' published in *L'Art de la Mode* in 1881. The ideal woman was the Parisienne, glimpsed "like an apparition at the theatre or the ball"; "the woman who appears with a constellation of diamonds, in sparkling light, at the back of a *loge* or *avant-scène*".[5]

Degas would continue to explore the pictorial and thematic possibilities of the *loge* in the 1880s, producing a series of works, predominantly pastels, in which our view of the stage is framed by a female occupant of a *loge* with a fan and opera glasses. However, the radical perspective and powerful effects of light of *Étude de loge au théâtre* would not be revisited until more than a decade later, when Toulouse-Lautrec produced his lithograph *La loge au mascaron doré* (fig. 42). EVVC

1. For the dating and other aspects of this work, see Richard Kendall's extended entry in Christie's *Impressionist and Modern Art*, 4 May 2005, pp. 135–39.
2. Review transcribed in Ruth Berson, *The New Painting: Impressionism 1874–1886*, San Francisco and Seattle, 1996, vol. I, p. 278.
3. *Ibid.*, p. 306.
4. "*Les cabots qui jappent*"; *ibid.*, p. 291.
5. Jules Claretie, 'La Femme', *L'Art de la Mode*, May 1881, p. 90. "*C'est la femme qui apparaît, constellée des diamants, dans un scintillement lumineux, au fond d'une loge ou d'une avant-scène.*"

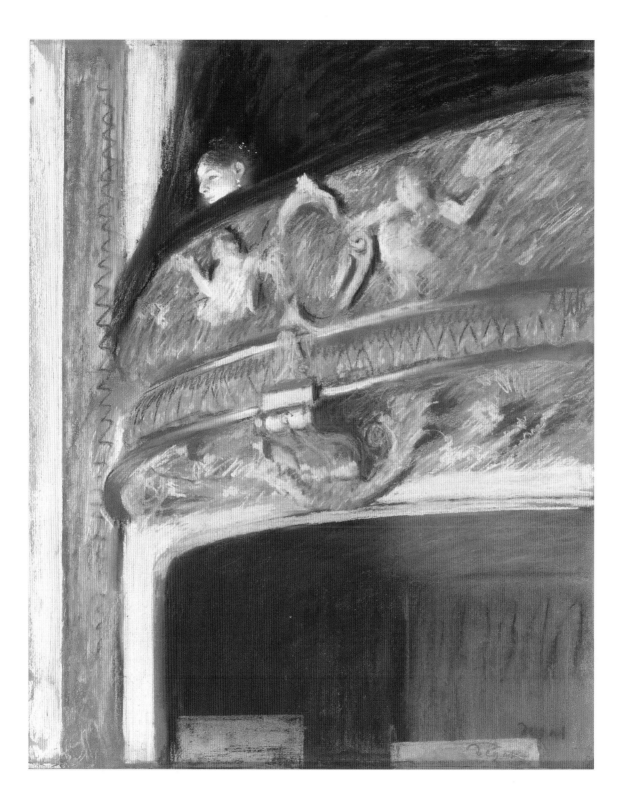

13

Jean-Louis Forain
(1852–1931)

La Loge
(The Theatre Box)

*c.*1885
Oil on panel
44 × 37 cm
Musée Carnavalet, Paris

1 Diego Matelli, *Roma Artistica*, 27 June and
 5 July 1879, translated and cited in Charles S.
 Moffett (ed.), *The New Painting: Impressionism
 1874–1886*, exh. cat., The Fine Arts Museums
 of San Francisco, 1986, p. 282.

Although a lesser-known figure of the Impressionist circle, Jean-Louis Forain showed work at four of the Impressionist group exhibitions between 1879 and 1886. His friendship with Edgar Degas helped to galvanize his interest in the theatre and *café-concert* as subjects of modern painting. Forain produced numerous images of Parisian audiences and performers at a range of different types of theatres. Many of these works are sketches in pencil and watercolour and often convey a sharp satirical edge, in the tradition of Honoré Daumier and Constantin Guys (see for example fig. 43). Indeed, Forain's career as an illustrator and caricaturist working for various Parisian journals was entwined with his ambitions as a painter, in ways that several critics found novel and distinctive. One reviewer of the 1879 Impressionist exhibition, where Forain exhibited a number of theatre subjects, suggested that he "follows Degas with one foot and the caricaturist Grévin with the other".[1]

In this painting of a woman in a *loge*, however, Forain's concerns are more closely aligned with the pictorial experiments and themes set up by Renoir's and Cassatt's *loge* paintings. The view of the woman dressed in black and rendered in profile is particularly reminiscent of Cassatt's *At the Français, a Sketch* (cat. 9). In common with that earlier painting, Forain's woman looks purposefully out of the theatre box. The assertiveness of her gaze is accentuated by her large, robust-looking binoculars, which are close at hand; not for her the dainty *lorgnette* of Renoir's model in *La Loge* (cat. 5). Forain also adopts the cropped framing of the *loge* scene which had become a hallmark of Impressionist treatments of the subject and was carried to a radical extreme in Degas's *loge* pastels (see cat. 12 and fig. 22, p. 41). By doing so Forain compresses the profile 'portrait' of the woman and the blurred throng of the audience into this one small canvas, effectively throwing her individuality into relief against the unknowable mass of the crowd. By the time Forain produced this work, the use of the *loge* as a space where the fascinating spectacle of Parisian society could be framed had been fully established within the Impressionist circle and claimed by them as a legitimate modern subject for fine art. BW

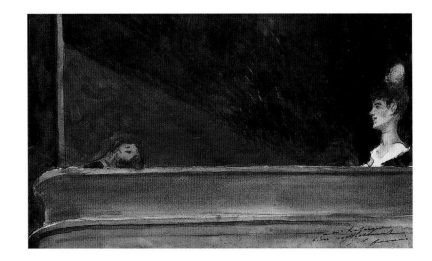

Fig. 43 Jean-Louis Forain
*La Loge, c.*1885
Watercolour on paper
15.7 × 26.7 cm
Whereabouts unknown

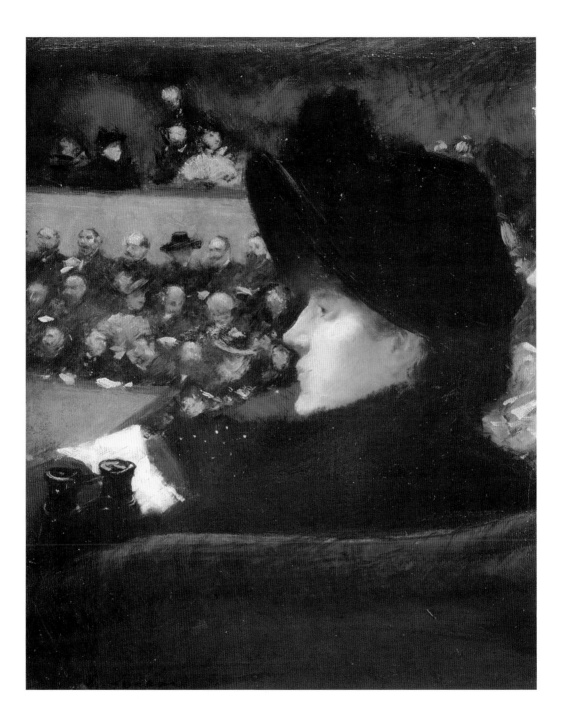

Nᵒ 48.

SEIZIÈME ANNÉE.

Dimanche 28 novembre 1875.

LA MODE ILLUSTRÉE

F. CATENACCI DEL. HUYOT.

JOURNAL DE LA FAMILLE.

Le numéro, vendu séparément.
25 centimes.
AVEC UNE PLANCHE DE PATRONS : 50 CENTIMES.

PARAISSANT CHAQUE DIMANCHE

Le numéro seul avec une gravure coloriée.
50 centimes.
AVEC UNE PLANCHE DE PATRONS : 75 CENTIMES.

CONTENANT LES DESSINS DE MODES LES PLUS ÉLÉGANTS ET DES MODÈLES DE TRAVAUX D'AIGUILLE, ETC. — BEAUX-ARTS — NOUVELLES — CHRONIQUES — LITTÉRATURE, ETC.

Toute demande non accompagnée d'un bon sur la poste ou d'un mandat à vue sur Paris, à l'ordre de **MM. Firmin-Didot et Cᵉ**, sera considérée comme non avenue.
— On s'abonne également chez tous les Libraires de France et de l'Étranger. (*Pour l'étranger le port en sus.*) — **LONDRES :** ASHER ET Cᵒ, 13, Bedford Street, Covent Garden, C. W. —

TOILETTES DE THÉÂTRE, MODÈLES DE CHEZ Mᵐᵉ FLADRY, RUE RICHER, 43.

Cat. 19

The *Loge* in Fashion Journals

ERNST VEGELIN VAN CLAERBERGEN

Nos. 14–22

14

Paul Gavarni
(Guillaume Sulpice Chevalier)

(1804–1866)

'Une loge à l'Opéra'

Lithograph from *La Mode*
5 February 1831
Private collection

15

E. Jacquel

(dates unknown)

'Belles de Jour – Belles de Nuit'

Lithograph, *c.*1850
47 × 39 cm
The Courtauld Gallery, London

16

Anaïs Toudouze

(1822–1899)

Untitled

Hand-coloured engraving
from *Le Conseiller des Dames et des
Demoiselles*, November 1856
The Courtauld Gallery, London

17

Emile Préval

(dates unknown)

'Toilettes de théâtre' and
'Toilettes de diner ou de soirée'

Engraving from *Journal des
Dames et des Demoiselles*
1 January 1871
The Courtauld Institute of Art, London

18

Artist unknown

'Veste sans manches'

Engraving
from *La Mode Illustrée*,
16 February 1873
The Courtauld Institute of Art, London

19

Artist unknown

'Toilettes de théâtre'

Engraving from *La Mode Illustrée*
28 November 1875
The Courtauld Institute of Art, London

20

Anaïs Toudouze

(1822–1899)

Untitled

Hand-coloured engraving
from *La Mode Illustrée*
26 January 1879
The Courtauld Gallery, London

21

Isabelle Desgrange

(1850–1907)

Untitled

Hand-coloured engraving
from *La Mode Illustrée*
2 March 1879
The Courtauld Gallery, London

22

Jules David

(1808–1892)

Untitled

Hand-coloured engraving
from *Le Moniteur de la Mode*, 1882
The Courtauld Gallery, London

THE IMPORTANCE OF THE THEATRE, and particularly the *loge*, as a primary space for the display of fashion was fully understood by those writing about the public sphere in the Third Republic. In his *Histoire de la Mode en France* of 1875 Augustin Challamel lamented the destruction by fire of the old Opéra on the rue Le Peletier; "One of the temples of fashion collapsed in a single night; the rich toilettes which could be seen in the amphitheatre and on the balconies of our principal lyric theatre have disappeared for a time….The toilette of the Opéra, rival of the toilette of the Italiens, waits until we rebuild its temple."[1] That temple was Charles Garnier's new opera house, and when it opened in 1875 it offered a grander stage for *la mode* than Paris had yet seen. Reviewing the opening night of the new opera in his *Les Soirées Parisiennes*, Arnold Mortier enacted for his readers the perfect *mondain* gaze. Scanning the social tableau offered by the great amphitheatre he named the occupants of all the main *loges*, giving an account of what the leaders of fashion were wearing, with certain toilettes described admiringly as *chefs-d'œuvres*.[2]

During the third quarter of the nineteenth century the fashion journal emerged as one of the principal agents in reinforcing and disseminating the social role of the theatre, and the *loge* in particular. Many of Paris's plentiful fashion journals had closed temporarily during the Siege and the Commune but by June 1871 they were re-engaging an audience which was gradually allowing itself to forget this period of deprivation and austerity. Challamel noted the change in mood and dress the following year: "It seemed as if *coquetterie* wanted to take its revenge on the years 1871 and 1872".[3] Existing publications were joined by new arrivals. Raymond Gaudriault has estimated that by the end of 1871 approximately 70 female fashion journals were being published in Paris.[4] They catered to an ever increasing demand in which dressing *à la mode* was no longer solely the privilege of those able to engage the services of exclusive couturiers, such as the great Charles Frederick Worth. The opening in 1852 of the *Bon Marché*, the first of Paris's many department stores, expressed the changes in consumer culture which had brought fashion within reach of a far greater swathe of the urban population. Technological advances, including the widespread use of the sewing machine after 1860, and new commercial strategies underpinned the success of mass-produced ready-to-wear clothes.[5] The journals, some of which were owned by department stores,

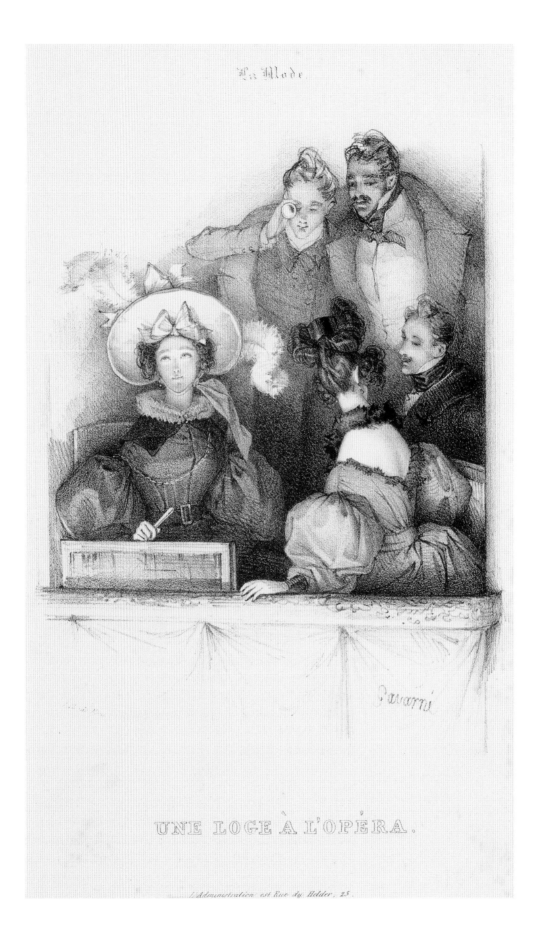

UNE LOGE À L'OPÉRA.

L'Administration est Rue du Helder, 25.

stimulated and disseminated knowledge of fashion, and helped to broaden its social role. Their columns and illustrations offered readers a mix of idealised domesticity and aspirational social scenarios; the races at Longchamps, a fashionable holiday on the coast, an elegant wedding, a grand reception, or a *première* at the theatre enjoyed from a fine *loge*.

Several of the most important fashion journals had their origins in the years of the July Monarchy, if not earlier. *La Mode* was first published in October 1829 by Emile de Girardin and Charles Mezaray. It entered a market in which publications such as the *Journal des Dames et des Modes* (1797) and the more recent *Le Petit Courrier des Dames* (1821) had started to establish a standardised format. The owners of *La Mode*, which was published every Saturday, deliberately set out to renew the role of the print that accompanied each issue, replacing "the dressed doll who has for the last 20 years had the honour of exclusively representing the people of Paris" with a more realistic interpretation of dress.[6] The artist who would help them realise this ambition was none other than the young Paul Gavarni (1804–1866), who, alongside Honoré Daumier, became one of the great satirists of his time.

Gavarni's lithograph *Une loge à l'Opéra* (cat. 14) was published in *La Mode* in February 1831.[7] *La Mode*'s predecessors had already abandoned the isolated posed model in favour of more animated arrangements; however, Gavarni's print is remarkable in the degree to which it seeks to create a scenario for its fashionable characters. Two women are seated at the front of the theatre box, the figure at the left picked out in the strong light which gathers under her bonnet, bedecked with ribbons and feathers. The other woman has turned to her male companion, ingeniously offering us a view of the back of her dress. One of the two standing male figures gazes through his opera glass, emphasising the acts of display and viewing inherent in the operation of fashion at the theatre. In its early years *La Mode*, despite its title, does not seem to have been primarily concerned with fashion and it is characteristic also of Gavarni that this image is closer to the realm of social observation than to the standard fashion plate. The inclusion of men in the theatre box would also remain unusual; the need to communicate the detail of female dresses in the constrictive space of the box ensured that men were almost never shown.

Although plainly too large to have formed part of a printed volume and lacking the necessary descriptive detail of costume, the lithograph by E. Jacquel (cat. 15), a minor illustrator active in the 1850s, illustrates formulae which were very much part of the representation of fashion in the *loge*. Framed by a gathered curtain and a somewhat uneasily delineated column, a solitary standing woman is set off against a backdrop of *loges*, where several figures with opera glasses may be made out. She is suitably dressed for what is clearly a privileged *première loge*, with an ermine stole and ermine also decorating her cuffs and the hem of her dress in luxurious quantities. The opera glasses, fan and flowers are all essential accoutrements of the theatre and regularly appear as such in fashion plates. The texts 'Belles de Jours' and 'Belles de Nuit' woven into the unusual gold floral border suggests that this print may have been conceived as part of a series

Cat. 15
E. Jacquel (dates unknown)
'Belles de Jour – Belles de Nuit', c.1850
Lithograph
The Courtauld Gallery, London

showing beauties at various emblematic scenes throughout the fashionable
hours of the day and evening.

The tension evident in many fashion prints between the need to create
engaging images with plausible scenarios and the primary interest in the
details of costume could be mediated by accompanying texts. Two prints
on facing pages in the *Journal des Dames et des Demoiselles* of 1 January
1871 provide a good example (cat. 17). This publication, which ran from
1841 to 1902, belonged to the firm of Adolphe Goubaud, which also owned
the highly successful *Le Moniteur de la Mode*. (It was not unusual for
single publishing houses to operate multiple journals and to reproduce
the same illustrations in several different publications.) Both prints are
by Emile Préval, who contributed work to numerous fashion journals.
They show women gathered in a *loge* and subsequently leaving their
box. In each case supporting texts elaborate on the costumes worn by
the individual figures. The similarity of the settings invites us to read the
prints as successive stages in a narrative, although this is not sustained
in the details of the costumes or the accompanying descriptions.

The space in both prints is occupied only by women, and rather than a man wielding opera glasses, as in Gavarni's print for *La Mode*, it is now a woman who gazes intently at what one assumes is a member of the audience. There is no evidence in such images of the sparing or decorous use of opera glasses increasingly recommended in contemporary etiquette guides. Rather the *lorgnette* repeatedly serves to emphasise the notion of display implicit in the public setting of these fashion illustrations. A further noteworthy detail is the score resting on the front of the theatre box. This too emerges as a convention in the representation of the *loge* in fashion prints and offers some comparison with painted representations, including Renoir's *Une loge au théâtre* (cat. 11). The second of the two images in *Journal des Dames et des Demoiselles* shows its models standing, allowing the reader to enjoy a full-length view of the costumes. The standing and the seated arrangements emerge as the two basic types in the use of the theatre box in fashion plates, each answering to different requirements for narrative and the display of costumes. Within the former category, showing women on the point of leaving the *loge* was a favourite device.

It is an indication of the social importance of the *loge* as a space that representations of it in fashion publications persisted and arguably even grew in popularity despite the inherent difficulties in the use of this compressed setting for showing the complexities of Parisian toilettes. Illustrators responded to these constraints with great inventiveness. Two principal figures rise above the body of often anonymous artists and artisans who sustained this industry: Jules David (1808–1892), who produced in the region of 2,600 images for *Le Moniteur de la Mode* and the no-less industrious Anaïs Toudouze (1822–1899). Toudouze was one of four daughters of the painter Alexandre Colin. Two of her siblings also worked as fashion illustrators, as did her youngest daughter Isabelle Desgrange (1850–1907). Toudouze's career spans the great years of the fashion print, before it was finally usurped by photomechanical reproduction,[8] and *loges* appear as a setting for fashion in her illustrations from at least the 1850s (cat. 16). She was prolific and worked for many of the leading fashion journals of the day including, perhaps most significantly, *La Mode Illustrée*.

First published in 1860 by Firmin Didot, *La Mode Illustrée: Journal de la Famille* was one of the most successful of all the French fashion journals of the nineteenth century. By 1866 it is estimated to have had a circulation of 40,000, which had risen to 100,000 by 1890.[9] *La Mode Illustrée* was published in a larger format than many of its rivals and it was available in multiple editions, the cheapest of which cost 12F for an annual subscription and 25c for a single issue. Even the most inexpensive edition was richly illustrated with high-quality engravings, in which the *loge* is regularly presented as a stage for fashion, both prominently on the cover of the journal and embedded within its pages (cat. 18, 19). In addition to its careful pricing and its luxurious format, the quality of the colour plates was also instrumental in the success of *La Mode Illustrée* and those of its rivals which sustained themselves in this hyper-competitive market.

LE CONSEILLER DES DAMES & DES DEMOISELLES *Novembre 1856.*

Journal d'économie domestique & de travaux d'aiguille,

159, rue Montmartre,

Paris, Un an, 10 francs, Province, 12 francs.

The primary function of these engravings was to describe in full colour various costumes and coiffures and to evoke for their readers the attractive modern settings in which they might be deployed. Readers were also encouraged to think of them as collectors' items. Writing in 1873, the editor of *La Saison: Journal Illustré des Dames* advised readers to make special albums out of the colour plates which enriched the publication, citing several views of "*des loges à l'opera*" in the years 1870 and 1871 as an example of a possible thematic approach to such an endeavour.[10]

The owners of *La Mode Illustrée* aimed self-consciously for precision in the representation of costume and Toudouze was able to combine the necessary descriptive qualities with a highly decorative and inventive approach to her subject-matter. Two hand-coloured prints may serve to demonstrate the quality of the colour illustrations featured in *La Mode Illustrée* and its main rivals in the first decade of the Third Republic. They convey also the conventions and constraints of the genre as applied specifically to the theatre. The first (cat. 20) by Anaïs Toudouze, shows a

Cat. 17
Emile Préval (dates unknown)
'Toilettes de théatre' and 'Toilettes de diner ou de soirée', engraving from *Journal des Dames et des Demoiselles*, 1 January 1871
The Courtauld Institute of Art, London

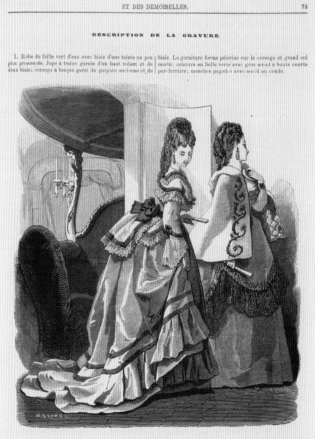

view of a group of elegant women seated in a *loge*, the accoutrements of the theatre – *lorgnette*, fan and bouquet of flowers – distributed amongst them. In its oblique viewpoint it is closely comparable to an unsigned print in *La Mode Illustrée* of 16 February 1873 in which the reader is also given a view of the back of an occupant of a second *loge* who is likewise holding a fan (see cat. 18). The careful arrangement of the heads of the models is primarily designed to display M. Boutin's coiffures; it is plainly not unified by any single action and renders the theatre and its stage largely irrelevant.

In the second hand-coloured print (cat. 21), drawn by Toudouze's daughter, we are shown two women standing at what appears to be the front of a *loge*, and here it is the need to give an uninterrupted full-length

LA MODE ILLUSTRÉE

Bureaux du Journal 56 Rue Jacob Paris

Coiffures de Mᵐᵉ BOUTIN 9 r. du 4 Septembre 9

Gilquin imp. Paris.

LA MODE ILLUSTRÉE

Bureaux du Journal 56 Rue Jacob Paris

Toilettes de Mmes FLADRY-COUSSINEL, 43.r. Richer.

Mode Illustrée. 1879. N°9.

view of the splendid and complex toilettes that is decisive for the composition. The arrangement is much like that adopted by Jules David in a print for *Le Moniteur de la Mode* (cat. 22), but here we are given a glimpse of occupants of a second *loge* in the background. One of David's models has turned to face her companion, who leans forward gently at the waist. Such exchanges help to enliven and dramatise *loge* compositions, where by and large the psychological isolation of the figures is severe.

The *loge* was one of the prime places from which to observe and participate in Paris's fashionable social parade during the Third Republic. The prevalence of the theatre box in such widely circulated fashion journals as *La Mode Illustrée* helped establish it as a subject and may plausibly have provided one context in which contemporary viewers responded to the *loge* paintings of the Impressionists. Certainly, dress is integral to the depiction of theatre box in the work of Cassatt and Renoir, and the innovative compositions evident in some fashion prints offer scope for comparison with painted representations of the *loge*. Isolated examples of the direct influence of fashion plates on Impressionist painting are known;[11] however, the search for specific sources for works such as *La Loge* (cat. 5) ultimately seems of limited value. More fruitfully, in this context, journals such as *La Mode Illustrée* describe the importance of the theatre box as a space for fashionable display and social observation – an aspirational setting in the geography of bourgeois values and a stage for the articulation of modern identity.

1. "*Un des temples de la mode s'était écroulé en une nuit; les riches toilettes qui se montraient dans l'amphithéâtre et aux balcons de notre premier théâtre lyrique allaient disparaître aussi pour un temps …. Le toilettes d'Opéra, rival de la toilette d'Italiens, attendait qu'on lui eût reconstruit son temple.*" Augustin Challamel, *Histoire de la Mode en France*, Paris, 1875, p. 219.

2. Arnold Mortier, *Les Soirées Parisiennes des 1875*, Paris, 1876.

3. Challamel 1875, p. 217.

4. Raymond Gaudriault, *La Gravure de la Mode Feminine en France*, Paris, Les Éditions de l'Amateur, 1983, p. 101.

5. See Philippe Perrot, *Fashioning the Bourgeoisie*, trans. Richard Bienvenu, Princeton, 1994, chapters 4 and 5.

6. "*…cette poupée uniforme qui, depuis 20 ans, a eu l'honneur exclusive de représenter les gens de Paris.*" Cited in Gaudriault 1983, p. 65.

7. J. Armelhault and E. Bocher, *L'Œuvre de Gavarni*, Paris, 1873, pp. 326–27, no. 2388.

8. In 1880 *L'Art de la Mode* became the first French journal to carry a fashion photograph. See Gaudriault 1983, p. 132.

9. Gaudriault 1983, p. 79.

10. *La Saison: Journal Illustré des Dames*, 22 February 1873, p. 191.

11. See Mark Roskill, 'Early Impressionism and the fashion plate', *The Burlington Magazine*, June 1970, pp. 391–95.

1876

N°5_1882

Larivière imp. r. du Cherche-Midi 79.

Goubaud & Fils Eds rue Paris

LE MONITEUR DE LA MODE

Paris, Rue du Quatre-Septembre, N°3.

Toilettes de M.me DUFOURMANTELLE Bd. des Italiens, 30. Etoffes pour deuil des Magasins de

LA SCABIEUSE, r. de la Paix, 10. Jupons & Tournures de P. de PLUMENT, r. Vivienne, 38. Veloutine FAY, r. de la Paix, 9.

Entered at Stationer's Hall

Numéro 565. 20, rue Bergère, 20. Prix : 10 cent.

PETIT JOURNAL POUR RIRE.

Directeur, Eug. Philipon. AUX BUREAUX DU Propriétaire-gérant, Eug. Philipon.

JOURNAL AMUSANT, DES MODES PARISIENNES ET DE LA TOILETTE DE PARIS.

Un Numéro : **10** Centimes. Un an, à Paris, **6** francs; — par la poste, **8** francs. Un Numéro : **10** Centimes.

On ne souscrit pas pour moins d'un an, et les abonnements partent tous du 1er janvier ou du 1er juillet. — Adresser un bon de poste à M. Philipon, 20, rue Bergère.

CROQUIS PARISIENS, — par A. Grévin.

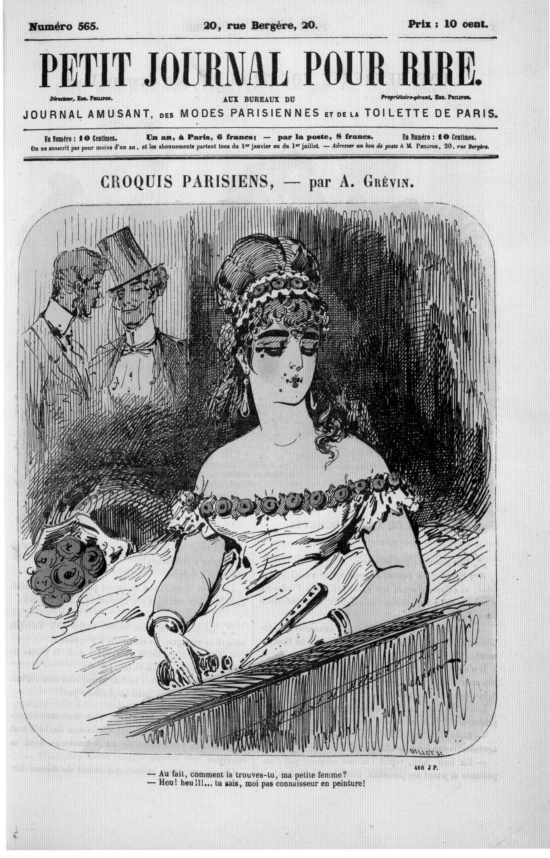

486 J P.

— Au fait, comment la trouves-tu, ma petite femme?
— Heu! heu!!!... tu sais, moi pas connaisseur en peinture!

The *Loge* in Caricature

BARNABY WRIGHT

Nos. **23—38**

23
Honoré Daumier
(1808–1879)
'La loge grillée'
Lithograph from *Album Galerie Physionomique*, 1836–37
(also published in *Le Charivari*, 1 June 1837)
Private collection

24
Grandville
(Jean Ignace Isidore Gérard)
(1803–1847)
Illustration from Grandville,
Petites misères de la vie humaine,
Paris, 1843
The Courtauld Institute of Art, London

25, 26
Paul Gavarni
(Guillaume Sulpice Chevalier)
(1804–1866)
'Une Lionne dans sa loge'
from *Le Diable à Paris*, Paris, 1845–46,
republished 1868
Private collection

'Au Théâtre Français,
La Cent-et-unième Représentation
de Le Mari, La Femme et L'Amant'
from *Le Charivari*, 28 May 1846
The Courtauld Gallery, London

27
Abel Damourette
(dates unknown)
Illustration from Edmond Texier,
Tableau de Paris, vol. 1, Paris, 1852
The Courtauld Gallery, London

28
Gustave Doré
(1832–1883)
'Paons'
Lithograph from the album
Le Menagerie Parisienne, Paris, 1854
The Courtauld Gallery, London

29–34
Petit Journal Pour Rire

29
Stop (Louis Pierre Gabriel Bernard Morel-Retz) (1825–1899)
'Les Douze Temps d'un Homme *Chic*:
Aux Italiens' no. 65, *c.*1857

30
Edouard Riou (1833–1900)
'Au Théâtre', no. 159, *c.*1859

31
Alfred Grévin (1827–1892)
'Les Parents terribles', no. 246, *c.*1860

32
Gustave Doré (1822–1883)
'Les Anglais à Paris', no. 306, *c.*1861

33
Marcelin (Emile Planat) (1825–1887)
'A l'Opéra', no. 433, *c.*1864

29–33 Private collection

34
Alfred Grévin (1827–1892)
'Croquis Parisiens', no. 565, *c.*1867
The British Library, London

35
Alfred Grévin
(1827–1892)
'Fantaisies Parisiennes: Au théâtre'
from *Le Charivari*,
20 December 1873
The Courtauld Institute of Art, London

36
Artist unknown
'Loges et Types de Grands Théâtre'
from *La Vie Parisienne*,
6 February 1875
Private collection

37
Artist unknown
'Les Folies-Garnier-Nouvel Opéra'
from *La Vie Parisienne*,
3 April 1875
Private collection

38
Mars (Maurice Bonvoisin)
(1849–1912)
'Le Public de Premières'
from *Journal Amusant*,
17 February 1877
Private collection

THE SPECTACULARLY RAPID GROWTH of Paris during the nineteenth century and the seismic political, social and cultural transformations played out within the expanding city were nowhere more vividly conveyed to contemporaries than through the tens of thousands of caricature illustrations, which poured off the printing presses at an ever increasing rate. Amidst an unprecedented boom in the production and circulation of printed material of all kinds, from newspapers to books, the rise of journals carrying satirical illustrations as an important part of their content was one of the most significant features. Whereas in the 1830s there had been less than ten such journals, during the period between 1860 and 1890 more than 150 publications of this type were in circulation. Some were very short-lived, such as *Le Frou-Frou* (1870–71), whilst the famous daily *Le Charivari* lasted for more than a century, from 1832 to 1937. For the Impressionists of the 1870s, eager to turn their art to contemporary subjects that captured the experience of modern life, the caricaturists of the past fifty years had provided a vast satirical map of modernity.[1] And on a daily and weekly basis they continued to chart, with extraordinary pictorial inventiveness and wit, seemingly every salient aspect of the changing character and latest preoccupations of French society. The novelty of Renoir's *La Loge* as a subject for fine art may have surprised viewers in 1874, but they would have been quite familiar with this type of composition, and especially its play on the theme of differently gendered forms of looking, from the numerous representations of theatre boxes and their occupants which are littered throughout the pages of periodicals and illustrated books during this period.

The birth of a distinctively modern form of nineteenth-century caricature occurred in response to the July Revolution of 1830, when that autumn Charles Philipon (1806–1862) began to found a series of satirical political journals such as *Le Caricature* and *Le Charivari* (the latter being a term for the practice of deliberately making a riotous din by clattering pots and pans together[2]). These publications mounted strident attacks upon Louis Philippe's July Monarchy and an important feature of their strategy was bitingly satirical illustrations, which Philipon believed had the potential to deliver a more powerful and far-reaching political punch than writings alone. He brought together an explosive group of illustrators who would became the leading caricaturists of the period, including

Cat. 23
Honoré Daumier (1808–1879)
La loge grillée/The box grated
Lithograph from *Album Galerie Physionomique*,
1836–37 (also published in *Le Charivari*, 1 June 1837)
Private collection

Honoré Daumier (1808–1879), Paul Gavarni (Guillaume Sulpice Chevalier;
1804–1866) and Grandville (Jean Ignace Isidore Gérard; 1803–1847). The
scourge of Louis Philippe's regime, Philipon's satirical journals prompted
the introduction of strict censorship laws, leading to various prosecutions
which were nearly financially ruinous (and in 1832 landed both Philipon
and Daumier in prison) but did not manage to stop publication. Instead,
caricaturists found inventive and subtle ways of scoring satirical points
but also concentrated their efforts upon social rather than purely political
caricature. It was in part the apparently insatiable bourgeois appetite
for this social satire that enabled the rapid growth of both specialist
caricature journals and other publications which regularly included
satirical illustrations during the Second Empire and Third Republic.
With popular success came a different type of caricature that was less
politically dangerous than the aggressively targeted journals of the 1830s.
Political satire continued and was sometimes biting, but from the 1850s
onwards caricatures were increasingly satisfying bourgeois demand for
humorous sketches on social types and manners, which were entertaining
and sometimes provocative but rarely genuinely subversive.[3]

A new generation of illustrators entered the profession to meet this demand with names such as Cham, Nadar, Random, Stop, Grévin, Mars, Bertall and Marcelin, quickly becoming famous on the rising tide of the popularity of caricature illustrations. Among the long list of publications containing caricatures which debuted at the newsstands from the 1850s onwards the titles *L'Illustration*, *Le Monde Illustré*, *Le Journal Amusant*, *Le Petit Journal Pour Rire*, and *La Vie Parisienne* were among the leaders in the field, alongside earlier established journals such as *Le Charivari*, which enjoyed continued success. Many were part of the same publishing group, one of the most important being Charles Philipon's, whose company remained at the forefront of the industry, founding, among others, *Le Journal Amusant* and *Le Petit Journal Pour Rire* in the 1850s. Different journals varied in style, character, content and price, and were geared towards different bourgeois tastes. For example, *La Vie Parisienne,* founded by Marcelin in 1863, was a light-hearted and slightly risqué journal which catered primarily to dandyish male tastes in its coverage of fashionable cultural activities such as the fine arts, the theatre, sports and music. Its large format and stylish draughtsmanship demonstrated

Cat. 24
Grandville (Jean Ignace Isidore Gérard)
(1803–1847)
Illustration from Grandville, *Petites misères de la vie humaine*, Paris, 1843
The Courtauld Institute of Art, London

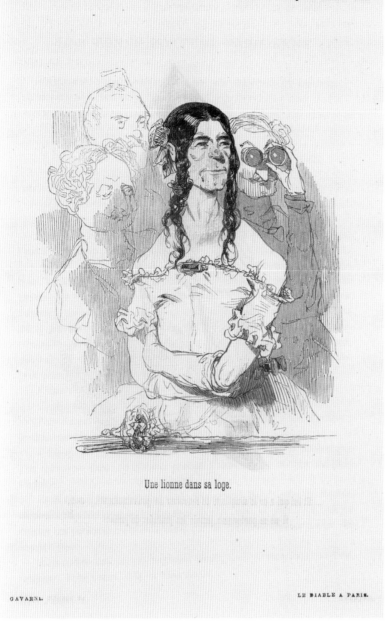

Une lionne dans sa loge.

GAVARNI. LE DIABLE A PARIS.

Cat. 25
Paul Gavarni (Guillaume Sulpice Chevalier)
(1804–1866)
'Une Lionne dans sa loge' (The Lioness in her Box)
from *Le Diable à Paris*, Paris, 1845–46,
republished 1868
Private collection

inventive and elegant ways of incorporating images and text and featured
elaborate double-page spreads. At 35 centimes in 1876, *Le Journal Amusant*
was about half the price of *La Vie Parisienne*, its smaller format and less
sophisticated tone and content looked towards a broader and perhaps
less urbane audience and it relied more heavily upon images rather
than passages of text.[4] Its spin-off, *Le Petit Journal Pour Rire*, launched at
10 centimes, was an even cheaper and more popularly orientated weekly.
Its eight-page format dispensed with text almost completely and presented
an eclectic selection of caricatures covering a wide range of topics, from

Cat. 27
Abel Damourette (dates unknown)
Illustration from Edmond Texier,
Tableau de Paris, vol. 1, Paris, 1852
The Courtauld Gallery, London

comical encounters in the Tuileries Gardens to the absurdities of contemporary artistic opinion. There was, however, significant cross-over in audiences for all these publications with *Le Petit Journal Pour Rire*, for example, being offered free with subscriptions to the mainly politically focused, *Le Charivari*. And far from this being an entirely ephemeral medium, subscribers commonly had their journals bound into annual volumes and indeed many of the leading caricaturists of the period produced individual prints for collectors or else published collections of their work in albums. The period is also marked by the publication of illustrated satirical writings in book form such as Grandville's *Petites misères* and Bertall's *Comédie de notre temps* (cat. 24 and fig. 1, p. 00).

A recurring feature of caricature throughout this period was a devotion to the Parisian theatre as a rich and seemingly endless source of social satire and comic situations. As the popularity and number of Parisian theatres grew during the century so too did the amount of space given to satirical sketches of theatre-goers, with caricaturists quickly realising that nowhere else in Paris was the social status of individuals more self-consciously (and therefore comically) on display than at the theatre. The basis of almost all caricatures of the theatre during this period was the theme of audience members scrutinising other theatre-goers or else of individuals courting the attentions of would-be admirers. These motifs had been established by the older generation of caricaturists, as epitomised by Grandville's illustration of a browbeaten young woman in the lobby of a theatre amidst a riot of lecherous men training all manner of ocular devices on her, from telescopes and field binoculars to opera glasses and spectacles (cat. 24). Perhaps because it was inherently a socially pretentious space, from the outset caricaturists seized upon the *loge* as the most fertile subject for social satire in the theatre. Within the frame offered by the velvet-cushioned theatre box a number of recurring themes emerge; a selection of these appears in this section.

One popular subject was that of women using their *loges* as a pedestal from which to court the attentions of male admirers or potential suitors. Gustave Doré's lithograph (cat. 28) casts the elegant looking women in their loges as *Paons*, or peacocks, their fans prompting associations with the shimmering tail displays of these most ostentatious of birds. Gavarni's early caricature, 'Une Lionne dans sa loge' (A lioness in her box; cat. 25) is more bitingly satirical in its presentation of a woman who is clearly well past her prime, in an ill-fitting and all too youthful dress, posing at the front of her theatre box. Gavarni plays on the alternative French usage of the word *loge* to describe a lion's den to convey her predatory character which he renders as distinctly unfeminine by giving her manly features. A comparable joke is made in Grévin's illustration for *Le Charivari*, where a mother and daughter in a *loge* discuss the arrival of an apparently beautiful lady with a man who looks like "an old monkey". On being told that despite first impressions to the contrary the lady in question is in fact "old Nana", the young woman is amazed that she has not yet "retired from business". Her bitchy comment that Nana has made the seduction of men her 'profession' chimed with a widespread belief that

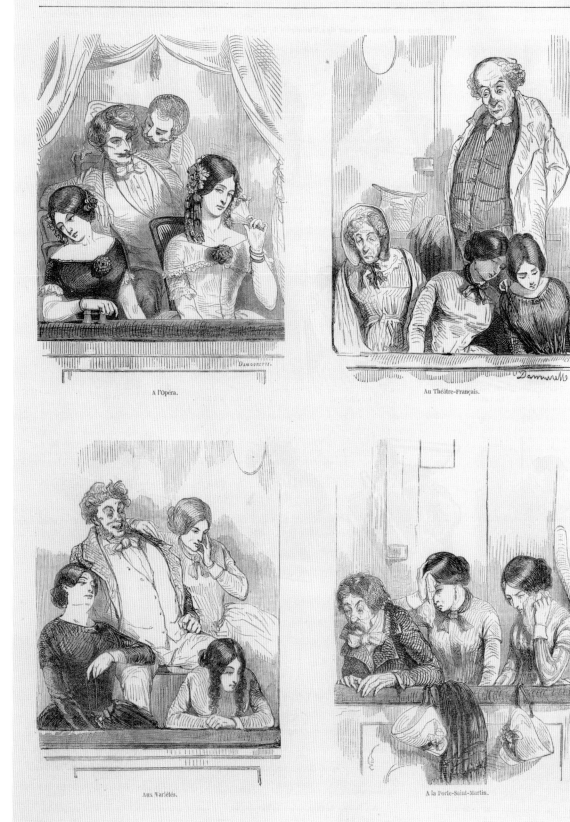

A l'Opéra.

Au Théâtre-Français.

Aux Variétés.

A la Porte-Saint-Martin.

women's pursuit of male attention at the theatre was so determined,
calculating and vulgar that it was hard to tell the debutants from courtesans.
The preponderance of women wearing tarty dresses and especially over-
using cosmetics was often commented upon in this regard, and Grévin
picks up the theme again in his front cover illustration for *Le Petit Journal
Pour Rire* (cat. 34). Here, two men in the background discuss the heavily
made-up woman in a low-cut dress posing in a *loge*: one says, "What do
you think of my little woman?"; the other replies, "Well, well I don't know,
I'm not a connoisseur of painting". But if women could be mocked for
their vanity, men were often pilloried for their lecherous sexual appetites,
like Daumier's fashionably attired gentleman who looks up the skirt of
a dancer on stage from the voyeuristic safety of his *loge grillée*, a discreet
type of theatre box with a conveniently screened opening (cat. 23). Stop's
series on the *chic* man of the day takes the idea to a comic extreme with its
sketch of a *loge* being used as a look-out post by a man with spectacularly
over-sized binoculars (cat. 29). Running through these themes of desirous
gazes and seductive poses was the question of infidelity, and several carica-
turists used the *loge* to explore the hypocrisy of marriages, none more so

Paons.

LES DOUZE TEMPS D'UN HOMME *CHIC*, — par STOP (suite).

Aux Italiens. Dans le monde.

Cat. 29

Cat. 29 – 34
Petit Journal Pour Rire:

29. Stop (Louis Pierre Gabriel Bernard Morel-Retz) (1825–1899), 'Les Douze Temps d'un Homme *Chic*: Aux Italiens' (The Twelve Times of the Chic Man), no. 65, *c.*1857

30. Edouard Riou (1833–1900), 'Au Théâtre' (At the Theatre), no. 159, *c.*1859

31. Alfred Grévin, (1827–1892), 'Les Parents Terribles' (The Terrible Parents), no. 246, *c.*1860

32. Gustave Doré (1822–1883), 'Les Anglais à Paris' (The English in Paris), no. 306, *c.*1861

33. Marcelin (Emile Planat) (1825–1887), 'A l'Opéra' (At the Opéra), no. 433, *c.*1864
29-33 Private collection

34. Alfred Grévin (1827–1892), 'Croquis Parisiens' (Parisian Sketches), no. 565, *c.*1867
The British Library, London
(illus. p. 104)

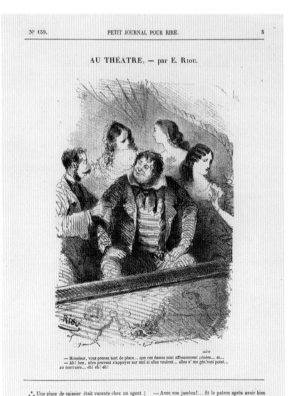

AU THÉATRE, — par E. RIOU.

— Monsieur, vous prenez tant de place... que ces dames sont affreusement gênées... et...
— Ah! ben, elles peuvent s'appuyer sur moi si elles veulent... elles n' me gên'ront point,... au contraire... eh! eh! eh!

.*. Une place de caissier était vacante chez un agent de change. Un grand gaillard dont les jambes rappellent assez celles de Nadar (118, rue Saint-Lazare; pas de succursale) vint la demander.

— Avec vos jambes!... fit le patron après avoir bien examiné le solliciteur. Mais, mon cher monsieur, s'il vous prenait fantaisie de vous sauver avec ma caisse, je ne pourrais jamais vous rattraper.

Numéro 246.

Prix : 10 cent.

PETIT JOURNAL POUR RIRE.

AUX BUREAUX DU

JOURNAL AMUSANT, DU MUSÉE FRANÇAIS–ANGLAIS ET DES MODES PARISIENNES,

Directeur, CH. PHILIPON

20, rue Bergère, 20.

Rédacteur en chef, NADAR.

LES PARENTS TERRIBLES, — par A. GRÉVIN.

148 P. J.

— Vraiment, papa, j'en suis honteuse ; tu ris comme aux places à quinze sous.

LES ANGLAIS A PARIS, — par Gustave Doré, etc. (suite).

LES ANGLAIS A L'OPÉRA.
O beautiful! beautiful indead!

LES ANGLAIS AUX VARIÉTÉS.
O choking, very choking!!

— M. Guizot s'abuse,
— M. Victor Cousin ruse.
En ce moment il y eut comme un petit temps de repos.

— Mais le reste! demandait-on au causeur.
Il répondit :
— Le reste s'use. Maxime Parr.

Cat. 32

A L'OPÉRA, — par Marcelin (suite).

UNE BONNE LOGE DE QUATRE PLACES
envoyée aux Crapoulots. Quand il y en a pour quatre, il y en a pour dix.

scène la cantatrice en train de chanter le finale du premier
acte de *Lucie*.
— J'arrive au vrai moment, dit-il.

Le ténor et la prima donna allaient entonner :
Vers toi toujours s'envolera
Mon rêve d'espérance!

Cat. 33

than Gavarni's *The Husband, the Wife and the Lover* (cat. 26), which presents all three sharing the same theatre box, the husband blissfully unaware of his rival rising spectre-like out of the shadows behind. His title suggests that such infidelities were not an uncommon state of affairs.

Perhaps the most recurrent topic of *loge* caricatures was that of social aspiration, with satirists lampooning mercilessly the uncouth manners of newly wealthy members of the bourgeoisie who took theatre boxes to show off their social status or simply to exercise their ability to take places in the theatre reserved for the upper echelons of middle-class society. None is more pertinent than Grévin's front cover for *Le Petit Journal Pour Rire* (cat. 31), which is dominated by a wealthy but inelegant and overweight man whose embarrassed daughter scolds him for laughing uncouthly as if he is still sitting in the cheap seats of the theatre rather than at the front of an expensive *loge*. A similarly overweight but scruffily dressed provincial type, who obviously has the money to buy himself a place in a *loge*, is the subject of Riou's *Au Théâtre* (cat. 30). When asked to move because his considerable bulk has squashed a group of elegant women into the side of the box, he shuns social decorum and invites them all to cuddle up closer to him. Caricaturists made much of the phenomenon of the over-crowded *loge*, a feature of high demand for *loges* by the aspirational bourgeoisie who would either make sure they got their money's worth by crowding their whole family into a single box or else were compelled to share with strangers if they could not afford to rent the *loge* in its entirety. In Marcelin's *A l'Opéra* (cat. 33) a young debutant finds herself in a hopelessly over-crowded *loge* and desperately tries to remain composed in her fashionable ermine stole but is squeezed between two unattractive women who quite literally cramp her style.

The *loge* lent itself particularly well to caricatures which compared the social and cultural status of different Parisian theatres. Damourette's full-page spread from *Tableau de Paris* (cat. 27) is an early example of this and shows four *loges* from a variety of well-known establishments ranging from the premier Opéra to the less prestigious Variétés. Accordingly the audiences at each venue represent different social types with the most fashionable and well-attired in the expensive Opéra *loge* and the less elegant or even scruffy-looking families seated at the cheaper establishments. In each case the *loge* seems to have been taken by a father to show off his daughters, which in the case of the *loge* at the Porte-Saint-Martin appears to have backfired because the theatre box is so hot and uncomfortable that his daughters are on the verge of fainting. In Gustave Doré's *Les Anglais à Paris* (cat. 32) we find a similar conceit, with the Opéra and the Variétés being contrasted, except that here foreign visitors to these theatres are the subject, with the social status of English and French audiences being reversed at each venue.

Perhaps the most inventive and lavish example of the *loge* caricature appeared as a double-page spread titled *Loges et Types de Grands Théâtre*, in *La Vie Parisienne* in 1875, the year in which Garnier's new opera house was opened to huge fanfare in Paris (cat. 36). It presents sixteen theatre-box vignettes showing the occupants of different *loges* typically found at

Cat. 36 (illus. pp. 114–115)
Artist unknown
'Loges et Types de Grands Théâtre'
(Theatre Boxes and Types of the Grand Theatres)
from *La Vie Parisienne*, 6 February 1875
Private collection

Cat. 37 (illus. pp. 116–117)
Artist unknown
'Les Folies-Garnier-Nouvel Opéra',
from *La Vie Parisienne*, 3 April 1875
Private collection

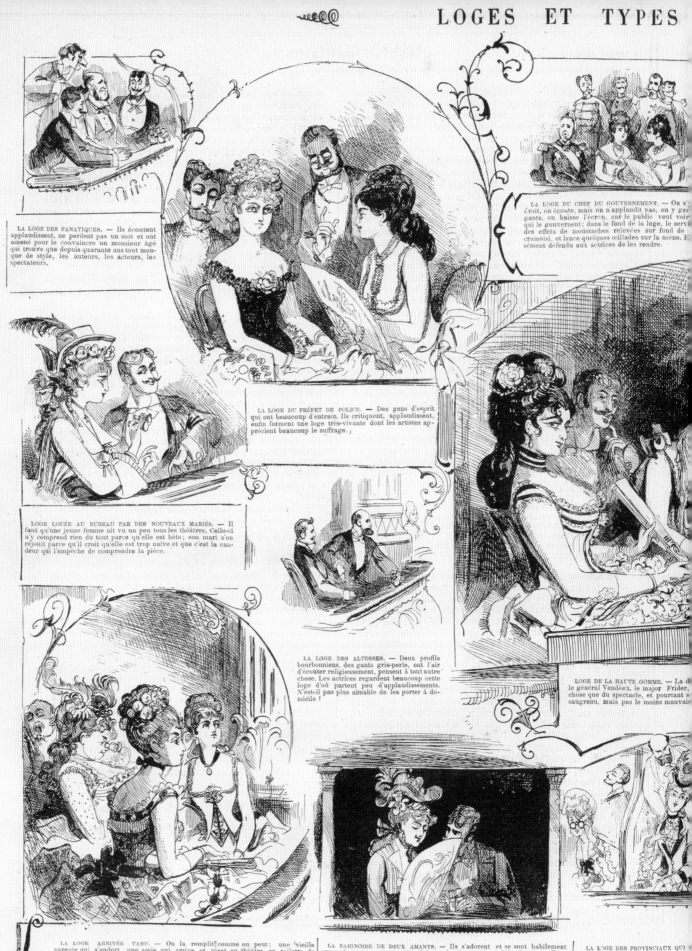

LA LOGE DES FANATIQUES. — Ils écoutent applaudissent, ne perdent pas un mot et ont amené pour le convaincre un monsieur âgé qui trouve que depuis quarante ans tout manque de style, les auteurs, les acteurs, les spectateurs.

LA LOGE DU CHEF DU GOUVERNEMENT. — On s'y croit, on écoute, mais on n'applaudit pas, on y gar gants, on baisse l'écran, car le public veut voir qui le gouvernent; dans le fond de la loge, le servi des effets de moustaches relevées sur fond de cramoisi, et lance quelques œillades sur la scène. E sément défendu aux actrices de les rendre.

LA LOGE DU PRÉFET DE POLICE. — Des gens d'esprit qui ont beaucoup d'entrain. Ils critiquent, applaudissent, enfin forment une loge très-vivante dont les artistes apprécient beaucoup le suffrage.

LOGE LOUÉE AU BUREAU PAR DES NOUVEAUX MARIÉS. — Il faut qu'une jeune femme ait vu un peu tous les théâtres. Celle-ci n'y comprend rien du tout parce qu'elle est bête; son mari s'en réjouit parce qu'il croit qu'elle est trop naïve et que c'est la candeur qui l'empêche de comprendre la pièce.

LA LOGE DES ALTESSES. — Deux profils bourbonniens, des gants gris-perle, ont l'air d'écouter religieusement, pensent à tout autre chose. Les actrices regardent beaucoup cette loge d'où partent peu d'applaudissements. N'est-il pas plus aimable de les porter à domicile !

LOGE DE LA HAUTE GOMME. — La d le général Vendéen, le major Frider, chose que du spectacle, et pourtant s saugrenu, mais pas le moins mauvais

LA LOGE ARRIVÉE TARD. — On la remplit comme on peut; une vieille parente qui s'endort, une amie qui arrive et vient au théâtre en toilette de voyage, l'institutrice, le secrétaire, public indulgent et de très-bonne humeur.

LA BAIGNOIRE DE DEUX AMANTS. — Ils s'adorent et se sont habilement arrangés pour passer cette soirée seuls. Son mari est à la chasse et elle a invité officiellement une amie qui a promis de ne pas venir. Voilà deux spectateurs qui trouveront tout bien.

LA LOGE DES PROVINCIAUX QUI MARIAGE. — Le futur est à l'orche quelque chose et à tout hasard tie eaux et l'engage à se tenir droite.

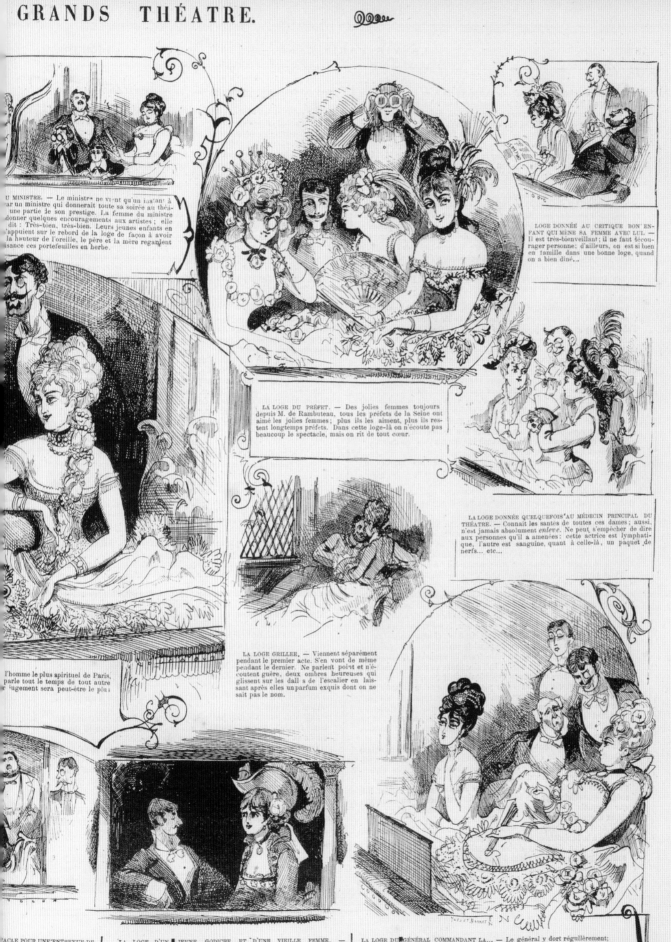

U MINISTRE. — Le ministre ne vient qu'un instant à ar un ministre qui donnerait toute sa soirée au théâ- une partie de son prestige. La femme du ministre donner quelques encouragements aux artistes; elle dit: Très-bien, très-bien. Leurs jeunes enfants en appuient sur le rebord de la loge de façon à avoir la hauteur de l'oreille, le père et la mère regardent ssance ces portefeuilles en herbe.

LOGE DONNÉE AU CRITIQUE BON ENFANT QUI MÈNE SA FEMME AVEC LUI. — Il est très-bienveillant; il ne faut décourager personne; d'ailleurs, on est si bien en famille dans une bonne loge, quand on a bien dîné...

LA LOGE DU PRÉFET. — Des jolies femmes toujours depuis M. de Rambuteau, tous les préfets de la Seine ont aimé les jolies femmes; plus ils les aiment, plus ils restent longtemps préfets. Dans cette loge-là on n'écoute pas beaucoup le spectacle, mais on rit de tout cœur.

LA LOGE DONNÉE QUELQUEFOIS AU MÉDECIN PRINCIPAL DU THÉATRE. — Connait les santés de toutes ces dames; aussi, n'est jamais absolument enlevé. Ne peut s'empêcher de dire aux personnes qu'il a amenées: cette actrice est lymphatique, l'autre est sanguine, quant à celle-là, un paquet de nerfs... etc...

l'homme le plus spirituel de Paris, parle tout le temps de tout autre jugement sera peut-être le plus

LA LOGE GRILLÉE. — Viennent séparément pendant le premier acte. S'en vont de même pendant le dernier. Ne parlent point et n'écoutent guère, deux ombres heureuses qui glissent sur les dalles de l'escalier en laissant après elles un parfum exquis dont on ne sait pas le nom.

ACLE POUR UNE ENTREVUE DE ment; la future se doute de Sa mère fait bouffer ses ban-

LA LOGE D'UN JEUNE GODICHE ET D'UNE VIEILLE FEMME. — Ils s'ennuient l'un et l'autre à mourir; mais que voulez-vous? Il faut bien fair quelque chose entre le dîner et le coucher.

LA LOGE DU GÉNÉRAL COMMANDANT LA... — Le général y dort régullèrement; sa femme vient surtout les jours de tragédie. L'un et l'autre préfèrent Scribe à Musset. Ils amènent leurs filles pour qu'elles apprennent à prononcer les r sans grasseyer. « C'est une leçon de bon langage, » dit le général.

LE FOYER.

« Où tant d'or se relève en bosse,
« Qu'il étonne tous les pays. »

Et tue complétement les peintures. Du reste, c'est bien ce que voulait l'architecte. Aux siècles passés, les nommés Titien Véronèse ou Rubens vous trouaient brutalement un plafond pour faire descendre tous les dieux de l'Olympe sous la voute; les Garnier de l'époque s'arrangeaient comme ils pouvaient. Vieux jeu cela. Aujourd'hui défense aux peintres de peindre autrement qu'en tons douçâtres éteints, déjà à moitié effacés, pour ne nuire en rien aux lignes de l'architecture. Que si un Baudry de génie s'avise de mettre là haut la page la plus exquise et la plus forte qu'on ait vue depuis trente ans, on enfouira et enfumera si bien son œuvre au moyen de lustres placés entre elle et l'œil du spectateur, que l'année prochaine on n'en verra plus rien; Mais les lustres à lyres et dessinés par Garnier lui-même nous restent, et c'est assez.

De tout, lyres, des des ronds et des cro nimbe side tronçon de de carabi roulés en eieuses, r bles de M

Toutes les cagnottes de provi et du sud en ruptures de mines ou toutes les perruches des colonies çais; tous les goûts, excepté le bo de se donner la peine de si bien ch Halanzier et Garnier en personne

du reste. Des
es d'éléphants,
des têtes des
, des chouettes
haut, dans un
sommet d'un
ans des rayons
es cheveux en-
en pierres pré-
jamais mémora-

LA SALLE.

Ni loges, ni balcons ; rien que quatre hauts tiroirs d'où surgissent à peine des têtes. De
l'or et des pointes, des pointes et de l'or ; en haut, en bas. Plus de toilettes, plus de femmes.
Les malheureuses, pour lutter désavantageusement avec cet épouvantable amoncellement de
saillies dorées qui les tuent, en sont arrivées à se mettre sur la tête des couronnes de gros
fruits d'or ou d'argent massif et brillant. A bientôt les appareils électriques qu'un ami d'en
face tiendra braqué sur vous ; quelques essais de petits phares lumineux sur la tête ont déjà
été essayés ; quant aux diamants, il n'en est plus question.

L.

omies ; tous les Américains du nord
es Anglaises en rupture de Nursery ;
outes les langues, excepté le Fran-
e Faure n'est pas quelque peu sot
e ménagerie domptée par messieurs
eux leur affaire !

Cat. 35
Alfred Grévin (1827–1892)
'Fantaisies Parisiennes: Au Théâtre',
(Parisian Fantasies: At the Theatre)
from *Le Charivari*, 20 December 1873
The Courtauld Institute of Art, London

FANTAISIES PARISIENNES, PAR A. GRÉVIN. 275

AU THÉATRE.

— Tu connais, mère, cette belle là-bas qui vient d'arriver avec cet affreux singe ?
— C'est Nana !
— La vieille Nana ! Tiens, je la croyais retirée des affaires.

the premier theatres. In the centre of the image the grandest, *Loge de la Grand Gomme*, contains a group of the *chic*est members of society who talk, we are told, about everything apart from the performance. Around this are arranged a spectrum of different social types and encounters, from romantic trysts in the *loge grillée* to the very formally composed family of a government minister. In another scene gauche visitors from the country occupy one rather crowded *loge* while a further box is taken by a group of male aficionados of the theatre who devour every aspect of the theatrical experience. This anthology of caricatured *loges* demonstrates the wide variety of social themes that could be conveyed by the theatre box, and which had been developed by satirical illustrators over the previous decades. It is no surprise then that when covering the century's biggest theatrical event in France, the inauguration of Garnier's opera house, *La Vie Parisienne* should again choose the *loge* as the central motif in its spectacular double-page cartoon of the opening night (cat. 37). Here, all manner of social types are packed into an imaginary oversized '*loge* in-the-round' from where they break out a veritable armoury of

LE PUBLIC DES PREMIÈRES, — par MARS.

— Nous causons, mesdames, et j'oublie mon compte rendu!...
— Eh bien! cher critique, vous parlerez de nous!
— Oh! oh! à propos de première... Si encore il s'agissait d'une centième! ..
— Merci! dites tout de suite d'une reprise!

Cat. 38
Mars (Maurice Bonvoisin) (1849–1912)
'Le Public de Premières' (The Public of
the Premieres) from *Journal Amusant*,
17 February 1877
Private collection

telescopes, binoculars and opera glasses, all pointed towards different parts of Garnier's fantastical architectural interior.

In choosing the *loge* as a new subject for painting in 1874, Renoir was taking a motif that had been thoroughly exploited in caricature and turned into one of the principal settings for social commentary and satire. It is telling that when Renoir exhibited *La Loge* at the first Impressionist exhibition, the critics attempted to read the painting as portraying particular social types, in ways that one might expect to find in a *loge* caricature, albeit without the explicit satirical sting. Thus, some critics thought the woman's heavy make-up and ostentatious attire betrayed the vulgarity of her social aspirations, while another saw her as a "woman from the world of elegance" courting attention in the fashionable space of a *loge* (see John House's essay). These were precisely the themes which caricature of the Second Empire and Third Republic had repeated endlessly and driven to the point of cliché. Renoir's *La Loge* did not so much invent a subject but rather transformed and reinvigorated an old favourite from the popular culture of caricature.

1. See Joel Isaacson, 'Impressionism and Journalistic Illustration', *Arts Magazine*, June 1982.
2. See Judith Wechsler, *A Human Comedy: Physiognomy and Caricature in Nineteenth-Century Paris*, London 1982.
3. See Beatrice Farwell, *The Cult of Images: Baudelaire and the 19th Century Media Explosion*, University of California Art Museum, 1977.
4. Isaacson 1982, p. 95.

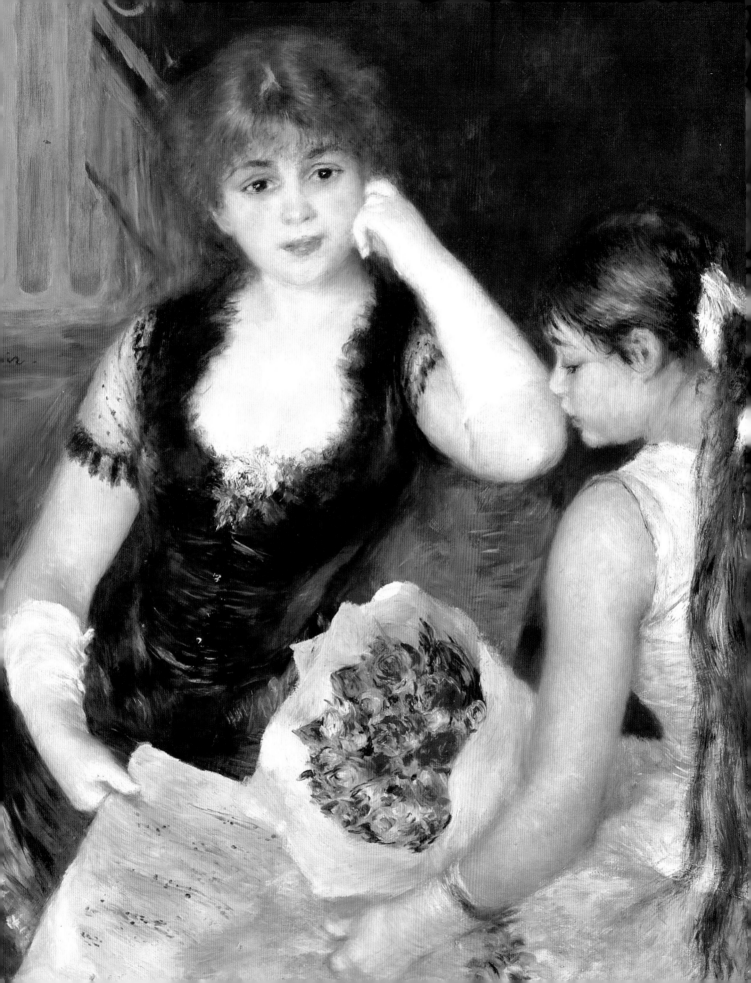

The following is a list of the principal publications consulted in the preparation of this catalogue.

Judith Barter (ed.), *Mary Cassatt: Modern Woman*, exh. cat., The Art Institute of Chicago, 1998

Ruth Berson, *The New Painting: Impressionism 1874–1886, Documentation*, San Francisco and Seattle, 1996

Merete Bodelsen, 'Early Impressionist Sales 1874–94 in the Light of Some Unpublished "Procès-verbaux"', *The Burlington Magazine*, June 1968

David Bomford *et al*, *Art in the Making: Impressionism*, exh. cat., National Gallery, London, 1990–91

Guy-Patrice and Michel Dauberville, *Renoir: Catalogue raisonné des tableaux, pastels, dessins et aquarelles, 1858–1881*, Paris, 2007

François Daulte, *Auguste Renoir: Catalogue raisonné de l'œuvre peint, I, Figures 1860–1890*, Lausanne, 1971

Anne Distel and John House *Renoir*, exh. cat., Hayward Gallery, London; Grand Palais, Paris; Museum of Fine Arts, Boston, 1985–86

Anne Distel, *Renoir impressionniste*, Paris, 1993

Tamar Garb, 'Gender and representation', in Francis Frascina (ed.), *Modernity and Modernism: French Painting in the Nineteenth Century*, New Haven and London, 1993

Raymond Gaudriault, *La Gravure de la mode féminine en France*, Paris, 1983

Charles Harrison, *Painting the Difference: Sex and Spectator in Modern Art*, Chicago, 2005

F.W.J. Hemmings, *The Theatre Industry in Nineteenth Century France*, Cambridge, 1993

Robert L. Herbert, *Impressionism: Art, Leisure and Parisian Society*, New Haven and London, 1988

Robert L. Herbert (ed.), *Nature's Workshop: Renoir's Writings on the Decorative Arts*, New Haven and London, 2000

John House, *Impressionism: Paint and Politics*, New Haven and London, 2004

John House *et al.*, *Impressionism for England: Samuel Courtauld as Patron and Collector*, New Haven and London, 1994

Joel Isaacson, 'Impressionism and Journalistic Illustration', *Arts Magazine*, June 1982

Ruth Iskin, *Modern Women and Parisian Consumer Culture in Impressionist Painting*, Cambridge and New York, 2007

Paul Jamot, 'Renoir, I', *Gazette des Beaux-Arts*, November 1923

Steven Kern *et al.*, *A Passion for Renoir: Sterling and Francine Clark Collect 1916–1951*, New York and Williamstown, 1996

Julius Meier-Graefe, *Auguste Renoir*, Paris, 1912

Charles S. Moffett (ed.), *The New Painting: Impressionism 1874–1886*, The Fine Arts Museums, San Francisco; National Gallery of Art, Washington, 1986

Philippe Perrot, *Fashioning the Bourgeoisie: A History of Clothing in the Nineteenth Century*, Princeton, New Jersey, 1994

Georges Rivière, *Renoir et ses amis*, Paris, 1921

Sidsel Maria Søndergaard (ed.), *Women in Impressionism. From Mythical Feminine to Modern Woman*, exh. cat., Ny Carlsberg Glyptothek, Copenhagen, 2006–07

Ambroise Vollard, *La Vie et l'œuvre de Pierre-Auguste Renoir*, Paris, 1919; reprinted in *En écoutant Cézanne, Degas, Renoir*, Paris, 1938

Nicholas Wadley (ed.), *Renoir: A Retrospective*, New York, 1987

Judith Wechsler, *A Human Comedy: Physiognomy and Caricature in Nineteenth-Century Paris*, London, 1982

Selected Bibliography

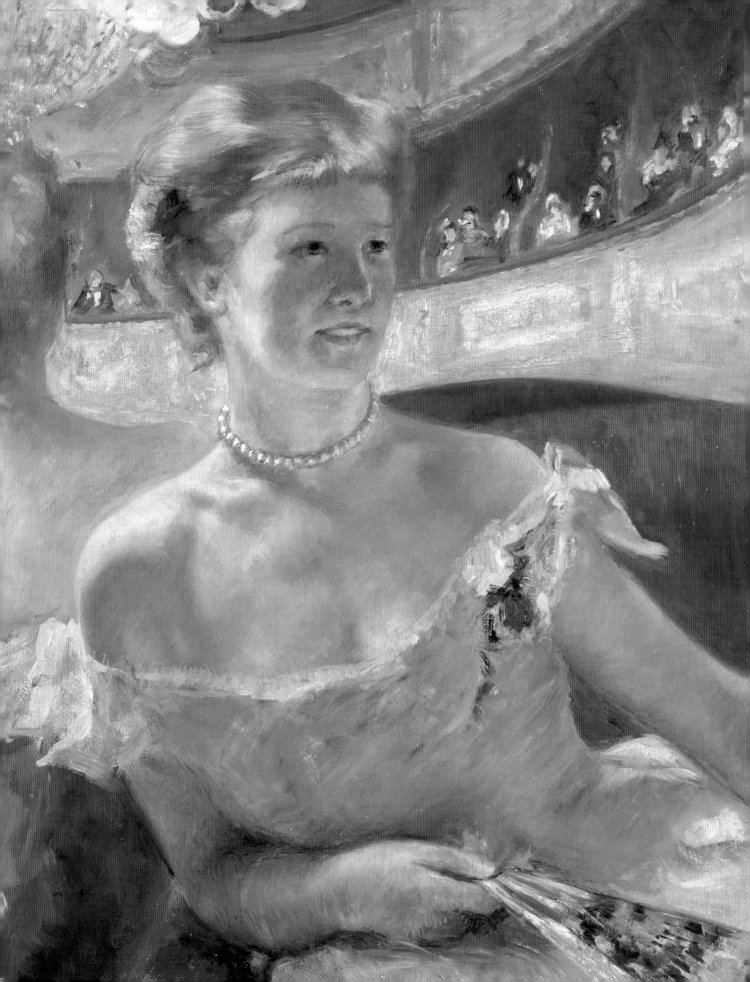

The Courtauld is grateful for the significant annual support that it receives from the members of the Samuel Courtauld Society.

Samuel Courtauld Society

Director's Circle

Andrew and Maya Adcock
Apax Partners
Christie's
Nicholas and Jane Ferguson
Sir Nicholas and Lady Goodison
The Worshipful Company of Mercers
Sotheby's

Patrons' Circle

Anonymous
Agnew's
Lord and Lady Aldington
Sabine Blümel
Charles and Rosamond Brown
Mr Damon Buffini
David Butter
Julian and Jenny Cazalet
Mr Colin Clark
Nick Coutts
Eric Coutts
David Dutton
Mr. and Mrs. Thomas J. Edelman
Mr Roger J.H. Emery
Ms Veronica Eng
Mr Sam Fogg
Lucía V. Halpern and John Davies
David Haysey
Hazlitt, Gooden & Fox
Mr and Mrs Schuyler Henderson
Nicholas Jones
Norman A. Kurland and Deborah A. David
Daniel Katz Ltd
James Kelly
Mr and Mrs David Lass
Helen Lee and David Warren
Gerard and Anne Lloyd
Mr Jay Massey
Clare Maurice
The Honourable Christopher McLaren

Cory Edelman Moss and James Moss
Mr John Murray
Mr Morton Neal CBE
Mrs Carmen Oguz
Mr Michael Palin
Lord and Lady Phillimore
Mr Richard Philp
Leslie Powell
Mr and Mrs Armins Rusis
Pam Scholes
Mr Richard Shoylekov
William Slee and Dr Heidi Bürklin-Slee
Colin Stewart and Sarah Kell
Sir Angus Stirling
Johnny Van Haeften
Mrs Elke von Brentano
Erik and Kimie Vynckier
The Rt. Hon. Nicholas and Lavinia Wallop
Susan and Jeffrey Weingarten
Jacqui and John White
Matthew and Molly Zola

Associates

Anonymous
Mrs Kate Agius
Lord Jeffrey Archer
Dr Charles Avery FSA
Simon and Caroline Barnes
Jean-Luc Baroni Ltd
Philip and Casie Bassett
Bonhams 1793 Limited
Mr Oliver Colman
Simon C. Dickinson Ltd
Mr Andrew P. Duffy
Mrs Judy Freshwater
The Rev. Robin Griffith-Jones
Historical Portraits Ltd
Dr Chris Mallinson
Michael and Jennifer Parsons
Yvonne Tan Bunzl

Photographic Credits

First published to accompany the exhibition

Renoir at the Theatre
Looking at *La Loge*

at The Courtauld Gallery,
Somerset House, London
21 February – 25 May 2008

The Courtauld Gallery is supported
with funds from the Arts and Humanities
Research Council (AHRC)

Arts & Humanities
Research Council

ISBN 9781903470732

British Library Cataloguing in Publication Data
A catalogue record for this book is
available from the British Library

Produced by
Paul Holberton publishing
89 Borough High Street,
London SE1 1NL
www.paul-holberton.net

Designed by Philip Lewis

Origination and printing by
Graphic Studio, Bussolengo,
Verona, Italy

Cover: Pierre-Auguste Renoir,
La Loge, cat. 5

Frontispiece: Detail cat. 5

Page 4: Detail cat. 34
Page 8: Detail cat. 20
Page 10: Detail cat. 9
Page 26: Detail cat. 8
Page 44: Detail cat. 21
Pages 64–65: Detail cat. 12
Page 124: Detail cat. 11
Page 126: Detail cat. 10